Henri Cole · Rossetter Cole · Tom Cole · Joan Colebrook VanKirk · Dan Coleman · Elnora Coleman · Glenn Coleman · Laurence Coleman · Patricia Coleman · Michael Colgrass · Yvan Coll · Paula Collery · Zena Collier · Martha Collins · Jaime Collyer · David Colson · Maurice Colton · Mary Colum · Padraic Colum · Patrick Comiskey · Gianna Commito · Gia Comolli · Harriet Comstock · Isabel Conant · Miguel Conde · Grace Conkling · Susan Conley · Ferris Connah · Anne Connell · Maureen Connell · Joan Connor · Gillian Conoley · Robert Conover · Earl Conrad · Carol Conroy · Marc-Antonio Consoli · Terri Constant · Mark Conway · Karin Cook · Kenneth Cook · Alvin Cooke · Doug Cooney · Ann Cooper · Barbara Cooper · Jane Cooper · John Cooper · Paul Cooper · Seth Cooper · Susan Cooper · T. Cooper · Thomas Cooper · Mark Coovelis · Virginia Copeland · Aaron Copland · Edward Corbett · Gena Corea · Christopher Corkery · Cathleen Corlett · Alfred Corn · Jennifer Cornell · Richard Cornell · James Corpora · Eduardo Corral · Raul Correa · Art Corriveau · Lydia Cortes · Eleanor Cory · Steven Cosson · John Costa · Constance Costigan · Gheorghe Costinescu · Jonathan Cott · Sarah Cotterill · Robert Cottingham · Jeffery Cotton · Marsha Cottrell · Cynthia Cotts · Monroe Couper · Erin Courtney · Marguerite Courtney · Nancy Couto · Christin Couture · Norma Cowdrick · Russell Cowles · Cindy Cox · Elizabeth Cox · Ralph Cox · Renee Cox · David Coxhead · Kathleen Coyle · Richard Coyle · John Coyne · Vincent Cozza · Kevin Craft · M. Jean Craig · William Craig · Ali Craighead · Gregory Crane · Margaret Crane · Robert Craner · Jay Craven · Curtis Cravens · Cair Crawford · Colin Crawford · Jane Crawford · Louise Crawford · Nelson Crawford · Ruth Crawford · Stanley Crawford · E. G. Crichton · Susan Crile · Agnes Crimmins · Grace Croff · Justin Cronin · Hume Cronyn · Ranice Crosby · Rebecca Cross · Stanley Crouch · John Crowley · Gertrude Crownfield · Margaret Croyden · David Crumb · Angie Cruz · Cynthia Cruz · Douglas Culhane · Catherine Cullen · Beatrice Cuming · Conrad Cummings · Deborah Cummins · Joseph Cummins · Megan Cump · Jan Cunningham · Virginia Cuppaidge · Joseph Curiale · Brian Current · Marilyn Currier · Nathan Currier · Sebastian Currier · Aileen Curry-Cloonan · C. Michael Curtis · Lynn Curtis · Timothy Curtis · Barbara Cushing · Rosie Cutler · Annette Cyr · Ruth Cyril · Chaya Czernowin · Stephen Czoka · Erica Daborn · Noel DaCosta · John D'Agata · Thomas Dahill · Ingolf Dahl · Lisa Dahl · Edward Dahlberg · Ralph Dale · Gregory D'Alessio · Joseph Daley · James Dalgliesh · Miklos Dallos · Jennifer Dalton · John Dalton · Power Dalton · Rae Dalven · James Daly · Julia D'Amario · Anthony Damato · Jack Damer · Bertha Damon · Lisa D'Amour · Lewis Daniel · Minna Daniel · Richard Danielpour · Eleanor Daniels · J. Yolande Daniels · Mabel Daniels · Traci Dant · Ann Darby · Corey Dargel · Ann Darr · Elisa D'Arrigo · Celius Daugherty · Kiana Davenport · Gregory Davidek · Jordan Davidoff · Ann Davidon · Gustav Davidson · John Davidson · Nancy Davidson · Allen Davis · Amanda Davis · Anthony Davis · Christina Davis · Christopher Davis · Doris Davis · Douglas Davis · Eisa Davis · Harry Davis · Katie Davis · Katie Davis · Olena Davis · Paxton Davis · Stephen Davis · Susan Davis · Thulani Davis · Bill Davison · John Davison · Nicholas Dawidoff · Cecil Dawkins · Cort Day · Frederic Day · Hoge Day · James Day · Jean Day · John Day · Jonathan Day · Larry Day · Linda Day · Robert Day · Worden Day · Susan Daykin · Monica de la Torre · Oscar De Las Flores · Francesco De Leone · Nicholas de Monchaux · Blane De St. Croix · Warren Deacon · Babs Deal · Borden Deal · Mark Dean · Mary Jane Dean · Michelle Deatrick · John DeBeradinis · Pat DeCaro · Elisa Decker · Greg Decker · Jonathan Dee · George Deem · Anthony DeFranco · Helen Degen-Cohen · Virginia Dehn · E. Hubert Deines · Dorothy DeJagers · Ormonde DeKay · Sandro Del Rosario · David Del Tredici · Roberta Delaney · Talaya Delaney · Pierre DeLattre · Nicholas Delbanco · Jose Delgado Guitart · Robert Dell · Ralph Della-Volpe · Norman Dello Joio · Alyssa DeLuccia · Jane DeLynn · Stephen Dembski · Deborah DeMoulpied · Franz Denghausen · Alice Denham · Deborah DeNicola · Robert DeNiro · Thorsten Dennerline · Candace Denning · Carl Dennis · Tory Dent · James D'Entremont · Shira Dentz · Peter Denzer · Katharina Denzinger · Wallace DePue · Stacey D'Erasmo · Marcy Dermansky · Jovan DeRocco · Steve Derrickson · Toi Derricotte · Christopher Deschenes · Arthur Deshaies · Paul DesMarais · Albert Deutsch · Babette Deutsch · Nabaneeta Dev Sen · John Devaney · Edward Devany · Alexis DeVeaux · Ann deVere · Aline DeVillele · Robert DeVries · James Dey · Uday Dhar · Sabrina Dhawan · Lorella Di Cintio · Rocco Di Pietro · Cara Diaconoff · David Diamond · Jamie Diamond · Dominique Dibbell · Antonio DiBenedetto · Martin Dibner · Ralph DiCapua · Arthur Dickerson · Daniel Dickerson · David Dickinson · Nancy Dickinson · Carol Diehl · Sari Dienes · John Diercks · Tamar Diesendruck · Anthony DiFranco · Nicholas DiLeo · Angela Diller · Fannie Dillon · Millicent Dillon · Robert DiMatteo · Laura DiMeo · Barbara Dimmick · Carol Dine · Tom Dineen · Lisa Dinhofer · Simon Dinnerstein · Donna DiNovelli · Marylyn Dintenfass · David DiPietro · Jed Distler · Stephen Dixon · Ivan Djeneef · Roberto Doati · Anne Dobbins · Lori Dobbins · Arnold Dobrin · Stephen Dobyns · E. Doctorow · Kate Dodd · Don Doe · Judy Doenges · William Doerrfeld · Clare Dolan · J. D. Dolan · Janice Dolan · Kerry Dolan · Mike Dolan · Hildegarde Dolson · Blanche Dombek · Tom Donaghy · Scott Donaldson · Sara Doncaster · Susan Donnelly · Seena Donneson · Richard Donovan · Danny Donovan-Wilhelmi · Emily Doolittle · Moshe Dor · Matt Doran · Jon D'Orazio · Thomas Doremus · Todd Dorman · Lesley Dormen · Iris Dornfeld McWilliams · Robert Dorsett · Douglas Dorst · Jan Doubrava · Celius Dougherty · Devin Dougherty · Maureen Dougherty · Nancy Dougherty · Laura Douglas · Thomas Doulis · Anita Douthat · Francesca Dow · Hilda Downer · John Downey · Cile Downs · Joan Downs · Chris Doyle · Catherine Drabkin · Sarah Draney · Ruth Draper · Kathy Drasher · Karl Drescher · Mark Dresser · Rosalyn Drexler · Sherman Drexler · Ellen Driscoll · Louise Driscoll · Grant Drumheller · Dean Drummond · Tom Drury · Amy Dryansky · Thomas Drysdale · Ralph Dubin · Anda Dubinskis · Doug Dubois · Maggie Dubris · Elizabeth Duffy · Denise Duhamel · Norman Dukes · Harris Dulany · Olivia Dunbar · Harry Duncan · Elaine Dundy · Loretta Dunkelman · Ferdinand Dunkley · Katharine Dunlap · Charles DunLeavay · Stephen Dunn · Judith Dupre · Edison DuPree · Jane Duran · Mark Alice Durant · Mary Durant Harwood · William Durkee · Sidney Durst · Marie Dutka · Louise Dutton · Barbara Duval · Jeanne Duval · Roger Duvernoy · Susan Dworkin · Gary Dwyer · Helen Dyckman · David Dzubay · Charles Eakin · Paul Earls · John David Earnest · Keller Easterling · Yvette Eastman · Louise Eastman Loening · Evelyn Eaton · Dennis Eberhard · David Ebersole · Jason Eckardt · Barbara Edelstein · Rona Edington · Peter Edlund · Susan Edmiston · John Edmunds · Beth Edwards · Ethel Edwards · George Edwards · Wendy Edwards · Robert Een · Akuo Ehoh · Leonard Ehrlich · Janice Eidus · Nancy Eimers · Daniel Eisenberg · Emanuel Eisenberg · Mark Eisenstein · Benita Eisler · Marjorie Eklind · Halim El-Dabh · Susan Elderkin · Letitia Eldredge · Arthur Elias · Ethel Eliot · Samuel Elkin · Scott Elledge · Daniel Eller · Alma Ellerbe · Paul Ellerbe · Gil Elliot · Dennis Elliott · George Elliott · Jonathan Elliott · Ronnie Elliott · Stephen Elliott · Dean Ellis · Thomas Sayers Ellis · Tori Ellison · Emily Elman · Richard Elman · Jean Elshtain · Lynne Elton · Paul Elwood · Linda Ely · Lynn Emanuel · Martin Emanuel · Lucy Embury · Susan Emerling · Sybil Emerson · Ty Emerson · Dale Emmart · Amze Emmons · Carol Emshwiller · David Engel · Kathy Engel · Mary Potter Engel · Carol Engelson · Elise Engler · Maurice English · Bevin Engman · Christopher Engstrom · Emigdio Enriquez · Richard Entel · Tony Eprile · Alvin Epstein · Amy Epstein · Cynthia Epstein · Jacob Epstein · Marti Epstein · Louise Erdrich · Steve Erickson · Harry Eriksen · Gaela Erwin · James Esber · John Escher · Pozzi Escot · Amy Eshoo · Robert Eshoo · Eugenio Espinosa · Nancy Esposito · Barbara Ess · Angie Estes · Nicolas Estevez · Gratiane Etchevers · Jeffrey Eugenides · David Evanier · Annie Evans · Christine Evans · Elizabeth Evans · Elizabeth Fay Evans · Julie Evans · Mari Evans · Paige Evans · Rodney Evans · Barbara Eve · Nomi Eve · Brian Evenson · Peter Evershed · Kevin Everson · Richard Exner · Alessandra Exposito · Scott Eyerly · Gwen Fabricant · Mark Facknitz · Kathy Fagan · John Fago · Raymond Fahrner · Tory Fair · B. H. (Pete) Fairchild · Margaret Fairlie Kennedy · Florence Falk · Marcia Falk · Evan Fallenberg · Camilla Fallon · Cate Fallon · Susan Fanshel · Edi Fanto · Patricia Fargnoli · Malcolm Farley · Peter Farmer · Mateel Farnham · Fred Farr · Noel Farrand · Graham Farrell · James Farrell · Herman Farrell III · Carolyn Farrington · Byron Farwell · Heide Fasnacht · Bruce Faulconer · Georgene Faulkner · Jemison Faust · Elton Fax · Julie Fay · Sarah Fay Baird · Laura Fayer · Steve Fayer · F. Feeney · Mary Kelly Feeney · Linda Feferman · George Feifer · Jules Feiffer · Joel Feigin · Cheri Fein · Barbara Feinberg · Elen Feinberg · Jean Feinberg · Tina Feingold · Emily Feinstein · Rochelle Feinstein · Merrill Feitell · Cecelia Feld · Ross Feld · Barbara Feldman · Elizabeth Felicella · Daniel Felsenfeld · John Felstiner · Mary Felstiner · Qin Feng · Beth Ann Fennelly · Carlos Ferguson · Elise Ferguson · Jesseca Ferguson · Kathleen Ferguson · Nancy Jo Ferguson Rhodes · Roberta Fernandez · Monica Ferrell · Lucy Ferriss · Anne Fessenden · Richard Festinger · Celeste Fichter · Arthur Fickenscher · Michael Fiday · Edward Field · Ruth Fields · Tom Filer · Peter Filkins · Parker Fillmore · Vernon Fimple · Mildred Finck · Diane Fine · Irving Fine · Irving Fineman · Jane Fink · Ann Finkbeiner · Caroline Finkelstein · Jeanne Finley · Sharyn Finnegan · William Finnegan · Dennis Finnell · Kathleen Finneran · Jeanette Fintz · Rosemarie Fiore · B. G. Firmani · Lisbeth Firmin · William Firschein · Lillian Fischel · Marjorie Fischer · Noah Fischer · Janet Fish · Peter Fish · Agnes Fisher · Alfred Fisher · Andrea Fisher · Arista Fisher · Edward Fisher · Elizabeth Fisher · Ellen Fisher · Linda Fisher · Sally Fisher · Valorie Fisher · C. Marian Fishman · Gertrude Fishman · Louise Fishman · Gloria Fisk · Claudia Fitch · Keith Fitch · Dudley Fitts · Frances FitzGerald · Maria Fitzgerald · Miro Fitzgerald · Robert Fitzgerald · Kimball Flaccus · Peter Flaccus · Marjorie Flack · Stuart Flack · Matthew Flamm · Erin Flanagan · William Flanagan · Jane Flanders · Stephanie Fleischmann · David Fleming · Alan Fletcher · Carlton Fletcher · Frank Fletcher · John Fletcher · Amy Fleury · Roland Flint · Charles Flowers · Nick Flynn · Robert Flynt · Sylviaelaine Foard · Richard Foerster · David Foley · Martha Foley · Peter Foley · Liza Folman · Franklin Folsom · Silvia Fomina · Nina Fonoroff · Dee Fonville · Laurie Foos · Hugh Ford · Laura Foreman · Maria Fornes · Patricia Forrester · Miles Forst · Charles Fort · Paul Fortunato · Lukas Foss · Eryn Foster · Michel Fougeres · Sandra Foushee · Karen Joy Fowler · Bernadette Fox · Cynthia Fox · Felix Fox · Judy Fox · Sarah Fox · [obscured] Fox Greenberg · Helene Fraenkel · Stephen Frailey · Janet Frame · Juliann France · Barbara Frank · Charles Frank · Joan Frank · John Frank · Michael Frank · Nan[obscured] · Alfred Frankenstein · Pearl Franklin · Tom Franklin · Lucinda Franks · Jonathan Franzen · Joelle Fraser · Candida Fraze · John Frazier · Paul Frazier · Suzan Freco[obscured] · Edna Frederikson · Arnold Freed · Isadore Freed · Lynn Freed · Morton Freedgood · Deborah Freedman · Anne Freeman · Joseph Freeman · Leslie Freeman[obscured] · Adam Frelin · Angela Fremont · Katherine French · Michelle French · Richard French · Nell Freudenberger · Darcy Frey · John Freyer · Joshua Fried · Elias Fri[obscured] · [obscured] Friedman · Deborah Friedman · Jeff Friedman · Joel Friedman · Jonathan Friedman · Michael Friedman · Paul Friedman · Sidney Friedman · Kenny Fries · Nancy [obscured] · [obscured]ristoe · David Froom · John Froome · C. Vernon Frost · Elisabeth Frost · Frances Frost · Helena Frost · Kathryn Frund · Jun Fu · Elinor Fuchs · Kenneth Fuchs · J[obscured] · Allison Funk · Erica Funkhouser · Donald Furst · Joshua Furst · Betty Fussell · Joe Fyfe · Frank Gaard · Gerald Gabel · Harley Gaber · Neal Gabler · Jay Gach[obscured] · Patricia Gaines · Patrice Gaines-Carter · Mary Gaitskill · Pio Galbis · Sally Gall · Carole Gallagher · Ellen Gallagher · John Gallagher · Nora Gallagher · Thomas G[obscured] · Elizabeth Gallu · Barbara Gallucci · Beth Galston · Eric Gamalinda · Philip Gambone · Carlton Gamer · William Gammill · Reginald Gammon · Jessica Gandolf · Indira Ganesan · Jane Gang · Donna Gans · Harriet Gans · Karen Ganz · Betsey Garand · Ramon Garcia · Anne Garcia-Romero · Alexandra Gardner · Isabella Gardner · Leonard Gardner · Paul Gardner · Sheila Gardner · Micah Garen · Herschel Garfein · Peter Garfield · Deborah Garfinkle · Marita Garin · Leslie Garis · Leah Garnett · Louise Garnett · Jessica Garratt · Christine Garren · Jean Garrigue · Lloyd Garrison · Stacy Garrop · Barbara Garson · Stanley Garth · Margaret Garwood · Shirley Garzotto · Glenn Gass · Raymond Gastil · Harry Gatch · Beatrix Gates · Robert Gatewood · Michael Gatonska · Douglas Gauthier · Wendy Gavin · Heinrich Gebhard · Ann Gebuhr · Tara Geer · Lynn Geesaman · John Gehm · Steve Gehrke · Janie Geiser · Madeleine Gekiere · Jan Gelb · Esther Geller · Timothy Geller · Judy Gelles · Sandy Gellis · Alexander Gelman · Janet Gemmell · Emily Genauer · Jackie Gendel · Kinereth Gensler · Olivia Gentile · Iqbal Geoffrey · Christy Georg · Will Georgantas · Kathleen George · Madeleine George · Thomas George · Danielle Georges · Ella Gerber · Steven Gerber · Timothy Gerken · Amanda Gersh · Robert Gessner · Lucia Getsi · Emmanuel Ghent · Dinu Ghezzo · Panos Ghikas · Raymond Ghirardo · Vito Giacalone · Camilla Gibb · Joe Gibbons · Hugh Gibson · Melissa Gibson · Wesley Gibson · Jackson Giddens · Gary Giddins · Miriam Gideon · Cadence Giersbach · Patricia Giff · Jessie Gifford · Celia Gilbert · Dorothy Gilbert · Gordon Gilbert · Henry Gilbert · Jan Gilbert · Sandra Gilbert · Steven Gilbert · Marie Gilchrist · Gary Gildner · Molly Giles · John Gilgun · John Gilhooley · Frances Gillespie · Gregory Gillespie · Alan Gillies · Carolyn Gilliland · Mary Gilliland · Jane Gillooly · Peter Gilman · Jane Gilmor · Gina Gilmour · Tom Gilroy · Marsha Ginsberg · Andrew Ginzel · Gina Gionfriddo · Elizabeth Giordano · Joseph Girandola · Norton Girault · Joan Giroux · Sherry Giryotas · Michael Gitlin · Peter Gizzi · Gordon Glasco · David Glaser · Sheila Glaser · Paul Glass · Sarah Glasscock · Carole Glasser-Langille · Lisa Glatt · Jonathan Glatzer · John Gletcher · Carole Glickfeld · Gary Glickman · Eugene Gloria · Katherine Glover · Nancy Glover · Alan Glovsky · Shirley Glubok · Robert Gluck · Grace Glueck · Rumer Godden · Daniel Godfrey · Amy Godine · Christina Godshalk · Peter Godwin · Rebecca Godwin · Patricia Goedicke · Monika Goetz · Frances Goforth · Susan Gofstein · Margaret Gohmann · Edward Gold · Glen Gold · Sharon Gold · Eva Goldbeck · Barbara Goldberg · Janee Goldberg · Lester Goldberg · Neil Goldberg · Joel Goldblatt · Eunice Golden · Michael Golden · Barry Goldensohn · Lorrie Goldensohn · David Goldes · Maximilian Goldfarb · Shari Goldhagen · Elliott Goldkind · Steven Goldleaf · Charles Goldman · Jane Goldman · Judith Goldman · Perry Goldstein · Patricia Goldstone · Osvaldo Golijov · Claire Goll · Yvan Goll · He Gong · Xavier Gonzalez · Regan Good · Gordon Goodban · Carol Goodman · David Goodman · Eric Goodman · Joanna Goodman · Lester Goodman · Matthew Goodman · Miriam Goodman · Richard Goodman · Amanda Goodwin · Richard Goodwin · Alastair Gordon

Mark Gordon · Michael Gordon · Ricia Gordon · Russell Gordon · Sarah Gorham · Herbert Gorman · Jean Gorman · Vivian Gornick · Gene Gort · Jacqueline Goss · Jim Goss · Madeleine Goss · Yaron Gottfried · David Gottlieb · Eli Gottlieb · Jack Gottlieb · Elaine Gottlieb Hemley · Jean Gould · Melissa Gould · Anna Grace · Nancy Grace · William Graef · Ted Graf · E. J. Graff · A. Cyril Graham · Dorothy Graham · Irvin Graham · Julie Graham · Philip Graham · Richard Graham · Nina Granada · Victor Granados · David Grand · Philip Grange · Stephanie Grant · Donald Grantham · Elizabeth Graver · Paul Graves · William Graves, Jr. · Agnes Gray · Ken Gray · Myra Gray · Patrick Gray · Peter Gray · Spalding Gray · Tony Gray · Richard Grayson · Edward Grazda · John Grazier · Lucy Grealy · Bernard Grebanier · Diane Green · Elliott Green · Hannah Green · Jesse Green · Kay Green · Marcia Green · Martin Green · Paul Green · Vanalyne Green · Nancy Green Madia · Marty Greenbaum · Arielle Greenberg · Gloria Greenberg · Yvan Greenberg · Gael Greene · Harris Greene · Michael Greene · Josh Greenfeld · Elana Greenfield · Mark Greenside · Elaine Greenstein · Mark Greenwold · Andrew Greer · Debora Greger · Cameron Gregg · Thomas Gregg · Lucio Gregoretti · Horace Gregory · Eamon Grennan · Joel Gressel · Sharon Greytak · George Griffin · Gerry Griffin · Susan Griffin · Elliot Griffis · Linda Griggs · Thomas Grille · Barbara Grisham · Lourdes Grobet · Susan Groce · Rinne Groff · Bernice Grohskopf · James Groleau · John Gross · Julie Gross · Michael Gross · Cary Grossman · Edward Grossman · Norman Grossman · Kathy Grove · John Gruen · Louis Gruenberg · Doris Grumbach · John Grunn · Jiri Grusa · Stephen Gryc · Sabrina Gschwandtner · Xiaomin Gu · Angelina Gualdoni · Susan Gubernat · Dawn Guernsey · Diana Guerrero-Macia · Eugene Guerster · Louis Guglielmi · Robert Guillot · Katrine Guldager · Charlotte Gullick · Stephanie Gunn · Perry Gunther · David Gurewich · Dan Gurskis · Alexa Gusick · Musa Guston · Charles Gute · Beth Gylys · Richard Haas · Marilyn Hacker · Joyce Hackett · Ayelet Hadar · Pamela Hadas · Rachel Hadas · Hank Hadden · Fred Haefele · Carol Haerer · Hermann Hagedorn · Jessica Hagedorn · Max Hagedorn · Cecelia Hagen · Daron Hagen · Terence Haggerty · Nancy Hagin · Kathryn Hagy · Robert Hahn · Jennifer Haigh · Robert Haiko · Edmund Haines · Lauren Haines · Roya Hakakian · Stefan Hakenberg · Christine Hale · Nancy Hale · Perri Hale · Marcus Halevi · Melissa Haley · Nade Haley · Patience Haley · Anna Hall · Emma Hall · Judith Hall · Lee Hall · Meredith Hall · Nancy Hallinan · Janis Hallowell · Martin Halpern · Brooke Halpin · Robin Halpren-Ruder · Hiroyuki Hamada · Sachiko Hamada · Susan Hambleton · Robert Hamburger · Sydney Hamburger · Barbara Hamby · Warren Hammack · Barbara Hammer · Signe Hammer · Harmony Hammond · Kara Hammond · Mary Hammond · Amy Hamouda · Stuart Hample · W. David Hancock · Darrell Handel · Rob Handel · Jared Handelsman · Jason Haney · Helene Hanff · Helen Hanford · Joelle Hann · Don Hannah · James Hannaham · Roger Hannay · Elaine Hansen · Patricia Hansen · Murray Hantman · Amanda Harberg · John Harbison · Stephen Harby · Paul Harcharik · Meg Harders · Gwen Hardie · Anna Harding · Tana Hargest · Elizabeth Harington · Matt Harle · Ann Harleman · Pagan Harleman · Mark Harman · James Harms · Curtis Harnack · Danielle Harned · Judith Harold-Steinhauser · Michael Harper · Rachel Harper · Sharon Harper · Margaret Harrell · Paul Harrill · Donald Harris · Duriel Harris · Evan Harris · Janet Harris · John Michael Harris · Lyda Harris · Mark Harris · Matthew Harris · Natalie Harris · Paul Harris · Peter Harris · Roy Harris · Amy Harrison · Barbara Harrison · Ellen Ruth Harrison · Jay Harrison · Joel Harrison · Pamela Harrison · Melissa Harshman · Kimberley Hart · Richard Harteis · John Hartell · Sylvia Hartell · Leon Hartl · Charles Hartman · Karen Hartman · Patricia Hartman · Yuki Hartman · Diana Hartog · Ryan Harty · Adrianne Harun · Charlotte Harvey · James Harvey · Steven Harvey · Judith Harway · John Haskell · Lola Haskins · Adam Haslett · Julia Haslett · Jean Hasse · Maren Hassinger · Caroline Hastie · Tanya Hastings · Camille Hatch · James Hatch · John Hatch · James Hatfield · Julian Hatton · Charles Haubiel · Helen Haukeness · Evan Hause · Ethan Hauser · Michelle Hauser · Reine Hauser · Deborah Hautzig · Mark Haven · Stephen Haven · Victoria Haven · Marion Havighurst · Walter Havighurst · Allan Havis · Stuart Hawkins · Sara Hay · Julie Hayden · Frederick Hayes · Richard Hayes · Sharon Hayes · Sherry Hayne · Bud Hazelkorn · Lesley Hazleton · Mary Hazzard · Cloyd Head · Harold Head · H. Headley · Anne Healy · Brian Healy · Eloise Healy · Carol Hebald · Anthony Hecht · Nova Hecht · Rose Hecht · Allison Hedge Coke · Meredith Hedges · Peter Hedges · James Hegge · Robin Heifetz · Govert Heikoop · Carol Heineman · Padma Hejmadi · Caroline Heller · Sarah Heller · David Hellerstein · Lenora Helm · Edmund Helminski · Robert Helmschrott · Robert Helps · Robert Hemenway · Cecil Hemley · Robin Hemley · Eugene Hemmer · Judith Hemschemeyer · Adele Henderson · Safiya Henderson-Holmes · David Hendricks · Geoffrey Hendricks · Laura Hendrie · Thomas Hendry · Michael Hennagin · Edith Henrich · Alicia Henry · Harold Henry · Robby Henson · Carol Hepper · Leon Herald · James Herbert · Josephine Herbst · Jeanine Herman · Michelle Herman · Daisy Hernandez · Constance Herreshoff · Linda Herritt · Carol Herron · Fred Hersch · Nona Hershey · Olive Hershey · Marcie Hershman · Leo Hertzel · Kenneth Hesketh · Stephen Hesla · Katherine Hester · Sue Hettmansperger · Madeline Hewes · David Heymann · Dorothy Heyward · DuBose Heyward · Allen Hibbard · David Hicks · Christine Hiebert · Ethel Hier · Joan Hierholzer · Mary Higgins · John Higgs · Oscar Hijuelos · Conrad Hilberry · Clara Hill · Edward Hill · Ingrid Hill · Jeanne Hill · Kathleen Hill · Nellie Hill · Nicholas Hill · Pati Hill · Ralph Hill · Richard Hill · Sean Hill · Susan Hiller · Stephan Hillerbrand · Rick Hilles · Edith Hillinger · Henry Hills · Roxanne Hills · Rust Hills · Frank Hilton · Harriet Hinsdale · Charles Hirsch · Gilah Hirsch · Joseph Hirsch · Kathleen Hirsch · Marla Hirsch · Stanley Hirshenson · Jane Hirshfield · Molly Hite · Jack Hitt · Robert Hivnor · Jane Hixon · Tomas Hlavina · Jacques Hnizdovsky · Hubert Ho · Charles Hoag · Tony Hoagland · Tessanna Hoare · Phoebe Hoban · Alice Hobbs · Morris Hobbs · Margaret Hoberg · Dorothy Hobson · Victoria Hochberg · Rolaine Hochstein · Rosalind Hodgkins · Lucy Hodgson · Ken Hodorowski · Rachel Hoeffel · Werner Hoeflich · Marietta Hoferer · Allen Hoffman · David Hoffman · Ellen Hoffman · Eva Hoffman · Joel Hoffman · Phoebe Hoffman · William Hoffman · Anastasia Hoffmann · Susan Hogan · Martin Hogue · Lee Hoiby · Meredith Holch · Ann Holcomb · Sara Holden · Ursula Holden · Vera Holding · William Holinger · Sherri Hollaender · Barbara Holland · Noy Holland · Stanley Hollier · Stanley Hollingsworth · Elizabeth Hollins · David Hollister · Martie Holmer · Janet Holmes · Mike Holober · Rachel Holstead · Pieter Holstein · Nancy Holt · Howard Holtzman · Madeleine Holzer · Helen Homer · Cathy Park Hong · Garrett Hongo · Donald Honig · Edwin Honig · Ann Hood · Mary Hood · Rebecca Hoogs · Helen Hoopes · Kathleen Hoover · Michelle Hoover · Nan Hoover · John Hoppenthaler · Dan Horn · Murray Horne · Jane Horner · Miller Horns · Bennett Horowitz · Diana Horowitz · Gene Horowitz · Michael Horowitz · Martha Horst · Ruth Horton · Jennine Hough · John Hough · Alan Houghtaling, Jr. · John Houghton · Paul Houghton · Timothy Houghton · Karen Houppert · Richard House · Tom House · Joseph Houston · Michael Houston · Ginnah Howard · Hollis Howard · Jane Howard · Fanny Howe · Hal Howe · LeAnne Howe · Marie Howe · Mary Howe · Royce Howes · Bette Howland · Judith Hoyt · Lisa Hsia · Chin Hsiao · Pia Hsiao · Pang-Chieh Hsu · James Huang · Robert Hubbard · Andrew Hudgins · Robert Huff · Luella Huggins · John Huggler · Allen Hughes · Cassandra Hughes · Chapin Hughes · Edwin Hughes · Holly Hughes · Mary-Beth Hughes · Eloise Huguenin · Melissa Hui · Lance Hulme · John Hultberg · Barbara Hults · Christopher Humble · Christine Hume · Gerald Humel · James Humes · William Humiston · Nene Humphrey · Helen Humphreys · John Humphreys · Richard Hundley · Herbert Hundrich · Michelle Huneven · Florence Hunt · Laird Hunt · Constance Hunting · Leonard Hunting · Cynthia Huntington · Helen Huntington · Barbara Hurd · Valerie Hurley · Dan Hurlin · Christina Hutchings · Jeannie Hutchins · Mary Hutchins · Robert Hutchinson · Earl Hutchison · Warner Hutchison · Simeon Hutner · Fatisha Hutson · Sarah Hutt · Gregory Hutter · Arlene Hutton · Frances Hwang · Imi Hwangbo · Leigh Hyams · Carl Hyatt · Lewis Hyde · Lee Hyla · Esther Hyneman · Samuel Hynes · Victor Ialeggio · Sherrilyn Ifill · Mary Ijichi · Sanda Iliescu · Etsumi Imamura · Kamran Ince · Sandra Indig · Colette Inez · Catherine Ingraham · Tina Ingraham · Cynthia Innis · Amanda Insall · Gisela Insuaste · Matthew Iribarne · Louva Irvine · Carol Irving · Judith Irving · Ivor Irwin · Edith Isaacs · Lewis Isaacs · Marcia Isaacson · Peter Iseman · Aki Ishida · Henry Israeli · Miyoko Ito · Susan Ito · Teresa Iverson · Elizabeth Ives · Jean Ivey · Ella Jack · Rodney Jack · Karen Jackel · Corinne Jacker · David Jackson · Donna Jackson · Jesse Jackson · Julian Jackson · Kai Jackson · Major Jackson · Sarah Jackson · Yvonne Jackson · Bruce Jacobs · Jaclyn Jacobs · Peter Jacobs · Josephine Jacobsen · John Jacobsmeyer · Bill Jacobson · Andre Jacq · Geoffrey Jacques · Julia Jacquette · Michelle Jaffe · Nora Jaffe · Stephen Jaffe · Lenore Jaffee · Aaron Jafferis · Robert Jager · Dorothy James · Jacqueline James · Philip James · Phyllis Janowitz · Louise Jarecki · Tadeusz Jarecki · Cora Jarrett · Alison Jarvis · Kate Javens · Teresa Jaynes · Honoree Jeffers · Wendy Jeffers · Catherine Jelski · Gish Jen · Penelope Jencks · Madge Jenison · Len Jenkin · Alan Jenkins · Amy Jenkins · Tamara Jenkins · Walter Jenkins · Kathleen Jenks · Donald Jenni · Jay Jennings · Pamela Jennings · Susan Jennings · Kaye Jennison · Diana Jensen · Julie Jensen · Elise Jerard · Christine Jerome · John Jesurun · Stephen Jimenez · Lawan Jirasuradej · Simen Johan · Erik Johns · Bradford Johnson · Bruce Johnson · Buffie Johnson · Dennis Johnson · Edgar Johnson · Ellen Johnson · Fenton Johnson · Frederick Johnson · Hunter Johnson · Jacqueline Johnson · Johnnie Johnson · Karl Johnson · Kenneth Johnson · Lockrem Johnson · Melissa Johnson · Michael Johnson · Nick Johnson · Richard Johnson · Robert Johnson · Sue Johnson · Una Johnson · Jill Johnston · Maryalice Johnston · Sibyl Johnston · Susan Johnston · Ann Jones · Arlene Jones · Barbara Jones · Brendan Jones · Brian Jones · Cassie Jones · Cori Jones · Gail Jones · George Jones · Jeffrey Jones · JoAnn Jones · Kristin Jones · Louis Jones · Mike Jones · Nalini Jones · Robert Jones · Sabrina Jones · Tayari Jones · C. Raymond Jonson · Courtney Jordan · Julia Jordan · June Jordan · Lorna Jordan · Virgil Jordan · Sheri Joseph · Daniel Josephs · Peter Josheff · Patricia Joudry · Tom Judd · Robert Judge · Heidi Julavits · Mervin Jules · Anees Jung · Dieter Jung · Alexa Junge · Donald Justice · Robert Kabak · Ervin Kaczmarek · Elizabeth Kadetsky · Rachel Kadish · August Kadow · Barry Kahn · Gus Kaikkonen · Diane Kaiser · Rebecca Kaiser Gibson · Luise Kaish · Morton Kaish · Nicholas Kalashnikoff · Julie Kalendek · Louise Kalin · Marilyn Kallet · Ann Kalmbach · Heiko Kalmbach · Daphne Kalotay · Agymah Kamau · Eunice Kambara · David Kamp · Irene Kampen · Susan Kan · Dana Kane · Jessica Kane · Michael Kang · Soon Kang · Amy Kao · Alan Kapelner · Amelia Kaplan · Cheryl Kaplan · Howard Kaplan · Janice Kaplan · Susan Kaprov · Kirun Kapur · Louis Karchin · George Karlin · William Karlins · H. Peter Karoff · Eleni Karotseri · Aaron Karp · Laura Karpman · Mary Karr · Rick Karr · David Kasdorf · Julia Kasdorf · Laura Kasischke · Nina Katchadourian · Stina Katchadourian · Joel Katz · Joy Katz · Leo Katz · Steven Katz · Mary Beth Kauffman · Christopher Kaufman · Michael Kaufman · Tamiko Kawata · Hershy Kay · Teresa Kay · Melanie Kaye · Pooh Kaye · Phoebe Kaylor · Susanna Kaysen · Luiza Kazanas · Alfred Kazin · Cathrael Kazin · Pearl Kazin · Doris Kearns Goodwin · Celine Keating · Jonathon Keats · David Keberle · Robert Keefe · John Keenen · LuAnn Keener · Anna Keesey · Kathryn Kefauver · Susan Keizer · Carol Keller · Germaine Keller · Homer Keller · Martha Keller · Donald Kelley · Edgar Kelley · Ethel Kelley · Brian Kellman · Tatana Kellner · Daniel Kellogg · John Kelly · Nancy Kelly · Robert Kelly · Robert Kelly · Aviva Kempner · Kenneth Kempton · Randall Kenan · Beatrice Kendall · Barbara Kendrick · Kent Kennan · Brigid Kennedy · James Kennedy · John Kennedy · Lucy Kennedy · Mary Kennedy · Terry Kennedy · Tamara Kennelly · Theda Kenyon · Sherry Kerlin · Ronni Kern · Catherine Kernan · Aaron Kernis · Maurie Kerrigan · Nora Kersh · Brad Kessler · Milton Kessler · Ruth Kessler · Eunice Kettering · Dina Kevles · Karen Kevorkian · Daniel Keyes · David Kezur · Muhonjia Khaminwa · Elyas Khan · Colleen Kiely · Joanna Kiernan · Carson Kievman · Maja Kihlstedt · Victoria Kilbourn · John Killens · Christopher Kilmartin · Jack Kilpatrick · Mark Kilstofte · Cheonae Kim · Eun-Kyung Kim · Helen Kim · Hi Kim · So Yong Kim · Suki Kim · Sunny Kim · Yong Ik Kim · George Kimmerling · Hiroshi Kimura · Nanci Kincaid · B. A. King · John King · John King · Lily King · Robert King · Roger King · William King · Karen King-Aribisala · Daniel Kingman · Gwen Kinkead · Galway Kinnell · Harrison Kinney · Hazel Kinscella · Mary Kinzie · Gib Kirby · Pamela Kircher · Gloria Kirchheimer · Manny Kirchheimer · Andrea Kirchmeier · Karl Kirchwey · Irina Kirk · James Kirk · Jay Kirk · Naomi Kirk · Jules Kirschenbaum · Elizabeth Kirschner · Andy Kirshner · Brian Kiteley · Suzy Kitman · Carol Kitzmiller · Evelyn Klahr · Brian Klam · Peter Klappert · Adam Klein · Alexander Klein · Ann Klein · Barbara Klein · Lothar Klein · Sabina Klein · Seymour Kleinberg · Andrea Kleine · Cindy Kleine · Edward Kleinschmidt Mayes · Vera Klement Shapey · Wendy Klemperer · Henry Klimowicz · Nancy Kline · Verlyn Klinkenborg · Georgina Klitgaard · Robert Klitzman · Richard Klix · Michelle Kloehn · Jay Klokker · Milton Klonsky · P. F. Kluge · Marjorie Knapp · Douglas Knehans · Dusty Knight · Edward Knight · Etheridge Knight · Johannes Knoops · Bill Knott · Lindsay Knowlton · Winthrop Knowlton · Zan Knudson · Nancy Knutson · Arthur Kober · Joann Kobin · Ken Kobland · David Koblitz · Frederick Koch · Vivienne Koch · Rosemarie Koczy · Peter Koenig · Christopher Koep · Phyllis Koestenbaum · Nathan Koffman · Ellis Bonoff Kohs · Barbara Kolb · Marianne Kolb · Joseph Kolman · Fumi Komatsu · Foumiko Kometani · Lucy Komisar · Charles Kondek · Harry Kondoleon · Edith Konecky · Michele Kong · David Konigsberg · Hans Koning · Daniel Koontz · Kendra Kopelke · Arthur Kopit · Jean Korelitz · Michael Korie · Gerald Korman · Jacob Kornbluth · Karl Korte · Roy Kortick · Carol Korty · Genevieve Kory Hirsch · Tadeusz Korzeniewski · Norman Kotker · Zane Kotker · Liz Kotz · Susan Kouguell · Boris Koutzen · Dennis Kowal · Patricia Kowalok · R. S. Koya · Paul Kozel · Joyce Kozloff · Sigmund Kozlow · Elaine Kraf · Arthur Kraft · James Kraft · William Kraft · Kathryn Kramer · Margia Kramer · Sherry Kramer · Timothy Kramer · Metka Krasovec · Mary Kratt · Sharon Kraus · Drew Krause · Anthony Krauss · Nicole Krauss

A PLACE FOR THE ARTS
THE MACDOWELL COLONY, 1907–2007

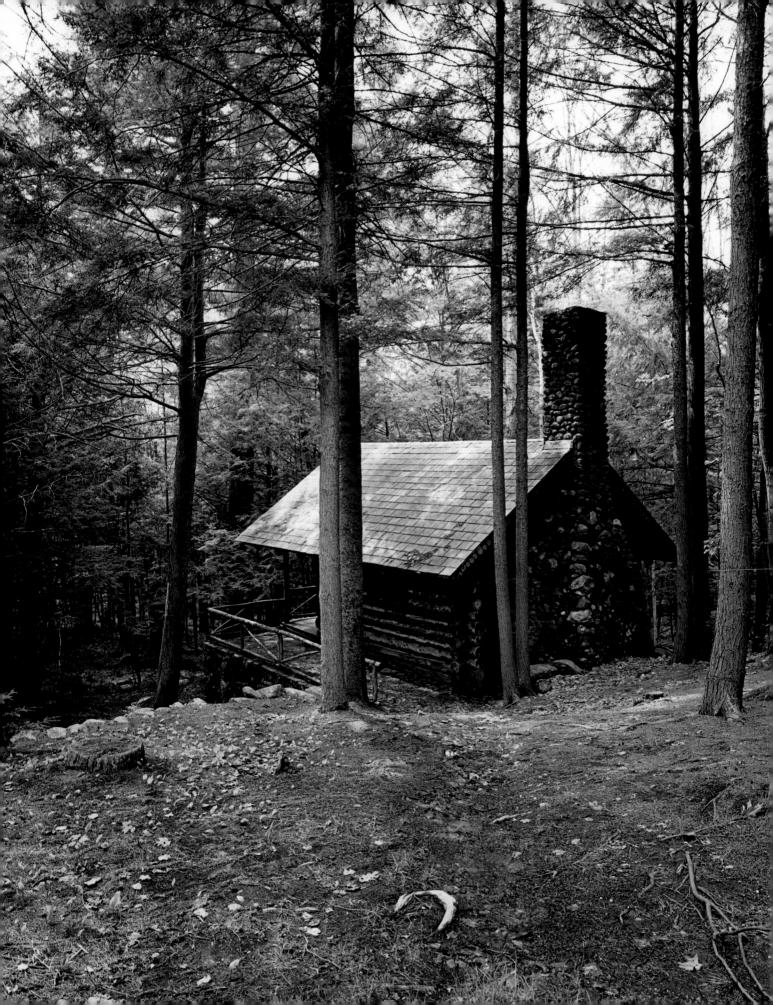

A PLACE FOR THE ARTS
THE MACDOWELL COLONY, 1907–2007

JOAN ACOCELLA

PETER CAMERON

MICHAEL CHABON

CAROL DIEHL

VARTAN GREGORIAN

VERLYN KLINKENBORG

ROBERT MACNEIL

PAUL MORAVEC

ROBIN RAUSCH

RUTH REICHL

JEAN VALENTINE

WENDY WASSERSTEIN

JACQUELINE WOODSON

KEVIN YOUNG

CARTER WISEMAN, GENERAL EDITOR

PUBLISHED BY THE MACDOWELL COLONY
DISTRIBUTED BY UNIVERSITY PRESS OF NEW ENGLAND, HANOVER AND LONDON

A Place for the Arts: The MacDowell Colony, 1907–2007 has been published to commemorate the centennial of The MacDowell Colony.

BOARD OF EDITORS:
William N. Banks
Robert Beaser
Peter Cameron
Barbara K. Bristol

Robert MacNeil
George M. Nicholson
Jeff L. Rosenheim
Amy Baker Sandback
Cheryl Young

Managing editor: Diana Murphy
Designer and production manager: Miko McGinty
Original photography: Victoria Sambunaris
Photo researcher: Rita Jules
Editorial assistant: Claudia De Palma
Separations and printing: EBS, Verona, Italy

Library of Congress Cataloging-in-Publication Data

A place for the arts : the MacDowell Colony, 1907–2007 / Joan Acocella...[et al.] ; Carter Wiseman, general editor.
 p. cm.
 Includes index.
 ISBN 1-58465-609-3
 1. Arts, American—New Hampshire—Peterborough—20th century. 2. Arts, American—New Hampshire—Peterborough—21st century. 3. MacDowell Colony (Peterborough, N.H.)—History. I. Acocella, Joan Ross. II. Wiseman, Carter.
NX511.P32P55 2006
700.9742'8—dc22

2006023092

Published by The MacDowell Colony
100 High Street
Peterborough, New Hampshire 03458
www.macdowellcolony.org

Distributed by University Press of New England
One Court Street
Lebanon, New Hampshire 03766
www.upne.com

PRINTED IN ITALY

Contents

Preface CARTER WISEMAN 10

INTRODUCTION

A Catalyst for Creativity VARTAN GREGORIAN 16

THE FELLOWS' MACDOWELL

Landscape of the Imagination VERLYN KLINKENBORG 24

Time Out JOAN ACOCELLA 30

Youngblood KEVIN YOUNG 36

Pure Communion RUTH REICHL 43

A PARTNERSHIP IN ART

The MacDowells and Their Legacy ROBIN RAUSCH 50

THE MAKING OF ART

On Fire, and Not CAROL DIEHL 136

Peace and Buzz WENDY WASSERSTEIN 144

Reunion PAUL MORAVEC 152

MARKS OF DISTINCTION

The Edward MacDowell Medal 160

Edward Weeks on Thornton Wilder | Meyer Schapiro on Alexander Calder

John Canaday on Louise Nevelson | John Leonard on Norman Mailer

John Hersey on Lillian Hellman | Elizabeth Hardwick on Mary McCarthy

John Szarkowski on Lee Friedlander | Ned Rorem on Leonard Bernstein

J. Carter Brown on I. M. Pei | William Styron on Philip Roth

Meredith Monk on Merce Cunningham | Richard Serra on Steve Reich

A COMMON GOOD

Art and Freedom ROBERT MACNEIL 178

THE PERMANENCE OF CREATIVITY

Extended Ownership PETER CAMERON 204

The Ghosts That Provoke MICHAEL CHABON 210

Passing It On JACQUELINE WOODSON 216

Postscript: The Place I Have Been JEAN VALENTINE 223

Acknowledgments 224
About the Contributors 226
Index 228
Photograph Credits 239

Preface
Carter Wiseman

When Edward MacDowell needed to get real work done, he went into the woods. As the first American-born composer to be taken seriously outside his native country, Edward indulged an especially American impulse: to seek creative strength by immersion in nature, apart from the pressures and distractions of normal—especially urban—life.

He was able to do this largely because he and his wife, Marian, in 1896 had bought a farm in the bucolic town of Peterborough, New Hampshire. The farm proved to be a refuge from the hurly-burly of New York, where Edward was serving as the first head of Columbia University's music department. Marian, an accomplished pianist who had met Edward as a student of his in Germany, eagerly supported her husband's need for time and space of his own. She commissioned a cabin in which Edward could grapple with the muses—as well as the frustrations—that have always been essential contenders in the creative process, and went so far as to bring him lunch and leave it in a basket on the porch of his cabin so as not to intrude on his work. (This gesture would launch a tradition that is honored at The MacDowell Colony to this day.)

After Edward died, in 1908, Marian set to fulfilling her husband's strongest wish: to provide to others the same circumstances that had advanced his own art. The result was The MacDowell Colony, a place in the woods of New Hampshire that has given time and space to thousands of artists to follow the perilous path of creativity that Edward knew so well.

As the hundredth anniversary of this pioneering institution approached, MacDowell's supporters began to discuss ways to mark the occasion. Among the proposals was that of a book, the spark for which was struck by Thomas Putnam, president of the board of directors from 1993 to 1999, when he said, "We should not wake up on the morning after our hundredth birthday and wonder why we had not put something between hard covers."

A Place for the Arts: The MacDowell Colony, 1907–2007 is meant to document—and to some extent explain—the relentlessly creative evolution of MacDowell. But it is also intended to convey a sense of what one board member memorably called the

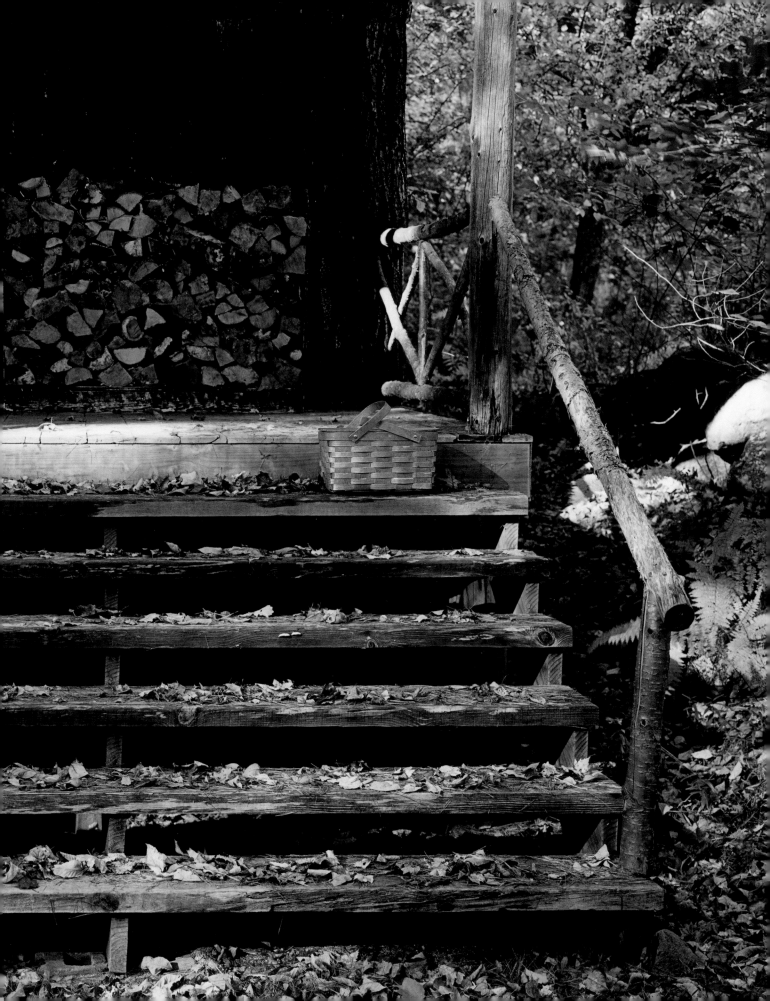

"being-there-ness" of the place, the inimitable experience that includes nature, fellow creators, and the interaction among them that has stimulated so much artistic innovation within the confines of a former farm. To fulfill those goals, the board turned to Vartan Gregorian, the educator and former chairman of MacDowell, for an essay that would set the Colony in a larger context. Robin Rausch, a scholar at the Library of Congress, agreed to chronicle the institution's colorful, and occasionally turbulent, history. And the journalist and author Robert MacNeil, MacDowell's current chairman, has laid out the role that the Colony in particular and creativity in general play in a democratic society. But for the "being-there-ness," we needed artists who had been through the experience, and we are happy to include texts by eleven of them to suggest how the Colony does what it does across the artistic disciplines.

These authors are sharing in a storied but uncertain process. When Thornton Wilder was writing *Our Town* at the Colony, neither he nor anyone else knew that his play would become one of the most frequently performed works for the stage in history. When Leonard Bernstein was refining his *Mass* in Watson Studio, he was already an established composer but not yet one of the legendary figures in American music. When Alice Walker, author of *The Color Purple*, was playing "cowboy pool" in Colony Hall in the winter of 1967, she was just another talented young writer.

The MacDowell Colony has no way to predict how far its Fellows will go. But it cares deeply about how serious they are, and it puts its trust in them. MacDowell is not alone in this effort. Since 1907, artists' colonies have proliferated in the United States and abroad. The reason for this is surely rooted in the fundamental rightness of the idea on which MacDowell was founded: that creativity requires time, space, and privacy.

We are grateful to Edward and Marian MacDowell for their singular understanding of this essential truth a century ago. And we are proud to join so many others in supporting its future.

OPPOSITE: MACDOWELL STUDIO WAS FUNDED BY A GROUP OF EDWARD MACDOWELL'S MUSIC STUDENTS AND CONSTRUCTED IN 1912. OVERLEAF: COLONY HALL

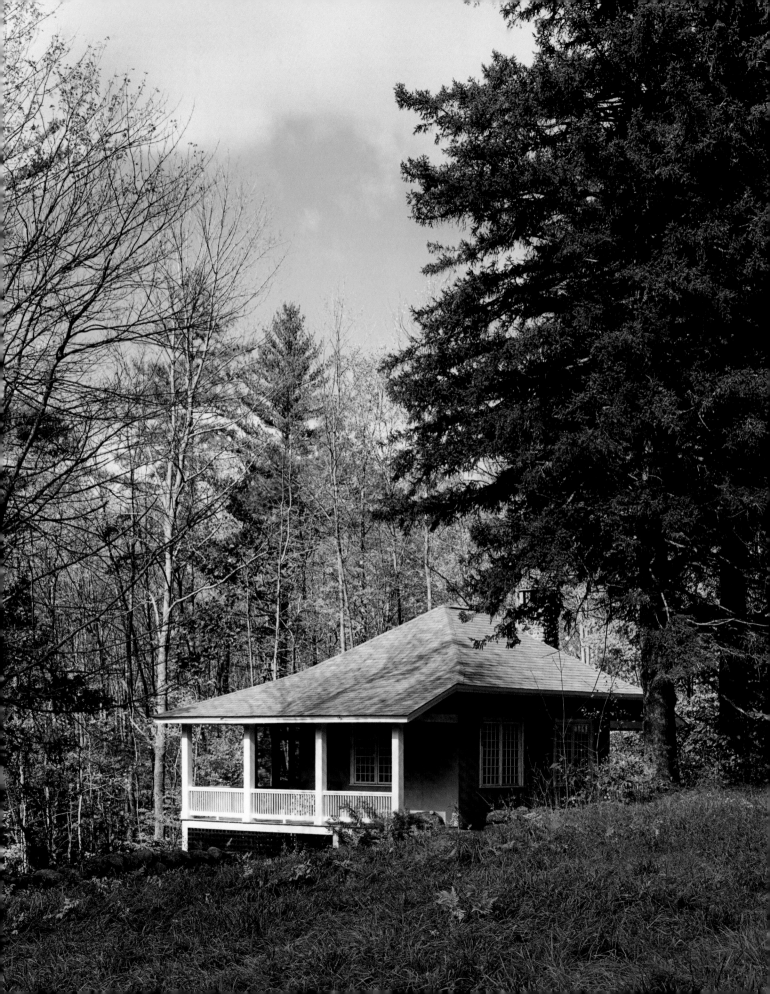

INTRODUCTION

A Catalyst for Creativity
Vartan Gregorian

Traditionally, the concept of a retreat has suggested visions of lonely exiles and austere monasteries, where one goes to sort out one's thoughts or gain perspective on life's trials and tribulations. That may sometimes be true for artists who find inspiration in solitude, but many would also echo the sentiments of the poet William Cowper, who wrote, "How sweet, how passing sweet, is solitude! But grant me still a friend in my retreat."

Since 1907, The MacDowell Colony has provided both a place of retreat and a gathering of like-minded friends and soul mates for painters, writers, sculptors, composers, architects, and many other artists from across the country and around the world. More than sixty-five Pulitzer Prizes have been won by its distinguished alumni, who include James Baldwin, Leonard Bernstein, Willa Cather, Aaron Copland, Galway Kinnell, Virgil Thomson, Alice Walker, and Thornton Wilder—artists who have helped define their generations. These individuals, along with the six thousand or so others who have spent time at this unique place over the years, go to the Colony to recharge their creative batteries in a supportive, nurturing, and collegial environment that encourages them to reemerge even more vital, inspired, and productive than before. It is a process that Gabriel García Márquez alludes to in his book *Love in the Time of Cholera*, when he speaks of the conviction that human beings are not born once and for all on the day their mothers give birth to them, but that life obliges them to give birth to themselves over and over again. Artists are constantly reinventing themselves with each new work and new idea, and in that spirit it is certainly not a stretch to say that MacDowell is perhaps America's premier center of retreat and reinvention.

I was privileged to be the chairman of The MacDowell Colony from 1990 to 1992, following the resourceful and energetic chairmanship of Varujan Boghosian. I was succeeded by a brilliant thinker and public intellectual, Robert MacNeil, under whose guidance the Colony has flourished. With the help of his thoughtful, creative oversight—as well as the indispensable and skillful leadership of many other volunteers—MacDowell continues to offer its facilities and resources to practitioners of the arts who otherwise might be without sponsorship, encouragement, or support. While our vibrant and remarkable democracy does spread its wings wide to uplift many segments of our society, the arts, unfortunately, do not receive a substantial amount of federal, state, or local support, and so depend on the generosity of Americans and American organizations for

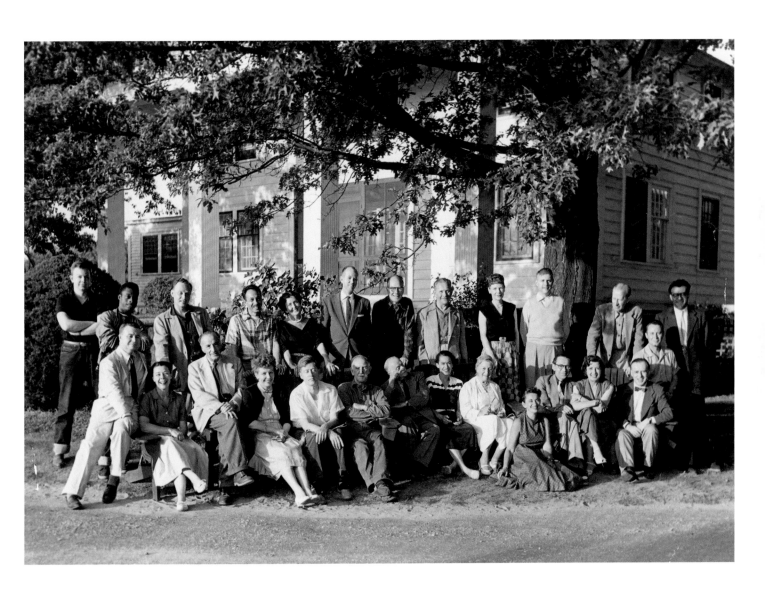

MACDOWELL FELLOWS OFTEN ASSEMBLE FOR "CLASS PICTURES." IN THIS ONE, FROM 1954, WRITER
JAMES BALDWIN APPEARS IN THE BACK ROW, SECOND FROM LEFT; LOUISE TALMA IS FOURTH FROM
RIGHT. MILTON AVERY IS SIXTH FROM LEFT IN THE FRONT ROW.

sustenance. And with extraordinary responsiveness and largesse, individuals, foundations, nonprofits, corporations, and others always come through.

The noted editor and essayist Lewis Lapham once suggested that libraries represent the many strands of knowledge combining like melodies, and the same can be said of the arts: they form a symphony that each of us can find something to feel in tune with, some experience to help us interpret, understand, and appreciate the lessons and experiences of our own lives.

After all, the arts play such a central role in our society that nothing else can substitute for them: they give texture to our culture; they provide a framework of both energy and introspection for our daily lives. The arts are a universal language that binds our diverse nation together, a language that needs no dictionary because it speaks with human images, human sentiments, and human aspirations. Its voice comes from deep within the human soul. Ralph Waldo Emerson said, "[The] arts open great gates of a future," and I believe that is absolutely true. Certainly, it is so often through the arts that we look back at our past, assess our present, and try to imagine what the future will

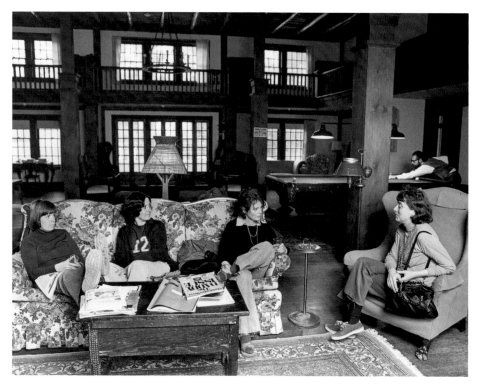

ABOVE: BOND HALL AS IT APPEARED IN THE 1970S. THE COLONY'S "LIVING ROOM" REMAINS A CENTRAL LOCATION FOR SOCIALIZING, READING, AND PLAYING "COWBOY POOL," A VARIATION ON POCKET BILLIARDS. OPPOSITE: COLONY HALL

hold for us as individuals, and collectively, as human beings. To me, the act of creating art is also an act of faith in the continuity of humanity, a statement of belief in the ability of men and women to share experiences, emotions, and perceptions across time, distance, gender, race, politics, upbringing, and age.

We should all take great pride in knowing that in the United States today there are more than seventeen thousand arts and culture organizations—including two thousand museums—and the great majority of them depend on private philanthropy. If Alexis de Tocqueville was right, they do not need to worry about their future because, as he noted in his well-known work, *Democracy in America,* our country is that rarest of places, a nation that actually belongs to its citizens, and this sense of ownership has fostered among us a communal spirit that includes a sense of responsibility for keeping our arts and cultural institutions strong and for nurturing the careers of individual artists who may one day, like their colleagues at MacDowell, add their own music to the great symphony, the great work of art, that is our common humanity.

After all, individually we will all pass by, but the art we experience, create, and partake of will remain. The arts will outlast us, they will reach beyond our temporality. They are witness to the fact that we are not mere socioeconomic units, not sociobiological entities, and not just consumers of entertainment, but moral beings with aspirations, cravings, anxieties, desires, and dreams.

We know that it is often the artists among us who save us from the great modern sin of indifference. Their constant, unquenchable desire to know, to create, to understand, to expand the human horizon—what Ingmar Bergman called "a boundless, insatiable curiosity that is always new and that pushes me onward"—is a force that invigorates our society and enlightens all our lives.

It is the artists who weave the past together with the future. They help us become good ancestors, people who bequeath, to those who follow after us, a legacy not only of our worldly goods and earthly kingdoms, such as they are, but of the seeking heart and restless, soaring spirit that are the true essence of man- and womankind.

The poet, the novelist, the composer, the painter, the sculptor, the photographer, the dancer, the musician, the designer, the architect—artists working in all different forms and media—are the ones who create this lasting bequest for us, who speak to our generation, surely, but are also already calling out to our children, and our children's children. It is our artists who bind the generations together in a great chain of life. Think about that for just a moment—how alive to us, even now, are objects created millennia ago: paintings on cave walls, handprints on rocks, pots and statues, hieroglyphs and carvings,

monuments and beads strung together with braided grass. When we gaze at these things in museums, or see pictures of them in books, what do we wonder about? Not only *what* the artists were trying to say or depict, but *who* they were, what these living beings thought about and cared about; what moved and inspired them; who they were, whom they loved, how they lived. It is extraordinary to realize that through art we can connect not only with our contemporaries but with people who haven't walked the face of the earth since almost the dawn of time, since any number of civilizations rose and fell. There is little else other than art that can create this kind of bridge across human experience and across the centuries, a bridge that anyone on earth is welcome to cross at any time.

The MacDowell Colony and so many similar institutions that have emerged since its founding serve all of us as incubators of creativity and of the art that enriches our societies and defines our civilization. They are the seedbeds from which culture and genius grow. And they provide individuals with a chance to be part of a gathering, a family of artists before breaking off, once again, to follow their own paths. But that seems to be the nature of life: to paraphrase Aristotle, we are all part of the universal while still retaining our individual identities—which is fitting, for in the end we all have to go our own ways.

For brief but precious periods of time, MacDowell provides that balance for those who create and work in its studios: it offers solitude and friendship, retreat and renewal, support and strength—as well as, to quote James Baldwin, a place "to crouch in order to spring." It is wonderful to consider, as the Colony celebrates its centennial, what extraordinary, moving, and transformational art may yet come from those who are waiting to spring out from behind its studio doors.

OVERLEAF: FIRTH STUDIO SITS NEAR HILLCREST, THE ORIGINAL HOME OF THE MACDOWELLS.

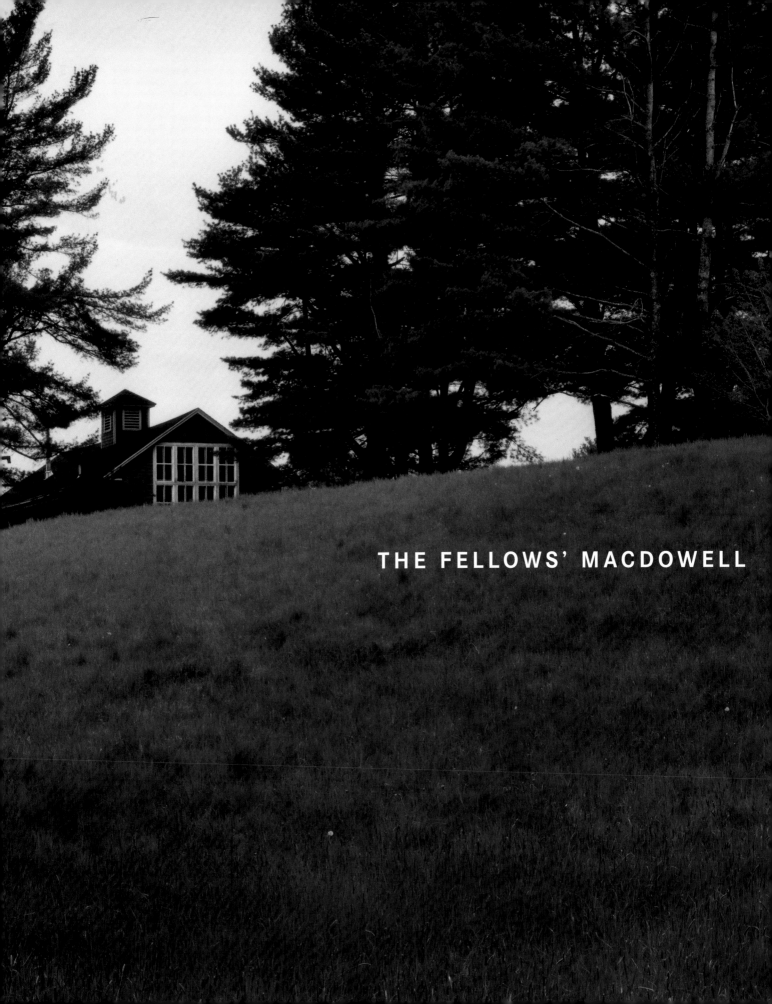

THE FELLOWS' MACDOWELL

Landscape of the Imagination
Verlyn Klinkenborg

Every artist is an opportunist of sorts, a scavenger of self, making the best of what cir-
cumstances offer. Most artists are relatively honest about that fact. What we do may
look deliberative, as though we sat at the console of our own lives, guiding them sure-
handedly through the chaos around us. (Another theory—always popular with the public—
is that artists hurtle chaotically through the order around them.) But there's always
something accidental about the work and the play of the imagination—the accidents of
who you are and where you were raised and what you know and how you learned to
employ yourself. Artists find themselves living, like most people, in places they don't
really remember choosing, along lines that often seem to have shaped themselves. The
real deliberation gets saved for the work itself.

This is one of the things that make The MacDowell Colony possible. If artists' imagi-
nations were as bound to habitat as the meadow vole or the marmot or the skink, there
would be no transplanting us, even for the short season of a residency. We would cling
to our burrow or our den in the rocks, and every gesture of our art would speak of just
that one place. The only artists who could stand the move to Peterborough, even for a
few weeks, would be those from the neighboring woods.

But we come, and we are temporarily liberated from the setting of our daily lives.
What liberates us isn't merely being away from home: it's the sense of place that the
physical setting of MacDowell imposes upon us. The Colony likes to think of itself as
offering artists the gift of time. But it's also offering something much more profound —
not merely a studio to work in, but a landscape, both natural and artificial, that is
powerful enough to overlay whatever habitat we consider ourselves native to. That
supplanting is instrumental to the work that gets done here. Just how or why, no one
really knows.

My own guess is that in the characteristic particularity of this place—dark woods,
precipitous streams, comatose boulders, curtained fields, the perpetual sense of some-
thing beyond the barrier of what you're actually seeing—many artists find a reawakening
of their sense of the strangeness of this present life. That is something nearly every
artist knows how to use. I mean the moment when the inevitability of your surroundings

falls away, and you see under the skin of the world you live in. For me that happens on the drive to Peterborough from eastern New York state, where I live. On the map, the two places are very near. But the arrangement of place has changed completely by the time I reach MacDowell. The villages cling more and more to the rivers the closer I come. The forests seem more and more to have herded the humans into the clearings. Some new declivity is always opening up before me, some surprising swamp.

These moments of dislocation come in glimpses during a residency at MacDowell. One night, walking back to your studio in the dark, you're overwhelmed by the reef of stars above you, by the transparency of the depths you find yourself staring into. But that night is no more striking than the night you find yourself back in your studio—dazed by the lights, no memory of how you got there—and realize you've been unraveling a problem all the way home. For an artist, coming to an unfamiliar place to work is a way of rediscovering how familiar the place of the imagination is. You may be walking through the New Hampshire woods after dinner, but only nominally.

These tensions and how they sort themselves out are the undercurrent of any artist's working life at MacDowell. Some artists—a few—come here and find themselves becoming naturalists, students of the other lives that go on in the forest canopy and under the ferns. But here every artist also becomes a naturalist of the imagination, a student of the places where it lurks, where it draws nourishment, how it cuts an arc in search of some satisfaction of its own, like a phoebe skimming the grass for an insect.

I make it sound as though the artists at MacDowell spend a good part of the day stunned, consumed by attention to the landscape of their own minds. That is obviously not the case, or not literally. But nearly every working artist learns sooner or later that you can set up a mill and millpond in some parts of the imagination while in other parts you always run the risk of getting lost among the deadfalls. You learn what to look at directly and what to coax into your presence by offering not to look. Most artists know these things before they come to MacDowell. But something about the quiet frame of the natural world changes the substance of that knowledge.

In the aftermath of the work that gets done here—the novel, the sculpture, the string quartet—MacDowell leaves only vestigial traces: an acknowledgment or a passing allusion. But in the artist it leaves something much more powerful. I mean more than a memory of the time spent here, the remembrance of season and the ways the light and the foliage changed. I mean the deep interior sense of how a work commingles with the worlds out of which it has been created. This is an utterly private knowledge, belonging

only to the artist. It is also something we almost never talk about, because so much of this knowledge lies beyond talking.

What matters, we like to say, is the finished piece. But there's a secret history hidden in every work of art. It consists of all the things the artist had to know before it could make its appearance. The work is one way of articulating those things. But so is the largely inarticulate awareness that remains with the artist—the backstage view, the consciousness of all the choices, all the inward trial and error that went into the making. It is astonishing how often and how deeply that awareness is interwoven with a sense of place, especially when the work has been done in a setting like MacDowell, where place feels so potent.

Nearly all the ways we talk about the relation between the natural world and the artist's imagination are too simple. For some artists, certainly, the landscape at MacDowell is little more than a scenic backdrop, like working in a room fitted with a spectacular Turkish carpet and a vague sense of Mount Monadnock brooding off in the distance. For others, MacDowell probably brings back memories of childhood camp, where nature is just part of the recreational program. But I think most artists who come here learn to rely on something more than the solitude and the quiet and the rank loveliness. They come, almost inevitably, from backgrounds where nature has been thinned too thoroughly, where the asphalt is always poking through. What they find here is the intricate self-sufficiency of nature, its omnivorousness, the incalculable attention to detail in every organism and in how every organism is fitted to the world around it. Something about the seriousness of the enterprise, the wholeness of every creature's commitment to living, is profoundly sustaining.

Time in this rural corner of New Hampshire seems more solid, more massive, than it does back in the life you left behind. But that is an illusion. It is all transformation here, always. The rigor of change never lets up. Every minute is a revision of the minute before —in the studios as well as in the meadows and woods. At MacDowell, the artist's proper labor is turning himself into the person he will be when the work at hand is finished, and that is a task that never lets up. To an outsider, a casual visitor, the mid-day serenity of the place can seem almost overwhelming, especially in winter. It feels as though every creature on these 450 acres had gone into a deep sleep. But that, too, is an illusion. Everything here is stirring.

ALEXANDER STUDIO AT NIGHT. THE
STUDIOS ARE OPEN SEVEN DAYS A
WEEK, TWENTY-FOUR HOURS A DAY.

Time Out
Joan Acocella

For me—and I think this must be true for everyone, or everyone who lives in a city, or in a family—the main gift of The MacDowell Colony is quiet. You go to your studio from nine to five, and the phone doesn't ring, and the doorbell doesn't ring. For most of my stays at MacDowell, I didn't even bring a computer, so I received no e-mail. I didn't have my regular mail forwarded, either. This meant paying late fees to Visa, but it was worth it. There I was, with just my project.

During my second stay at MacDowell, this produced a bonanza. In seven weeks, I wrote three chapters of my first book, and once I got home, that launching was enough to carry me to the end. I didn't get such a result from every visit I made to the Colony, but I got it twice. Other times, I came home with a long essay or two, and that was good enough.

The benefit is more than productivity, though. The long daily spell of solitude brings you up against yourself. For some people, this can be a rattling experience. I know an artist who lasted only a week at the Colony. It frightened him to think that now he could *really* work. He packed up his things and left. But for most people the self-confrontation that takes place in the silent cabin, if hair-raising, is a uniquely instructive experience. You discover what's in your project, and in your head: how much substance, how much hot air. You go to the bottom of your thought, and find out what the ideas you spoke of so confidently in your application are actually worth, and also what they mean to you, in a personal sense.

One summer, at the Colony, I edited the memoirs of my grandmother, Jessie MacKinnon Hartzell, who was a missionary, the director of a small mission hospital, in northern Thailand in the 1910s and 1920s. I took on this project as an act of piety to my family. I had known my grandmother Jessie (who was dead by the time I came to MacDowell) when I was a child, but I didn't love her much. She was a stern Presbyterian lady who stayed with my sister and brother and me when our parents went away on vacation, and told us to eat our oatmeal. I don't know how my editing, or the introduction that I wrote to the memoir, would have turned out if I had done it at home, in New York, rather than at MacDowell. But at the Colony, because of my isolation, my perception was heightened. I could feel the heat (105 degrees indoors during the hot season) of the dusty little town, Prae, where my grandparents were stationed; I could feel Jessie's exhaustion when, in the course of what was routinely a seventeen-hour day at the hospital, she

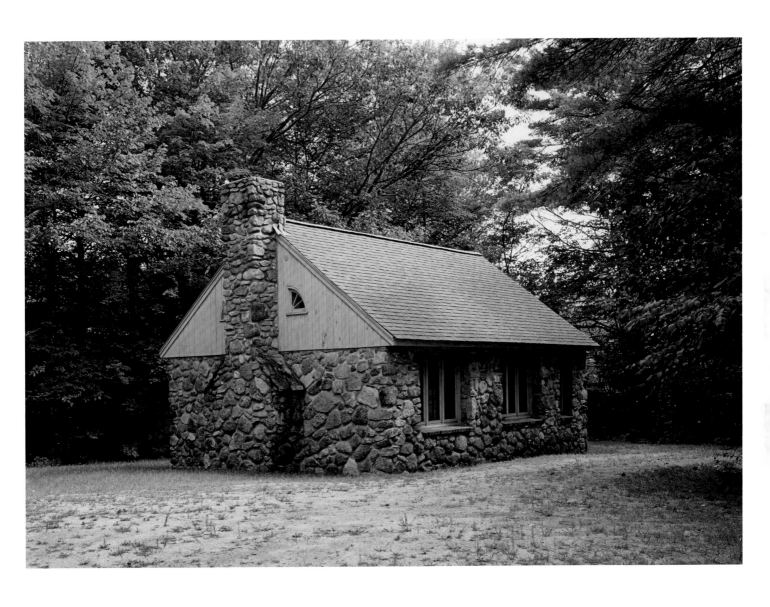

IN JANUARY 1976, THE ORIGINAL SPRAGUE-SMITH STUDIO WAS DESTROYED BY FIRE. REDESIGNED
BY PETERBOROUGH RESIDENT WILLIAM GNADE, WHO LATER JOINED THE MACDOWELL STAFF,
SPRAGUE-SMITH HAS BEEN USED BY *NEW YORKER* WRITER JOAN ACOCELLA, COMPOSER AND MACDOWELL
MEDALIST DAVID DIAMOND, AND NEW HAMPSHIRE POET LAUREATE PATRICIA FARGNOLI.

took a break to attend services at my grandfather's church. The mission was practically in a jungle; the hospital had no electricity, no running water, no rubber tubing, no plasma. When bandages were taken off a wound, they were washed and hung up to dry so that they could be reused. My grandmother had patients who were screaming in pain, patients who were dying, but she was not a doctor or even, at that point, a registered nurse. For surgery, she had to wait for a doctor who came once a month from Chiang Mai, the nearest big city.

Sitting in the silence of my studio, I could feel, almost on my skin, her frustration and her determination, and her other emotions, too: what it meant for a farm girl from Nova Scotia, orphaned at eight, with no university education, to have such urgent and useful work, and what it also meant that this occupation, which she so loved, deprived her of her children. (Like other Westerners working in Asia at that time, my grandparents sent their children back home very young to be educated.) Then, too, I felt what it must have been like for her, in her old age, with Thailand—and any useful project—far behind her, to sit down and produce this restrained and factual memoir. I had always thought that whatever gift I had for writing came to me from my father, who wrote a few short books. From my grandmother's manuscript I found out otherwise.

I learned other things as well. My grandparents, like many missionaries in Asia and Africa, were in some measure broken by their work, and forced to give it up before they wanted to. My grandmother came down with a skin ailment that wouldn't go away; the Presbyterian mission board ordered her back to America for a rest. Soon afterward, my grandfather, who had promised her that he would keep the mission going in her absence, suffered what was then called a nervous collapse. He, too, was sent home, and promptly died of pneumonia. My grandmother begged the mission board to let her return to her hospital. But without a clerical husband, she was not allowed to go. So she enrolled at Columbia-Presbyterian in New York, and amid a gaggle of teenage girls, she— a woman of forty-seven, who had run her own hospital—studied to become a registered nurse. The courses must have seemed elementary to her; in any case, her later nursing career, in the United States, held for her none of the romance of Thailand. She became the disappointed old lady I knew as a child. So I learned from her memoir some very specific things about the situation of women in the generations immediately preceding mine, and also something about what lives are like, for men as well as women: that the good part may come to an end long before the life does. I don't know how much of this I would have understood, or properly valued, had I not thought about it at MacDowell— probably some. But in Sprague-Smith Studio, where my brain was stripped by solitude

and silence, these matters printed themselves on me permanently. The Colony turns you into an existentialist.

Novels about artists' colonies (my favorite is T. Coraghessan Boyle's *East Is East*) often make much of what their authors see as the competitiveness, the professional jostling, among the residents: how this one or that one will mention casually at dinner that he just got a call from an editor at Knopf, or is friends with Camille Paglia. Some of this goes on; I've seen it. I was less involved in it, not because I'm a higher type, but because, like my grandmother and many other women, I got my chance when I was a little older, past the age when one is really desperate. Also, for much of the time, I was doing a kind of work (dance criticism) that no one else at the Colony was doing, so I had no one to wave my credentials at. But if Colonists do jockey for status at dinner, it should be remembered that dinner lasts for only about an hour. For the preceding eight hours, these people have been in their studios, impressing no one, and finding out who they really are.

OVERLEAF: HEINZ STUDIO, NOW USED PRIMARILY BY SCULPTORS, WAS ORIGINALLY AN ICEHOUSE.

Youngblood
Kevin Young

I drove two thousand miles to get there. On my pilgrimage to MacDowell I crossed deserts and the plains, survived my Midwest hometown and the City, where my ten-year-old stick shift was continually broken into on the street where I parked it on the Lower East Side—this despite the fact that, having learned my lesson after donating a few radios to the car thief gods, I had already cleared my car of everything, even maps. Luckily, though reaching MacDowell required a map, and an invitation, once you got there no map was necessary.

Given my pace those days, I'm sure I was a day or two late. Still, I was welcomed by the terrific staff, and a mailbox with my name on it awaited me. That mailbox was the kind of promise MacDowell held, and fulfilled; it's amazing the small things that mean so much to a young writer. My own mailbox! Not to mention the room, and studio, and the broader sense of shelter that, for any artist, can be hard to find.

Omicron Studio, the closest to Colony Hall, was a shaded place where I spent my first few summers at MacDowell. Besides the desk, and the standard cot in the corner, was a grand piano—a reminder of the composers who had often used the studio, but also, I think, a kind of inspiration for the musicality I would seek in my work.

I always write with music on (and sometimes even the TV). Television doesn't much exist at MacDowell, but music is everywhere: whether the music of readings or musical pieces by fellow Colonists many nights; or the music of the spheres, which one listens to while sitting out on the Colony's lawn, waiting for a meteor shower; or of the fox who lived at the edge of the field Omicron shared. MacDowell meant such beauty, plus the great talk of the artists at dinner, and especially after. I suppose beauty plus talk became for me a good definition of poetry.

This is not to say that the talk that is poetry need be beautiful—indeed, it should be as ugly or long-winded, as lush or listless, as spare and unsparing as life is. Of course, I didn't know all this then. Then I was happy to not have to work, and to save on rent. It was of course a blessing to be able to write when and what I wanted.

MacDowell was something of an extension of that—there you learned your natural rhythm, the pace at which you worked when you didn't have to worry about bills, and

THE PASSAGE BETWEEN BOND HALL AND THE DINING ROOM SERVES AS THE COLONY'S POST OFFICE. POSTINGS ON "OPEN STUDIOS" – WHEN ARTISTS SHARE THEIR WORK WITH OTHER COLONY FELLOWS – CAN BE FOUND ON THE BULLETIN BOARDS.

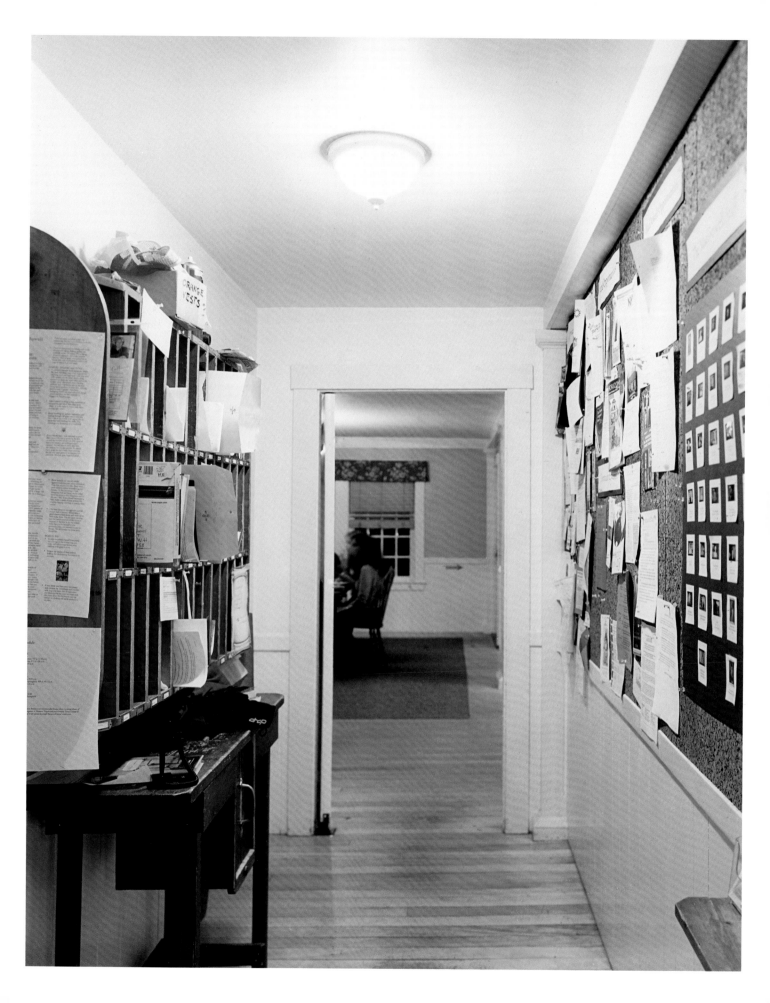

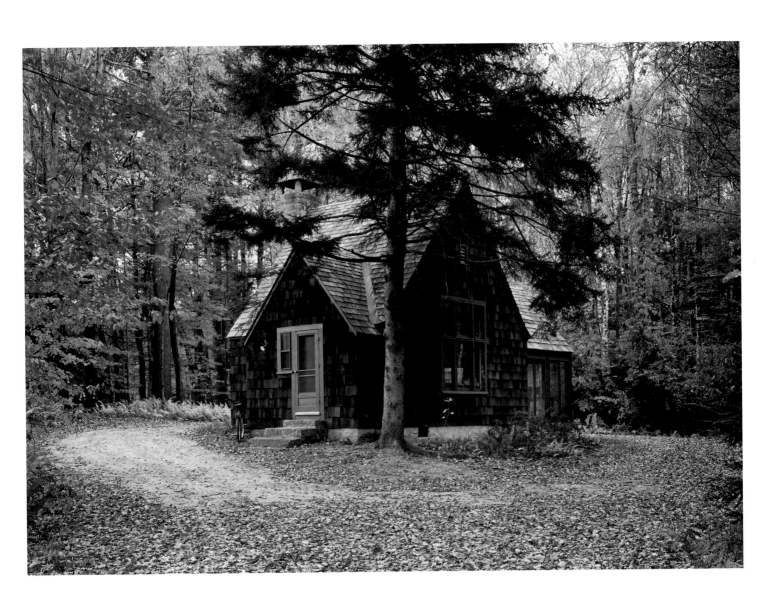

DELTA OMICRON INTERNATIONAL MUSIC FRATERNITY FUNDED A STUDIO IN 1927. WRITERS ALICE WALKER AND LOUISE ERDRICH, VISUAL ARTIST JANET FISH, AND POETS GALWAY KINNELL AND KEVIN YOUNG HAVE ALL WORKED HERE.

had no phone to distract you. No Internet yet. Of course, I logged more time than I'd care to admit, evenings, in the Colony Hall phone booths; I also wrote fewer letters than I wish I had, and still have the blank MacDowell stationery to prove it. If my time in San Francisco had taught me how to be a person, a grown-up of sorts, then MacDowell taught me how to be a writer. It didn't matter that it was in idealized form — even then I was painfully aware how rare such free time was, that time in what gets called the real world was never really free. Even in the free time I had earned in San Francisco, there were plenty of distractions, which I needed and even liked. But it's another thing to learn to write without distraction, to face every day the blank page that is already inscribed with fear of both failure and success. I learned how to handle this best at MacDowell.

People respond to the newness of such undivided attention in many different ways, but in my experience, most people spend the first week at MacDowell sleeping. Imagine one's alarm at being given several weeks, even months, to write, and not seeming to be able to wake for the first part of it! Much like jet lag, people have different theories of how to cure it, but few can deny its impact — a decompression of sorts, not just from the pressure of the outside world, but from preparing for the pressures of facing the blank page or the canvas or the not-yet musical score head on. I usually set unrealistic and vague goals that I hoped to realize as many of as possible; still, the main realization I had was that anything done in one's studio constituted work. Reading was work; revising, especially, was work — I jumped at the chance and time to go through a range of notebooks and put together pieces, written over quite a bit of time, into a whole poem, or even a whole manuscript. If poetry is a series of moments (like its writing), and a novel is life day in and out (its writing a daily endeavor), then MacDowell helps novelists seize moments of inspiration, and helps poets learn regular practice. It gives us, you could say, a new set of maps, however internal.

The most difficult thing about writing may be how to handle not writing — something you have to confront at MacDowell and, if you're lucky, learn to manage there. It certainly makes dinner easier, answering over salmon loaf how your day of making went, if you can be positive even when stalled, or stilled. That, too, is part of the process, full of directions and misdirections, and also the solitary and social aspects of the writing life.

In some way, I think I was used to the solo aspects of writing — though I'd work-shopped plenty before, I think that only heightened my view of its "solo-ness" — but MacDowell certainly taught me its social aspects. Not just with a drink (or two) after

dinner, or a discussion over lunch, but by getting to know other artists and writers and their processes.

Not all lessons were friendly ones—but even these were useful. My first time at MacDowell I had just begun in earnest a series of poems based on the late artist Jean-Michel Basquiat (which would become a full blown, 350-page epic and my second book). This was only five years after Basquiat's death, but I was interested in the painter's life— and what's more, his work.

At my first dinner there, I was seated with an older sculptor who taught at an Ivy League school, and when he asked what I was writing, I told him of my interest in Basquiat. Without hesitation he told me Basquiat was a trendy phony of little quality, merely a media phenomenon. While much of what was written about Basquiat—what little there was then—had the same tenor, it was strange to hear it live and kicking. But also instructive—it taught me a lot about snap judgments, loose lips, and, more specifically, about the kinds of challenges that a now-acknowledged genius like Basquiat faced, and in a smaller sense, the challenges I was experiencing writing about him. Whether short-sightedness, professional envy, or the often thinly disguised racism that Basquiat faced, such dismissive attitudes became one of the topics of the book, which I wouldn't have written without the example of Basquiat, the support of MacDowell, or the challenges of fools whom we all suffer, gladly or not.

I don't believe in muses but in music. I mentioned earlier the fear of facing the page— writing isn't always joyful, which is why they call it work. But one can learn as much from example as counterexample; at MacDowell I learned what I wanted to write against, as much as what to write about. Both are easier on a full stomach. The power of three hots and a cot shouldn't be underestimated.

Such routines and reassurance, mixed with freedom, are the backbone of the kinds of experimentation that can be found at MacDowell. Indeed, the freedom to explore all aspects of your work, despite or rather because of the time limit on that freedom, is the very essence of experiment and artistic endeavor. Meeting a composer—where else could I meet a composer!—or a visual artist can inspire as much as the library at MacDowell, filled as it is with former Colonists' works and signatures. Collaboration is in the water there, however short-lived, and lets us learn about our own work and its possibilities. One of my best memories is of hearing my friends who are also fiction and non-fiction writers declare their favorite poems—one grabbed a collection of Lorca off my shelf and spontaneously read through a poem, then we all shared our favorites. In the world, or even a writing program, you can lose sight of the place poetry takes in the

world—fearing it belongs nowhere, or is all important. It was at MacDowell that I realized, and heard an older poet declare, that "poetry both doesn't matter, and is the most important thing in the world." In fact, poetry belonged as it did that long night of Lorca: on the shelf, in the air, spontaneous and selfless.

The latter two are part of MacDowell's charm and uniqueness. The spontaneity of writing whenever and whatever, of deciding on a course if only for a few weeks, is an experience not even time can erase. I would return to Omicron and fill it with words, quite literally pinning my Basquiat poems to the walls, where, like an artist's unfinished canvases, they both inspired and haunted me. They sat alongside what are called tombstones—the pieces of wood you write your name on to say *I was here*. Most folks I know signed them only when leaving, as I did, to ensure you'd left your mark in other ways. Many folks also took them down, feeling the old names, often famous, eyeing them expectantly.

To me, like the words I wrote, like the tradition of that place, of experiment and expectation, those names seemed to hold up the walls. Such a mix of past and possibility was the headiest cocktail of all—and reminded me of how a few of the older generation would call me and some of the younger writers there "Youngblood," a term of 1960s Black Power-era affection and connection and cool. Now, I've heard many an annoying joke about my last name, but this wasn't like that—Youngblood was honorific, a way of letting me know that I was both seen and new to the scene. That I belonged. And that whatever I was to learn, I had earned or would earn—it was only a matter of time.

Time, and belonging, and learning: those are things MacDowell has to offer everyone, youngblood or old.

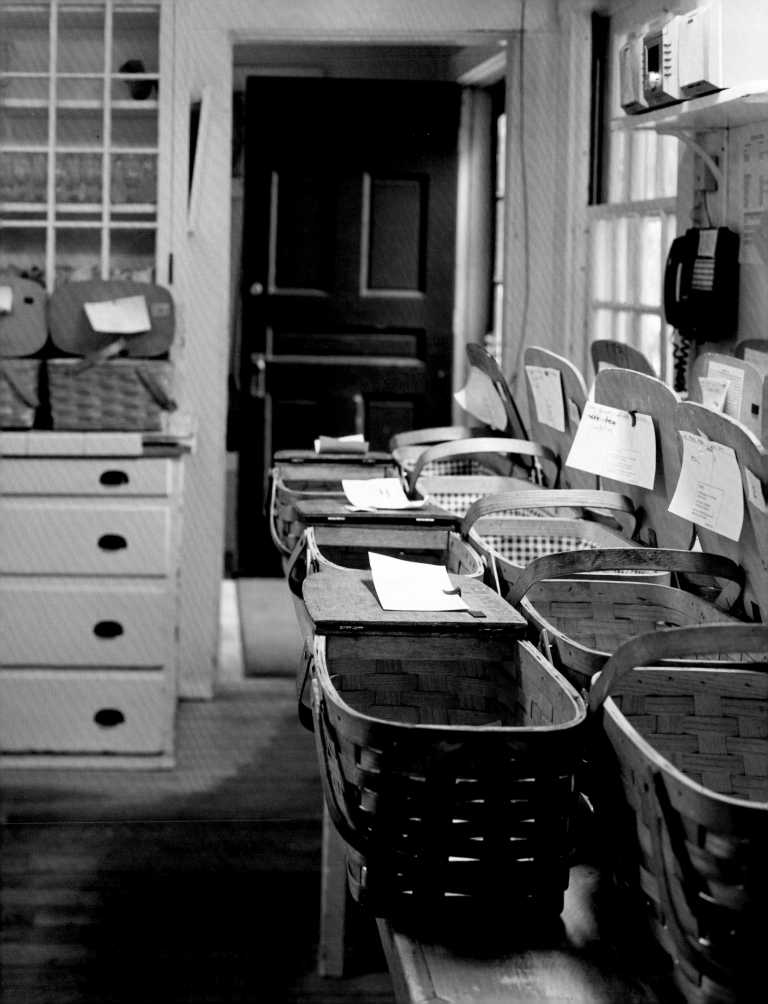

Pure Communion
Ruth Reichl

Breakfast

In the just-light of morning, the gathering at the scarred wooden table feels like a family reunion of long-lost relatives you had always hoped to find. Fueled by the first cups of coffee, buoyed by the knowledge that speech will be unnecessary for the rest of the day and eager to see what's on the menu, you walk into this roomful of sleepy talkers and slide into conversation.

This early, people move unselfconsciously in and out of subjects in ways that will be impossible later in the day. It lends the meal a slightly surreal aura, more *You Can't Take It with You* than *Philosopher at the Breakfast Table*. Snatches of dialogue float by—a dream, some politics, a few lines of music. You can reach up and grab hold of a sentence or simply let it glide past.

"This is insanely good."

Yevgeny, dreamily pouring more maple syrup onto his strawberry pancakes, has spoken louder than he intended, and as heads turn his face glows red. The entire table watches the tawny liquid eddy across his plate. At our end we've been dissecting utopian communities, while down near the toaster Martin (an architect) and Frances (a poet) have just discovered that they share an obsession with the same obscure conceptual artist. Their conversation has been going at a gleeful gallop, but they stop now, and there's a moment of silence as we watch Yevgeny fork up another bite of pancake. Then, one by one, we all troop into the kitchen to demand pancakes of our own.

Unaccustomed to being cared for, you find the endless morning parade of omelets and oatmeal, bacon and toast as much of a miracle as the easy conversation. And so you stay to have another blueberry muffin and a final cup of coffee, mindful that at this time next week, or next month, you'll be gulping smoothies on the subway.

And most mornings, with the sun coming over the meadow and the song of the hermit thrush hanging in the air, you push back your seat and head off to the studio, convinced that this will be a gloriously productive day.

THE "LUNCH RUN" BEGINS IN THE KITCHEN. EACH OF THE THIRTY-TWO STUDIOS IS ALLOTTED A BASKET. THE PETERBORO BASKET COMPANY MAKES THEM SPECIALLY FOR MACDOWELL.

Lunch

The feeling fades, of course. By noon you're at your desk, pretending to be deep in thought but actually obsessing over what's for lunch.

And so you sit—idly watching a wild turkey munch her way across the meadow, ten tiny chicks in tow—dreaming about food. You remember the cucumber soup that showed up on the hottest day of summer, pale and cool, the surface dappled with little flecks of dill, the flavor electric with the bite of buttermilk—or was it yogurt? And that time four years ago when Japan popped out of your basket in the form of soy-brushed salmon, strips of nori, miso soup, and green tea. Or that Fourth of July when you found sparklers hidden beneath the cupcakes, and you took them out to the woods to sit cross-legged on the moss, having a private party.

Is that Blake's car crunching up the driveway? No, just an errant deer who's come to watch you work. Guiltily you go back to your book, but now the memory of yesterday's gazpacho has you in its grip, and you find yourself hoping that today's lunch basket will hold egg sandwiches, or that great Caesar salad, the crackle of the croutons sharp against the lacy lettuce. There was good cheese in the tangy dressing, and a fat anchovy stretched languidly on top of the single sweet tomato. If you're really lucky there will be more of those slightly sour lemon cookies whose flavor lingered in your mouth all afternoon.

There's Blake's car! No, it's just the turkeys taking off.

And so you think some more about the basket, how it is the ultimate gift of a sojourn at MacDowell. This studio is lovely, but you can always find a place to work. The basket is what you really come for, not just the meal it holds, but the respect that's packed in with it. Anyone can find a desk, but a lunch that whispers encouragement is a very rare thing. It is edible acknowledgement that your work is worthwhile.

There's a car coming! This time it really must be Blake. And sure enough, the basket hits the porch with that satisfying little thud. Today there is fresh corn soup, creamy and sweet, and a fat slice of vegetable tart dusted with cheese. The crumbs gather on the keyboard as you eat, and you brush them away, wondering if Shelly, over in Omicron, is deconstructing her lunch as she is wont to do, or if Fritz, in Heinz, has succumbed to the lure of the cookies rather than feeding them to the chipmunk who lives in his tree. With this thought comes a pure moment of communion, a sense that people all around you are silently sharing this meal.

BLAKE TEWKSBURY, A LONGTIME STAFF MEMBER, DELIVERING LUNCH

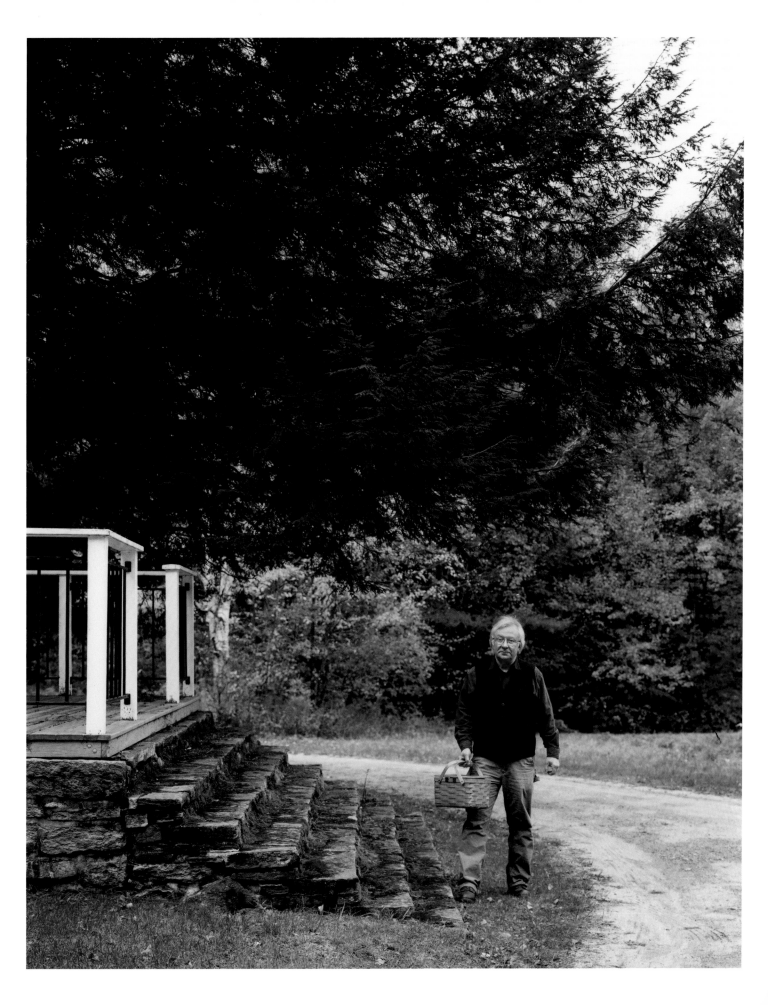

And then, suddenly it seems, there's nothing left but a lone carrot stick and a fat little brownie. You linger over them and get back to your book. Lunchtime is over. The work goes better now.

Dinner

Tonight you find a puffy papillote on your plate. When you pierce the paper, fragrant steam comes hissing out and clears to reveal an herb-strewn slice of salmon perched on a plump bed of potatoes. The salad on the side is fresh and fine, a tangle of beet greens and mache and little strands of fennel mixed with arugula. Mike and Judy have each offered up a bottle of wine, and as the glasses are passed around the table you find yourself engulfed in a surprisingly passionate argument about the relative merits of red and white.

Then Dan stands up to make an announcement: he'll be reading in the library at eight. When he sits down the raucous clapping begins. He started it, and by now it has turned into a ritual, more strident every night so that now there is a wild cacophony every time someone stands to speak. We like it; we've been together for a few short weeks but already we have a tradition.

Tonight, however, you feel an edge of sorrow just beneath the laughter. It's Dan's last night, and tomorrow he will have left this enchanted table and gone back to the real world. We're sorry for him—out there people are not as smart or as kind as they are here. Out there every meal is not a celebration. And we're sorry for us, because each person who leaves takes something with him, and each departure is another reminder that sometime soon you, too, will have to leave the table.

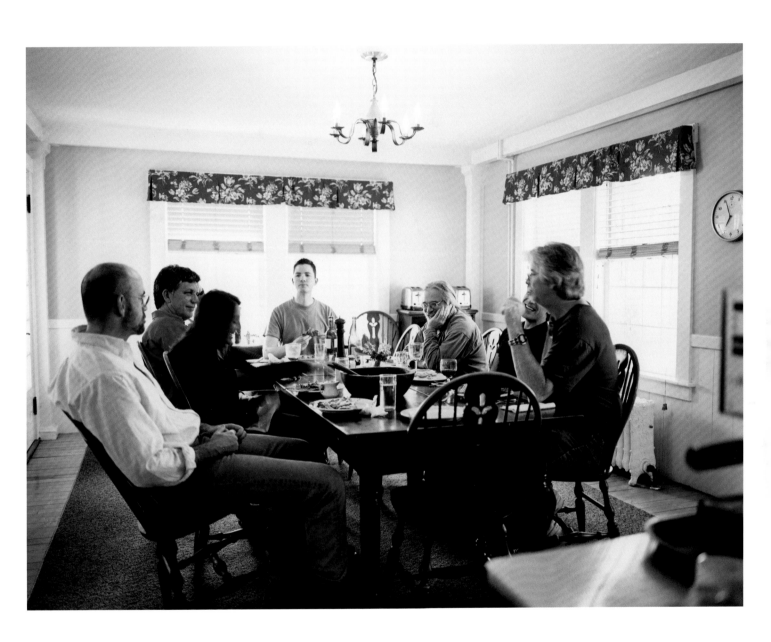

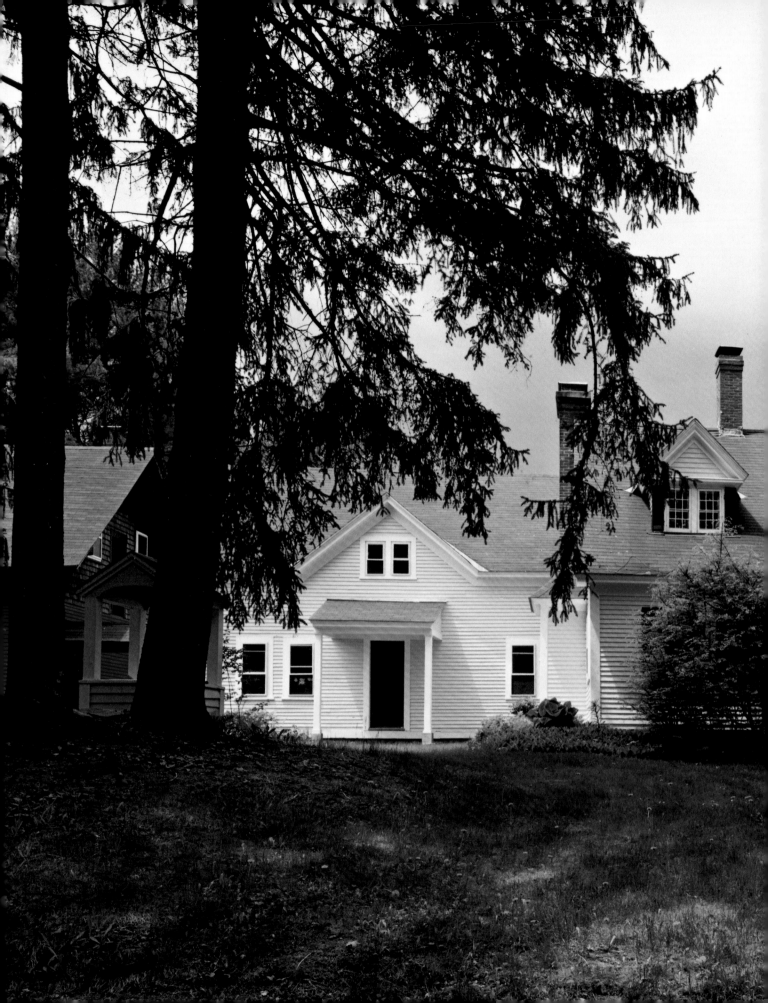

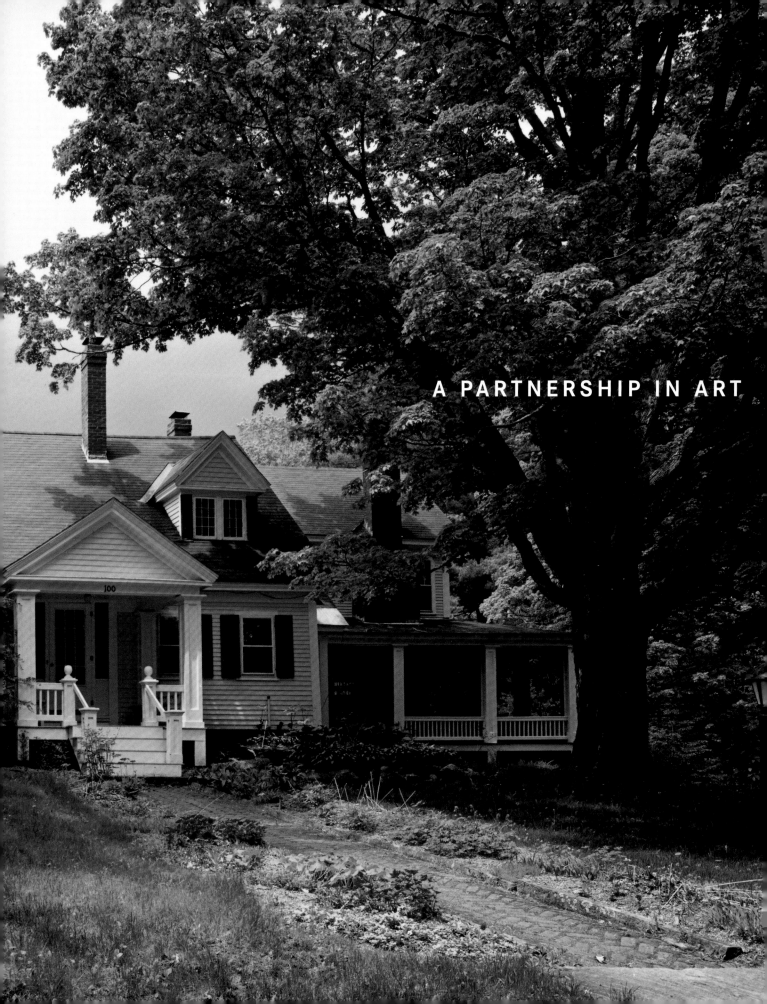

A PARTNERSHIP IN ART

The MacDowells and Their Legacy
Robin Rausch

The arts in the United States in the nineteenth century were seen through the prism of Europe. American composers struggled to find an original, national voice, but there was little agreement as to what defined American music or if such a thing even existed. When asked in the early 1880s to write a history of music in America, critic Richard Grant White declined, saying that such a history "would be mostly to record the performance... of music written in Europe by artists born and bred in Europe."[1] Indeed, no aspiring musician in America was taken seriously without the imprimatur of a European musical education—a fact that drove countless music students from the United States across the Atlantic in the late nineteenth century. Among them were Edward Alexander MacDowell and Marian Griswold Nevins. They met in Germany and in time formed a partnership that would leave a far-reaching legacy.

Edward MacDowell's talent at the piano, and the motivating force that was his mother, brought him to France in 1876 at the age of fifteen. He had come to study piano at the Paris Conservatory, but he grew dissatisfied with his instruction and eventually moved to Frankfurt. There he was encouraged to turn his attention to composing by Joachim Raff, head of the Frankfurt Conservatory. Raff sent him to the venerable Franz Liszt in Weimar, who praised the young man's compositions. It was a turning point for MacDowell; he began seriously to consider himself a composer. MacDowell was teaching students of his own in 1880, when Marian Nevins arrived in Frankfurt. She had hoped to study piano with Clara Schumann, but Schumann was unavailable. Marian sought out Raff for advice. She was not fluent in German, so Raff referred her to his brilliant American pupil Edward MacDowell. Marian met him begrudgingly—she had not come all the way to Europe to study with an American. But she became his student, his friend, and ultimately his wife, a relationship that has been called Browning-like in its perfection.[2]

MacDowell was well liked in Germany and felt that his chance of success as a composer was greater there than in America. After the couple wed in 1884, they decided to

PAGES 48–49: HILLCREST, THE MACDOWELLS' HOME, HAD BEEN ABANDONED WHEN MRS. MACDOWELL PURCHASED IT IN 1896. TODAY HILLCREST IS USED FOR COLONY FUNCTIONS AND AS GUEST QUARTERS.

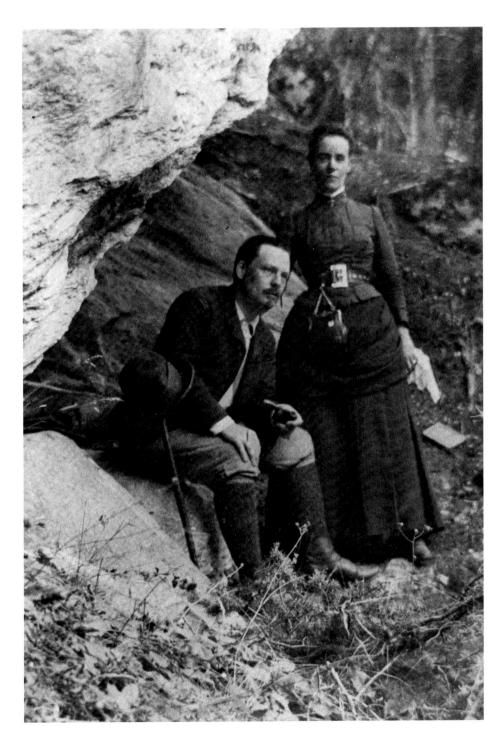

EDWARD AND MARIAN MACDOWELL EARLY IN THEIR MARRIAGE

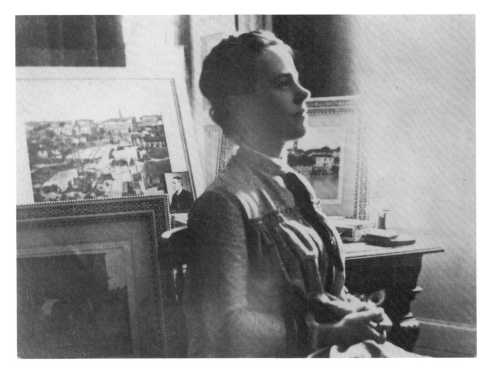

MARIAN MACDOWELL AS A YOUNG WOMAN

settle in Wiesbaden. Edward's reputation continued to grow, and as his works began to receive performances in the United States, American musicians started to seek him out. One of them was Benjamin Lang, a prominent Boston musician, who in 1888 urged the composer to return home and become part of the effort to shape a new American music. The MacDowells were running low on funds and had already contemplated such a move. Lang's appeal tilted the balance, and in September 1888 they sailed for Boston. The *Musical Courier*, a popular weekly of the day, heralded the composer's arrival: "In the return of Mr. E. A. MacDowell to this country after some twelve years' absence we can welcome a sterling musician, pianist and composer—one whose work has done much toward placating certain foreign critics who could see no merit in American compositions....Mr. MacDowell is a great acquisition to the rapidly growing group of young and talented American composers."[3]

Edward MacDowell was young, handsome, and by this time could rival the best piano virtuosi of his day. He was soon in great demand, and his performances of his own works became highly anticipated events. The critics embraced him. He was pronounced

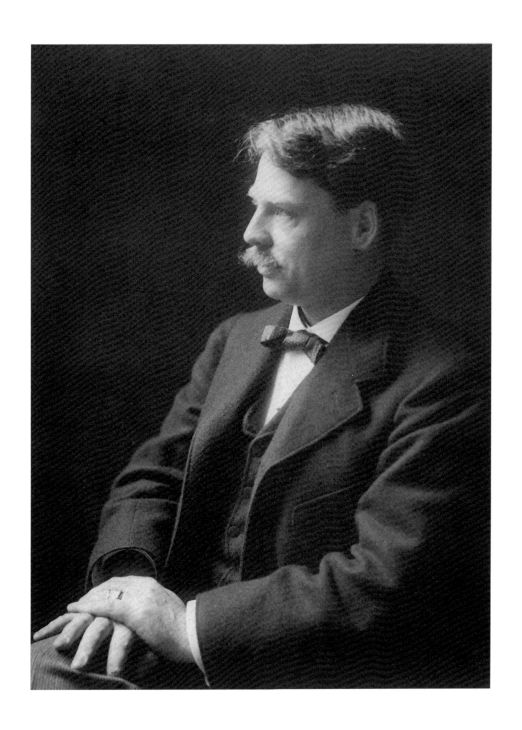

EDWARD MACDOWELL

"a pianist of rare fascination" and earned "a success, both as pianist and composer, such as no American musician has ever won before a metropolitan concert audience."[4] It was prestigious to be a MacDowell student. In 1895, a group of them began meeting for performance opportunities and organized the MacDowell Club of Boston. It was the first club to bear his name and the inspiration for numerous others that followed. MacDowell was regarded so highly that the Boston Symphony Orchestra programmed his first piano concerto, with the composer at the piano, and the premiere of his *Indian Suite* on their New York concert at the Metropolitan Opera House on January 23, 1896. In the audience that night was Seth Low, president of Columbia University. By the end of the evening, Low was convinced that he wanted MacDowell to fill a newly endowed professorship that would establish the first department of music at Columbia.

Marian MacDowell believed in her husband's talent as a composer, and from the beginning of their married life together she dedicated herself to fostering his creative gift. She understood the artistic temperament and realized MacDowell's need for a quiet place where he could work undisturbed. After they moved to Boston, she made sure that they escaped the hectic pace of city life during the summer. Marian discovered Peterborough, New Hampshire, on the recommendation of fellow Bostonian Mary

ABOVE AND OPPOSITE: MARIAN AND EDWARD NEAR THE SITE OF THE FUTURE LOG CABIN, EDWARD'S STUDIO

Morison, whose family had a home there. Morison described it as "a simple quiet little place in lovely country" that had not been invaded by "the summer people."[5] Peterborough became the MacDowells' favorite summer refuge, and in 1896 Marian purchased an abandoned farm about a mile from town, making the couple permanent summer residents. The farm consisted of eighty acres, a few outbuildings, and a house they called Hillcrest; it would be their sanctuary from the demands of their new life in New York. In 1898, Marian surprised MacDowell with a little log cabin studio that she had built in the woods nearby. Here Edward would go each summer morning to compose what became some of his best-loved music. He often stayed until dusk. If he did not show up for lunch, Marian silently left a lunch basket on the studio doorstep. MacDowell's productivity under these idyllic conditions convinced him of the value of working in such an environment. He began to imagine how other creative artists might use their Peterborough home.

When MacDowell accepted the Columbia position, he did so in part because of his long-held belief in the relationship between the arts and his desire to promote them as legitimate disciplines within academia. His dream was to establish a faculty of fine arts that would bring literature, sculpture, painting, architecture, and music together into a school of fine arts that was equal to such traditional areas of study as philosophy and science. Undoubtedly, MacDowell's views stemmed from his own multifaceted talent. He wrote poetry, was well read, and enjoyed talking about literature. He was also a talented visual artist, and almost gave up music in his student days at the Paris Conservatory to study drawing. He was an avid amateur photographer and dabbled in architecture—he designed and constructed most of the renovations to Hillcrest. Upton Sinclair, who studied with MacDowell at Columbia, recalled that the composer "differed from most musicians whom I have since met in being a man of wide general culture."[6]

MacDowell enjoyed the support of Columbia president Low during the early years of his tenure, but Low resigned in 1901 to run for mayor of New York. Nicholas Murray Butler, who had a different vision of the fine arts at Columbia, succeeded him, and by 1904 all three department heads of Columbia's Division of Fine Arts had resigned: W. R. Ware, head of architecture; George Edward Woodberry, head of comparative literature; and Edward MacDowell. The news of MacDowell's impending resignation was leaked to the press early in 1904, and a long public airing of grievances between the composer and Columbia officials ensued. The media attention triggered a national debate on the role of the fine arts in academia. MacDowell unwittingly became a cause célèbre. The stressful situation turned nasty when allegations were made that MacDowell's assistant had borne

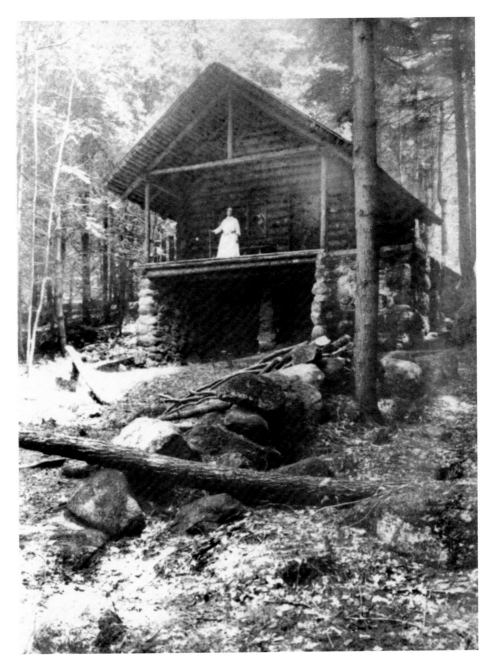

MARIAN AT THE LOG CABIN

the brunt of the teaching load, a blatantly false statement. The composer was crushed and sank into a deep depression.[7]

MacDowell turned his energies to other projects. A member of the National Institute of Arts and Letters, he was appointed to a committee charged with its reorganization in 1903. The restructuring resulted in the formation of the American Academy of Arts and Letters; MacDowell was a founding member. He was particularly interested in the plan of his colleague Charles McKim to establish an academy in Rome and had talked with him about a possible music component as early as 1896. President Theodore Roosevelt signed the bill establishing the American Academy in Rome into law on March 3, 1905, and MacDowell was appointed to the Academy's board of trustees shortly thereafter. In May, his ideas about music at the American Academy were submitted to McKim in a letter written by Marian on her husband's behalf due to his poor health.[8] MacDowell was seriously ill by this time, though no one realized how grave it was or dreamed that he would never recover.

It was commonly believed that MacDowell was suffering from exhaustion and the effects of stress brought on by the Columbia episode. What most people did not know was that shortly after his resignation from Columbia MacDowell was injured in a traffic accident. He was thrown from the doorway of a streetcar and run over by a hansom cab, the wheel of the carriage rolling over his spine. Marian said it was a miracle that he had not been trampled to death by the horses. Remarkably, he was able to walk away from the incident. But he was badly bruised and complained constantly of pain in his back. The following winter he was stricken with a temporary paralysis and was unable to walk. His doctors began to attribute greater significance to the accident and its aftereffects. Friends began to notice signs of physical and mental impairment. MacDowell's student T. P. Currier had dinner with the composer and his wife in April 1905. "His looks and response to my eager greeting struck a chill to my heart," Currier reported. "Pale, and thin, all his old brightness and energetic bearing gone, he seemed like one just up from a serious sickness."[9] By May 1905, his private students were told that he would not resume teaching in the fall. The summer in Peterborough did not revive him. MacDowell broke down completely. His friend Hamlin Garland announced the news to the press late in November. The front page headline of the *New York Daily Tribune* on November 28, 1905, read: "E. A. MacDowell a Wreck—His Days of Work Over—Columbia Trouble and Overwork Blamed for Composer's Illness."

Edward MacDowell knew that he was gravely ill in the summer of 1905, and he became obsessed with the fate of his and his wife's Peterborough property. Marian consoled him

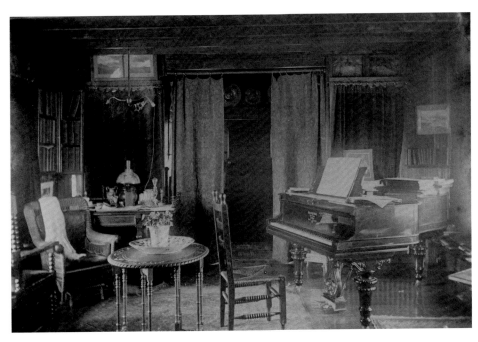

ABOVE: THE HILLCREST MUSIC ROOM WAS THE CENTER OF ENTERTAINING AT THE MACDOWELL HOME.
OVERLEAF: THE MUSIC ROOM TODAY

only by promising to turn their home into the artists' retreat that he envisioned. She offered their property to the newly formed MacDowell Club of New York in the fall of 1905. Minutes from the October 29 meeting state, "Mr. MacDowell's object was, that it might form a tiny imitation of the American Academy of Rome, thus fulfilling his ideal of bringing together students in the different arts."[10] After news of MacDowell's breakdown appeared in the press, interest in the MacDowell Club of New York surged. It became a vibrant force in the cultural life of New York.[11] Early in 1906, the organization incorporated in order to assume ownership of the MacDowells' property. But the final transfer was delayed so that the club could investigate possible collaboration with another group that was working on MacDowell's behalf, the Mendelssohn Glee Club.

MacDowell had directed the Mendelssohn Glee Club for two seasons after his arrival in New York and composed several works for men's chorus for the group. Under its administration, a fund was started to help with the composer's expenses. A nationwide appeal went out that drew subscribers such as Andrew Carnegie, Grover Cleveland, and J. P. Morgan. Marian insisted that she had enough money to care for her husband, and suggested that the Mendelssohn Glee Club Fund be used to establish the memorial to

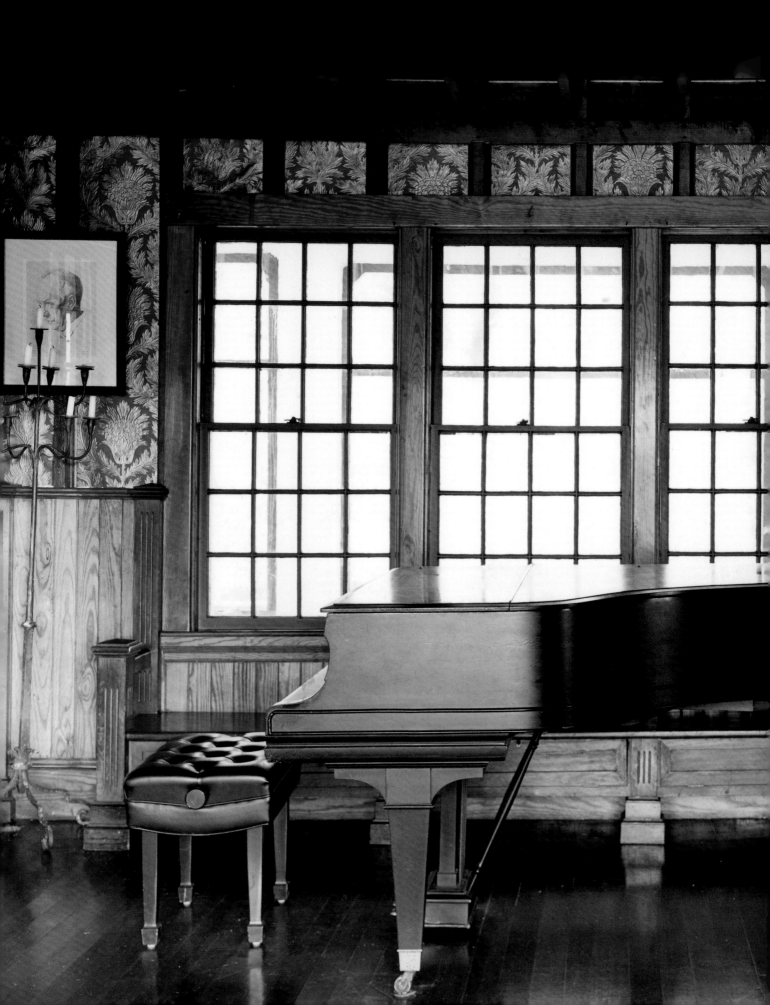

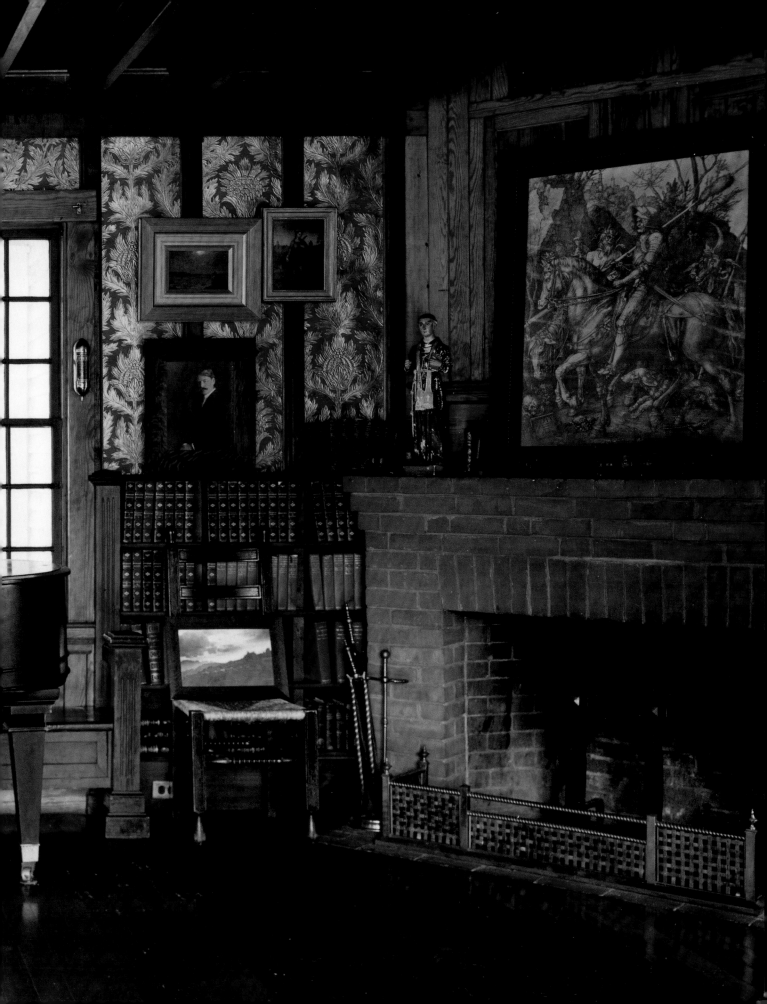

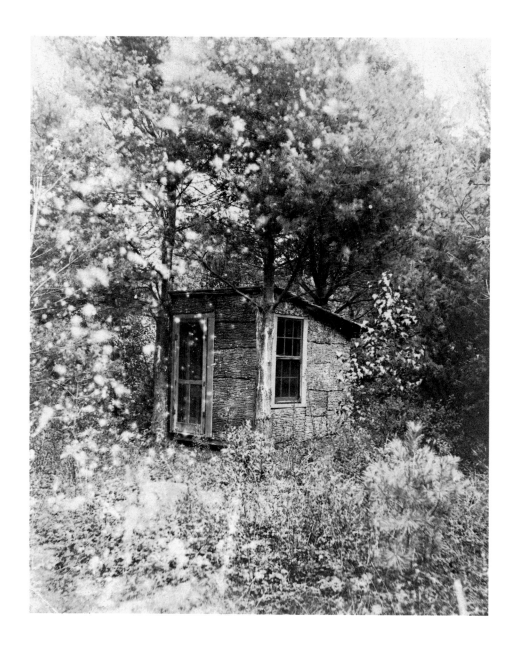

AN EARLY STUDIO

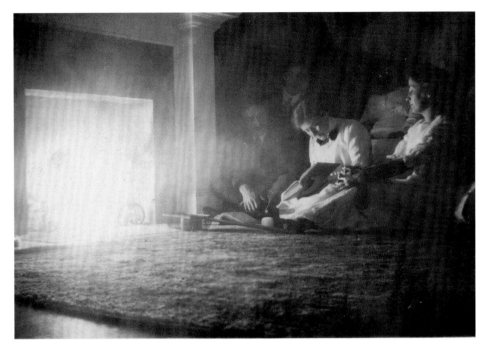

A GATHERING OF ARTISTS AROUND THE FIRE

MacDowell in Peterborough. However, not all of the contributors were enthralled with the idea of an artists' colony. Morgan wanted to help Marian in some way but declared, "I'll do nothing unless she gives up that damn, foolish scheme in the country." "Well, of course," Marian recalled, "that meant I had nothing."[12]

The MacDowell Club of New York and the Mendelssohn Glee Club joined forces and created the Edward MacDowell Memorial Association in March 1907. The organization was formed for the purpose of taking legal possession of the MacDowells' Peterborough property and administering the funds to support it. The deed of gift clearly stated Marian's intentions for their home. Her wish was that it should become a center for "artists working in varied fields" who, through contact with one another, "may learn to appreciate fully the fundamental unity of the separated arts." She also allowed its use by "others who are sympathetic with the aims and purposes of the donor" and stipulated that "no social distinctions shall be allowed to determine the choice" of those who made use of the home. Finally, she stated that it was not to be considered "a charitable institution" and therefore, resident artists "should be required to pay such moderate sums as might be proper, in return for the benefits gained."[13]

Eager to make her scheme a reality, Marian astonished everyone by breaking ground on a new studio and inviting sculptor Helen Farnsworth Mears and her sister, writer Mary Mears, to become the first official creative workers at The MacDowell Colony. The Mears sisters had been to Peterborough in 1906, after Marian engaged Helen to sculpt a bas-relief of her husband. Now, during the summer of 1907, they came as Colonists, the appellation first given to resident artists. Helen and Mary Mears returned to the Colony every summer through 1911.

When Edward MacDowell died on January 23, 1908, public opinion placed the blame squarely on Columbia. Marian tacitly seemed to concur—the accident had not been widely reported. Years later, she admitted, "I did not feel so sure of this at the time but with a calmer mind, and perhaps a juster [sic] one, I can look back and realize that not enough attention had been called to the bad accident that he had had that same winter."[14] In the end, it mattered little what physical malady led to MacDowell's death.[15] A New York Times reporter, writing in 1910, summed up what many felt: "MacDowell's death was that of a martyr to a cause, his task uncompleted, and his genius only partially recognized by his countrymen."[16]

1910–19

The face of the early Colony was distinctly feminine. Living quarters were limited and separate lodging for men was not available until 1911. Colonists paid a dollar a day for room and board and stayed in Lower House, an old dwelling down the road from Hillcrest that was converted to a boarding house, where meals were taken and tea was served on certain weekday afternoons. During the summers of 1908 and 1909, Lower House was filled with Edward MacDowell's students, who came at Marian's invitation. While the Colony was never intended for amateurs, the composer's students were an exception "because of their understanding of MacDowell's ideals." They became some of Marian's most devoted supporters; a group of them from Barnard College donated one of the first studios in 1909. Mrs. MacDowell was a one-woman selection committee at this time. Few knew about the Colony or understood its purpose. She quickly recognized the need for a major public relations campaign to draw new talent and to win over the townspeople of Peterborough, some of whom were wary of an artists' retreat in their midst. By the summer of 1909, plans were in preparation "for the giving of a unique festival" the following season.[17]

Early in 1910, Marian approached George Pierce Baker, professor of dramatic literature at Harvard, with the idea of producing a pageant based on the history of Peterborough.

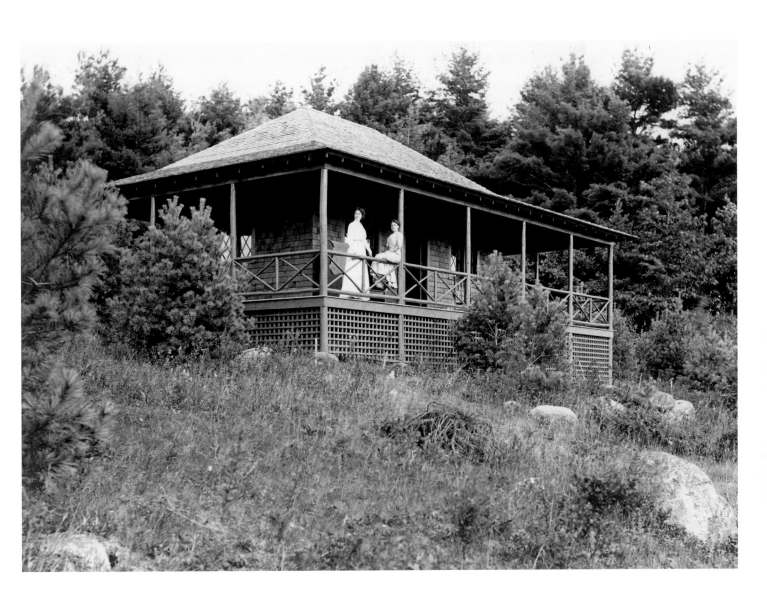

THE MEARS SISTERS, THE FIRST COLONISTS AT MACDOWELL, IN 1907, WORKED IN SCHELLING STUDIO.
WRITER MARY MEARS SAID OF THE COLONY, "WHATEVER INFLUENCES THE ART OF A COUNTRY,
INFLUENCES IN THE MOST INTIMATE SENSE ITS CIVILIZATION, AND CERTAINLY FEW PEOPLE ARE
AWARE THAT MACDOWELL'S PLAN, NOW PROVED PRACTICAL BEYOND QUESTION, IS ONE OF NATIONAL
IMPORTANCE."

BELOW AND OPPOSITE: BUILT IN 1907, SCHELLING STUDIO WAS THE FIRST STUDIO AT THE NASCENT MACDOWELL COLONY. ORIGINALLY CALLED BARK STUDIO FOR ITS RUSTIC ARCHITECTURE AND BARK SIDING, IT WAS RENAMED IN 1933 IN HONOR OF ERNEST SCHELLING, A CONDUCTOR AND PIANIST WHO WAS PRESIDENT OF THE COLONY FROM 1928 TO 1933. IT HAS SERVED SUCH WRITERS AS PETER CAMERON, JONATHAN FRANZEN, MARY GAITSKILL, DUBOSE HEYWARD, ARTHUR KOPIT, AUDRE LORDE, AND TILLIE OLSEN.

OVERLEAF: BARNARD STUDIO, BUILT IN 1909, EXEMPLIFIES THE CRAFTSMAN STYLE. IT WAS FUNDED BY BARNARD COLLEGE MUSIC STUDENTS BUT HAS HOUSED WRITERS, FILMMAKERS, AND COMPOSERS.

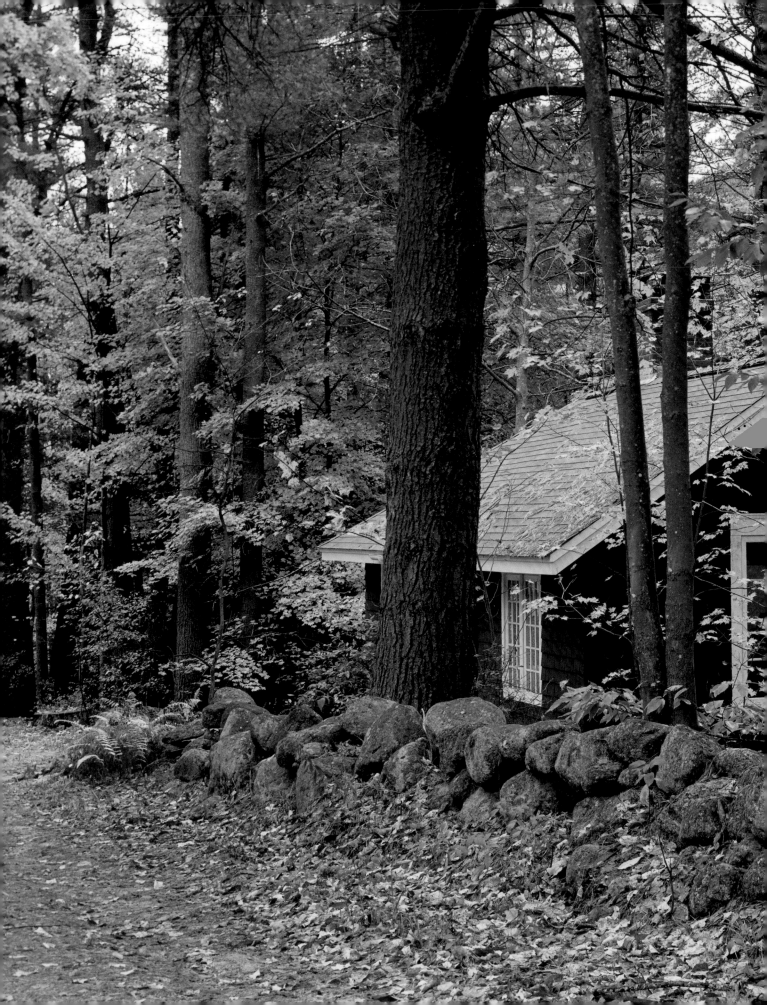

He was reluctant at first, but he was won over by her suggestion that the pageant feature the compositions of MacDowell. Baker considered the challenges of creating a pageant that used MacDowell's music to tell the town's history to be "perhaps the most delightful dramatic task I have ever faced." According to Baker, Peterborough was "the first place in the United States, and I think anywhere, to produce a pageant primarily musical."[18] The 1910 Peterborough Pageant occurred at the forefront of the burgeoning historical pageantry movement that swept America in the early twentieth century. It was a landmark in the annals of American pageantry and the cornerstone of the future success of the Colony.

Pageantry was community theater on a grand scale. Roughly 10 percent of Peterborough's twenty-two hundred residents participated in the 1910 event in some way. Baker was astounded at their dedication, for most of them were busy during the day in the shops, mills, or on farms. Remarking on their loyalty, he wrote: "Some drove eight miles and back for rehearsals; others walked miles to each meeting; very many walked into the village from the outlying regions, to be conveyed thence to the stage by carriages specially provided. One member of the company more than once—doubtless there were others—came for an afternoon rehearsal, drove home four miles, milked and returned for an evening rehearsal."[19] The townspeople took the production so seriously that by mutual agreement the stores of Peterborough were closed during the three days of performances.

The 1910 Peterborough Pageant was a huge critical success. People came from across the country to see it. Some came all the way from Europe. On one day alone it was estimated that more than fifteen hundred people attended. The audience was eclectic. The farmer's wife and mill worker mingled with members of the musical and artistic elite, including at one performance Isabella Stewart Gardner from Boston, who had been a champion of Edward MacDowell and supported the Colony until her death. Noted theatrical manager and producer Winthrop Ames was amazed by the performance and compared it to the famous Oberammergau Passion play that he had recently seen in Europe. Others drew comparisons between Marian MacDowell and Richard Wagner's widow, Cosima, and speculated that Peterborough might become the "Bayreuth of America."[20]

In spite of its artistic and popular success, the pageant left a deficit of more than $2,000. To cover it, Marian MacDowell took to the road. Using connections that she had with MacDowell Clubs and women's clubs, she traveled around the country giving lecture recitals. She spoke fervently about the Colony and the pageant's success, and she

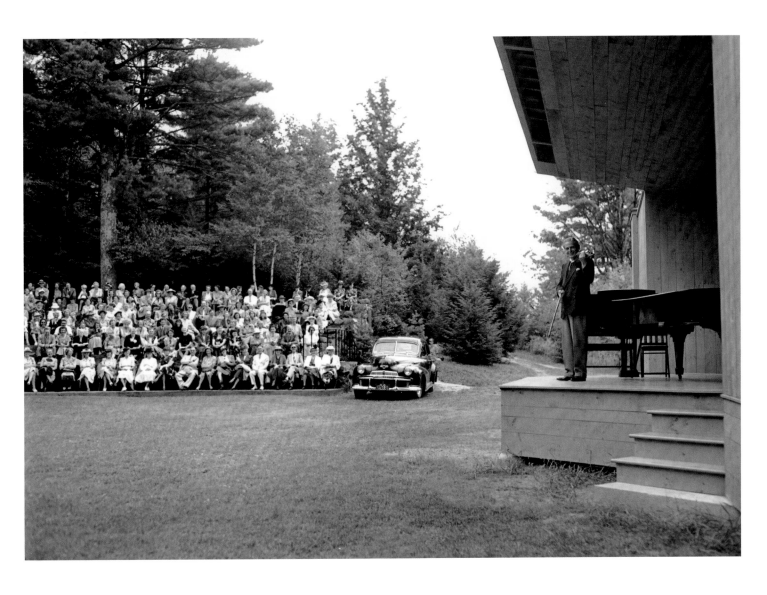

PAGEANT THEATRE, OR THE MACDOWELL AMPHITHEATRE, WAS DESIGNED IN 1910. ORIGINALLY IT HAD WOODEN BLEACHERS, BUT IN 1919 THE NATIONAL FEDERATION OF MUSIC CLUBS FUNDED EIGHT ELLIPTICAL ROWS OF STONE SEATS THAT RISE IN TIERS. THE FIRST PLAY, THE PETERBOROUGH MEMORIAL PAGEANT, WAS STAGED IN 1910 AND INCLUDED PETERBOROUGH TOWNSPEOPLE. SINCE THEN, THE MACDOWELL AMPHITHEATRE HAS HOSTED OTHER PUBLIC PERFORMANCES AND IS OCCA-SIONALLY USED BY ARTISTS-IN-RESIDENCE TO PRESENT NEW WORK.

played her husband's compositions as no one else could. This became her annual routine for almost twenty-five years. She ran the Colony from June through September, and after it closed for the winter, she went on tour, carrying news of the recent season and always performing Edward's music. Audiences were charmed by the diminutive Mrs. MacDowell, who moved about on crutches due to a bad back, which she had re-injured while caring for her dying husband. The modest sums she charged added up, but more important, she earned the support of these clubs and left numerous new ones in her wake. Many became regular contributors to the Colony.

The proceeds of Marian's 1910–11 lecture recital tour went toward the purchase of a house that was remodeled as a men's residence hall. Poet Edwin Arlington Robinson was one of the first men to work at the Colony when they were formally admitted in the summer of 1911. He did not go happily. Robinson was a friend of Baker and his pageant collaborator and Harvard colleague Herman Hagedorn. The two men convinced Robinson to give Peterborough a try. Suspicious of anything called a colony, he arrived with a fake telegram in his pocket calling him away on an imaginary emergency should he decide to leave prematurely. Before long, however, the place had worked its magic on him. "MacDowell knew what he was about," Robinson wrote to a friend that July. "One summer of it in one of the isolated studios, with an open wood fire, would undo you for life."[21]

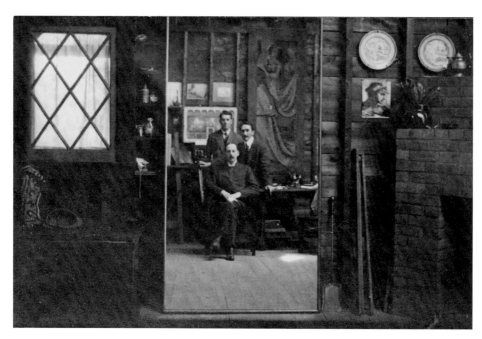

A SELF-PORTRAIT IN ADAMS STUDIO BY EDWIN ARLINGTON ROBINSON. THE POET WOULD GO ON TO WIN THREE PULITZER PRIZES.

Robinson tore up his telegram, stayed for ten weeks, and returned to the Colony every year until his death in 1935.

Robinson's struggles and disappointments shaped his belief that no one should write poetry unless he was willing to starve for it. The MacDowell Colony became a reassuring constant in his life. In time, he became the grand old man of the Colony, a stabilizing presence to whom the younger Colonists looked for advice. Known for his reticence, he did not give advice readily. When he took up his usual station at the pool table after dinner, his tall, lean frame wrapped in the smoke from his Sweet Caporals, aspiring poets were quick to pick up a pool cue in hope of conversation. Marian MacDowell turned to him often for counsel. Such was their rapport that at times she violated the cardinal Colony rule that even then forbade visiting another Colonist's studio without an invitation. Once, while showing a visitor around, she saw Robinson relaxing on his studio porch. "Let's go in," she said. "If he hasn't had a big thought by 4:30, he won't have one today." Late in her life, Marian confided, "If I had never done anything else than give Edwin Arlington Robinson a place to work for twenty years, when he was sure he would never be able to find such a place, I feel that the Colony has been worth while."[22]

Baker's influence was felt at the Colony long after the 1910 pageant. His class at Harvard known as English 47 was an attempt to make playwriting a respectable discipline

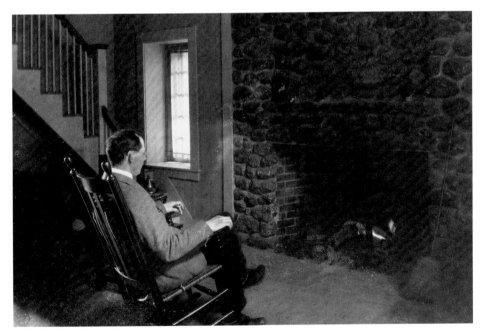

ROBINSON BY THE FIRE IN VELTIN STUDIO

in academia, a struggle not unlike that waged by MacDowell at Columbia. The MacDowell Club of New York created a MacDowell Fellowship in dramatic composition at Harvard—a playwriting fellowship. Frederick Ballard was the first candidate for a master of arts degree to submit original plays as his qualifying achievement. Baker called it Harvard's "first advanced degree for creative writing." Ballard was the first in a long line of playwrights from Baker's English 47 class to work at the Colony. Others included Esther Willard Bates, Agnes L. Crimmins, Elizabeth McFadden, and Edwin Carty Ranck.[23]

The early Colony was a model of economy under the management of Mrs. MacDowell. Edward's interest in farming had inspired him to convert some of their fields to arable land. Marian continued this work, and with the addition of some chickens and cows she had a fully functional farm in operation that produced food for her summer residents and hay that was sold for a profit at summer's end. Marian was ahead of her time in offering naming opportunities to donors of studios and took pride in the fact that all of them were privately funded, an arrangement that has endured throughout the Colony's history. By 1912, there were five new studios and two more under construction. Close to two miles of roads were needed to connect the growing number of buildings— and Marian was about to embark on a real estate deal that would more than double the Colony's acreage.

The old Tenney farm consisted of almost two hundred acres of prime forestland that bordered the Colony to the north and east. When it was put on the market in 1912, rumor was circulating that a developer wanted to turn it into a summer camp. Marian saw no alternative. She had to buy the property herself. When she brought the matter to her board, they flatly rejected the idea, refusing to take on any additional mortgage. She was forced to confess that she had already put $500 down. She begged one board member, a real estate agent, to come out and look at the property. If after seeing it he felt it was a foolish purchase, she promised she would abide by his decision. Marian knew the timber on the property alone was worth more than the asking price. After inspection of the land, during which her board member was as "cross as it was possible for a man to be," he left with these parting words: "Don't you dare sell an inch of that land!" The acquisition of the Tenney farm was a milestone in the Colony's history. It enabled future expansion and brought with it a large old barn that became the hub of Colony life when it was remodeled and dedicated as Colony Hall in 1916.[24]

Construction on the new property commenced almost immediately. In 1913, Colonist F. Tolles Chamberlin designed Adams Studio, as well as Colony Hall and the Men's

ADAMS STUDIO WAS BUILT BETWEEN 1913 AND 1915. DESIGNED BY F. TOLLES CHAMBERLIN, A COLONY FELLOW AND DISTINGUISHED PAINTER, ITS FAÇADE IS ORNAMENTED WITH A FLORAL PAINTING, LIKELY DONE BY CHAMBERLIN HIMSELF.

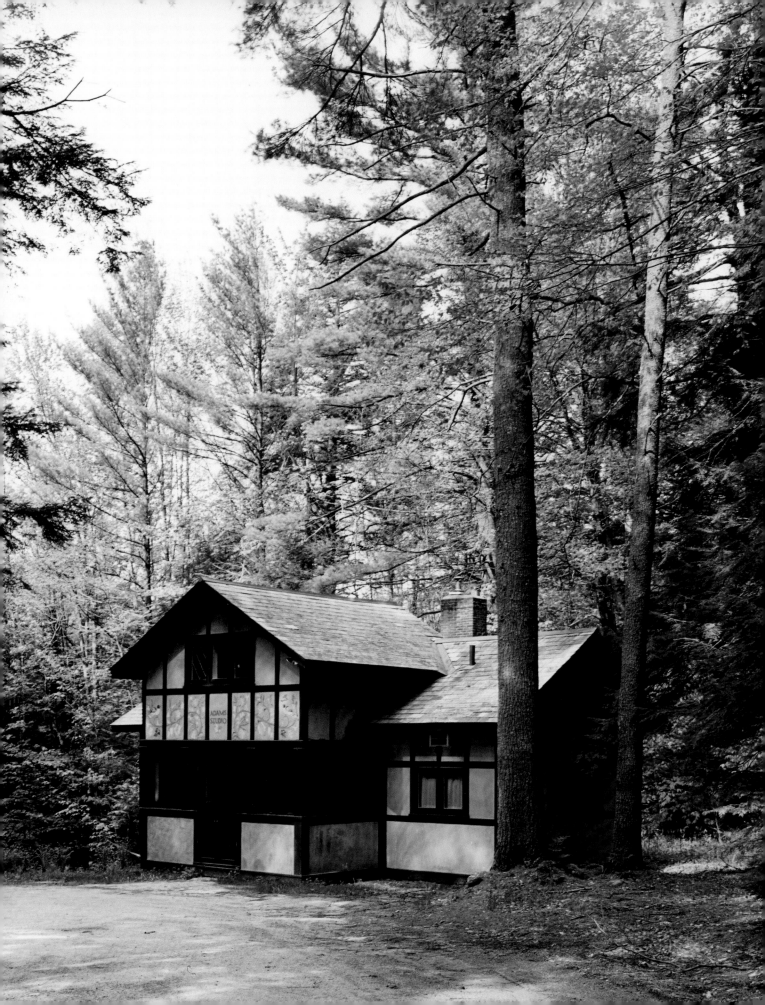

Lodge, a new residence that was nicknamed "Mrs. MacDowell's Folly" because it took eleven years to complete.[25] Both a painter and an architect, Chamberlin had recently returned from a four-year stay at the American Academy in Rome and he noted "the existence of more than a sentimental tie between the Academy and the MacDowell Association."[26] When he returned to the Colony in 1914, he renewed his acquaintance with Katharine Beecher Stetson, a painter he had first met in Rome who was also in residence that season. The couple married in 1918.

The 1910 pageant was the first in a series of music festivals that were held each August through 1914. The festivals drew many American composers to Peterborough to direct the first performances of their works. In 1914, a particularly ambitious year, compositions by Gena Branscombe, Henry F. Gilbert, Edward Burlingame Hill, and Deems Taylor were among the nine new works that were premiered. Like the 1910 pageant, the festivals were well attended, received critical acclaim—and lost large sums of money. When an alumni group of Colonists organized in 1911 to "promote the general welfare of the Colony, preserve its traditions, and perpetuate the ideals upon which it was founded," these large-scale summer productions became the subject of heated debate.[27] The so-called allied members of the Edward MacDowell Memorial Association served as

WRITER PARKER FILLMORE

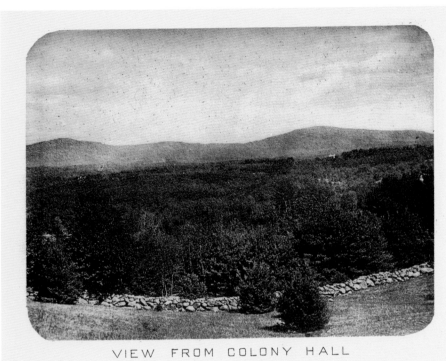

VIEW FROM COLONY HALL

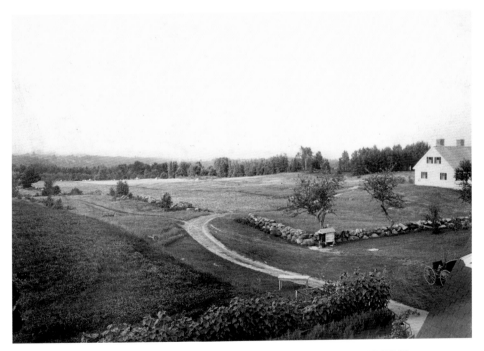

AN EARLY VIEW OF THE COLONY'S FARMLAND INCLUDES PAN'S COTTAGE, ONE OF THREE
RESIDENCE HALLS.

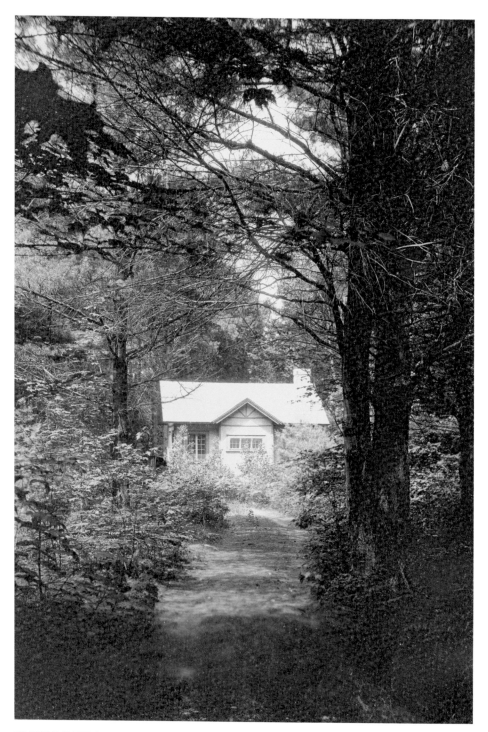

CHAPMAN IS THE FARTHEST STUDIO FROM THE MAIN BUILDING. IT WAS GIVEN TO THE COLONY IN MEMORY OF GEORGE CHAPMAN, A COMPOSER, IN 1918. COMPOSERS AARON COPLAND AND BRIGHT SHENG, AS WELL AS WRITER COLSON WHITEHEAD, ALL WORKED IN CHAPMAN.

a valuable sounding board for evolving policy, and some of them argued that the festivals were disruptive. The preparations, the rehearsals, and the performances themselves disturbed the quiet rhythm of the Colony and seemed increasingly at odds with its purpose. Wartime conditions brought the festivals to an end.

In the summer of 1919, the National Federation of Music Clubs held its biennial meeting in Peterborough at Marian's invitation. It was a gesture of thanks on her part, intended to show the clubwomen what their past support had accomplished. The town could barely hold the more than five hundred delegates in attendance; some of them slept in large tents that were set up on the grounds of the Colony and the golf course to handle the overflow. The highlight of the meeting was a reprise of the 1910 pageant, a fitting culmination to the pageants and festivals that brought MacDowell into America's consciousness.

1920–29

The Colony began to thrive in the 1920s. By 1922, its seventeen studios could accommodate roughly fifty Colonists per year; they were chosen by an admissions committee from more than three hundred applicants each season. Colony life had settled into a well-established routine. Women were now housed in The Eaves, a converted farmhouse acquired in the Tenney farm deal, and in Pan's Cottage, an annex that was built in 1919

ABOVE: A VINTAGE POSTCARD OF THE EAVES, A RESIDENCE HALL. OVERLEAF: THE EAVES TODAY

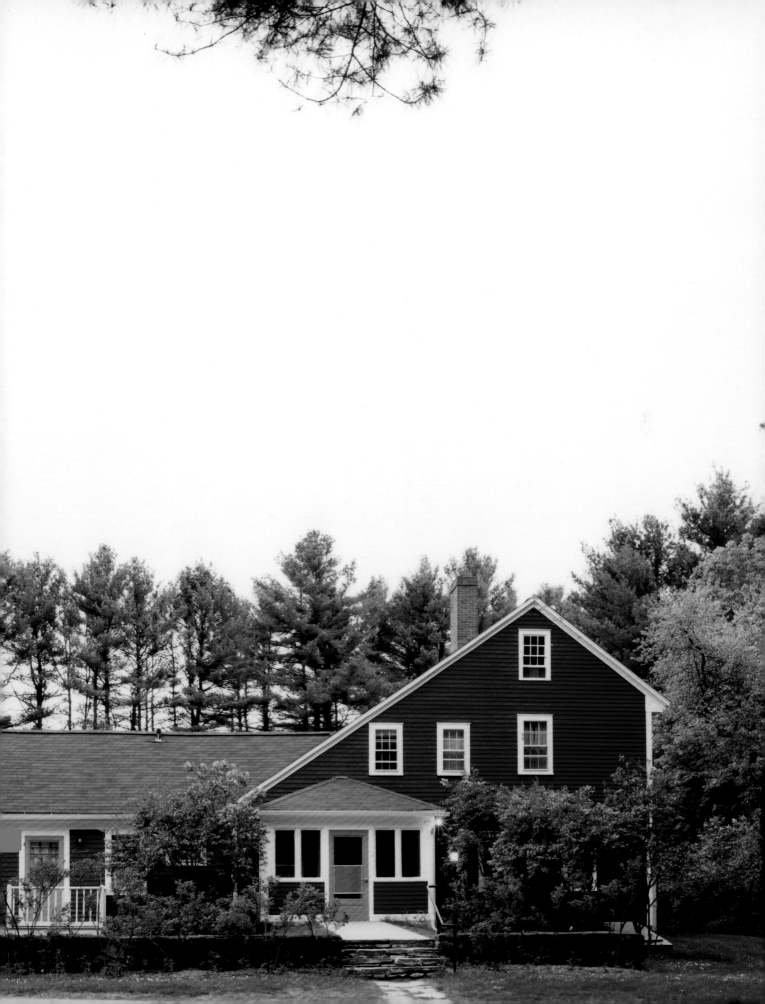

with donations from Sigma Alpha Iota, the international women's music fraternity. The Men's Lodge was finally completed in 1924. Breakfast and dinner were taken communally in Colony Hall, now the social center of the Colony. Lunch baskets were discreetly delivered to studios in a ritual that dated back to the days when Marian had taken one to Edward while he was composing in his log cabin.

Many who came to work at the Colony during these years became distinguished names in American arts and letters. Brothers William and Stephen Benet, Willa Cather, Aaron Copland, DuBose and Dorothy Heyward, Thornton Wilder, and Elinor Wylie counted among them. Colonists' works were receiving accolades. Three of the best books of 1927 were written at the Colony: Robinson's *Tristram*, which won the second of three Pulitzer Prizes he received in his lifetime; Wilder's *The Bridge of San Luis Rey*, another Pulitzer Prize winner; and Cather's *Death Comes for the Archbishop*. Honor also came to Mrs. MacDowell when she was named the winner of *Pictorial Review*'s $5,000 Annual Achievement Award for 1923, a prize given to "the American woman who makes the most valuable contribution to American life during the year."[28] Marian called these the golden years.

Dorothy Kuhns was a playwright from Baker's English 47 class. She met poet DuBose Heyward at the Colony in 1922. They were allegedly the first couple to admit getting engaged in the sheep pasture.[29] Mrs. MacDowell reportedly frowned on Colony romances. She decreed that Colonists were not to return to their studios after dinner, a rule that was second only to the prohibition on uninvited guests in the artists' studios. She insisted it was for reasons of safety. Studios had no electricity and the threat of fire was a constant worry. At the end of each day, Mrs. MacDowell rode through the Colony to check that each studio was secure and safe, a habit that some regarded as spying and considered a vain attempt to thwart budding liaisons. Relationships were made and broken at the Colony nonetheless. The many weddings that were held at Hillcrest suggest that Mrs. MacDowell was not as draconian as she seemed. She gave her blessing to DuBose and Dorothy, and when their daughter Jennifer was born Marian was named godmother, a role she would play to many Colony children.

Mrs. MacDowell was always aware of the public face of the Colony, for the public was the base of her support. She did not hesitate to ask Colonists to leave if their behavior while in residence reflected badly on the Colony. Her Victorian social mores, however, did not prevent some colorful characters from gaining admittance, as the only criterion for acceptance was talent. When he was at the Colony in 1928, Mark Blitzstein gained notoriety for his afternoon ritual of bathing, covering himself with talcum powder, and

MRS. MACDOWELL BECAME THE FOREMOST INTERPRETER OF HER HUSBAND'S MUSIC. AT THE AGE OF FIFTY, SHE RESUMED HER CAREER AS A PIANIST AND FOR THE NEXT TWENTY-FIVE YEARS TRAVELED THROUGHOUT THE UNITED STATES AND CANADA, GIVING BETWEEN FOUR HUNDRED AND FIVE HUNDRED CONCERTS TO RAISE MONEY FOR THE COLONY.

ALEXANDER STUDIO, A STONE STRUCTURE
COMPLETED IN 1922 AND NAMED AFTER
JOHN W. ALEXANDER, A PROMINENT
PORTRAIT PAINTER AND ONE-TIME DIREC-
TOR OF THE COLONY, IS A REPLICA OF A
SEVENTEENTH-CENTURY SWISS CHAPEL.

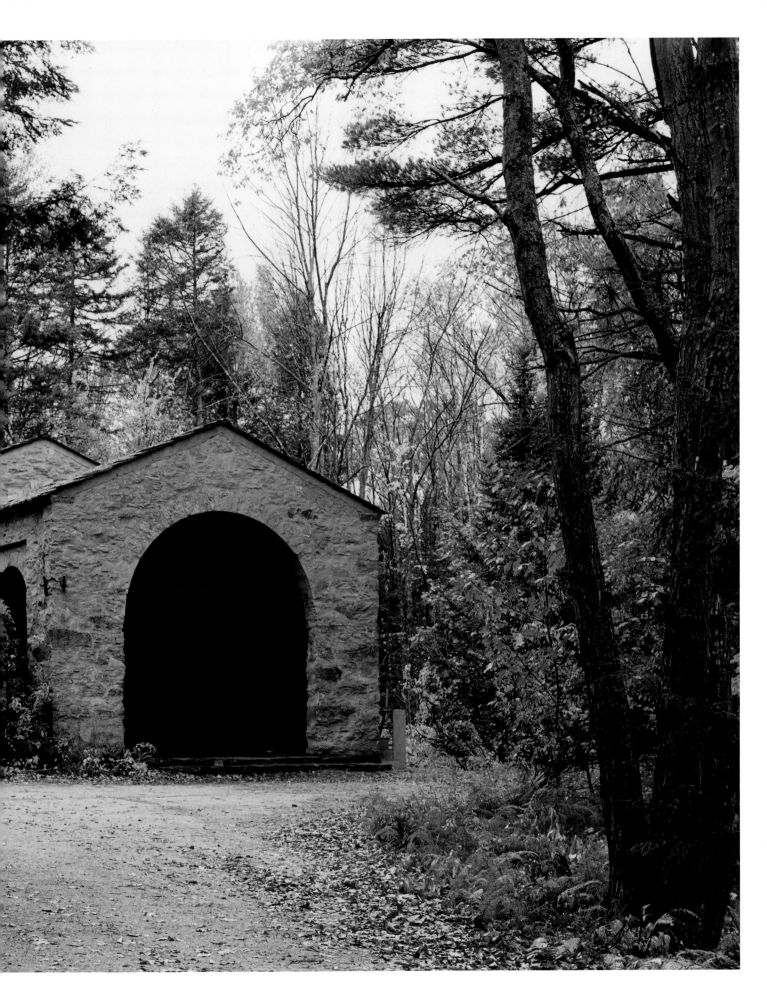

lying naked on his bed in the men's dormitory with the door wide open. Poet Maxwell Bodenheim was once arrested for vagrancy. During one of several residencies in the early 1920s, a Colony staff member assured him that "they were happy to accommodate many kinds of people at the colony—the talented gentlefolk, and his kind too." Known for his self-destructive Bohemian lifestyle, he was later murdered in a seedy neighborhood in New York. And the beautiful Elinor Wylie was as vain as she was glorious. A renowned femme fatale, she had left her husband and small child in 1910 to run off with a married man. William Benet became husband number three in 1923. Composer Mary Howe found her so scandalous that she refused to be introduced to her at a Colony gathering. Howe later regretted this decision, became an admirer of Wylie's poetry, and set several of her poems to music.[30]

The Heywards returned to Peterborough in 1924 with their new baby daughter in tow. DuBose was working on a novel, doubtful that his poetry could support his new family. He shared his work with a few Colonists in Barnard Studio. "We all agreed that the story of the little crippled Negro was atrocious," Chard Powers Smith recalled, "and that he and Dorothy and Jennifer would be wiser to starve for poetry."[31] The novel was called *Porgy*, and DuBose finished it despite their criticisms. It was Dorothy Heyward who saw the dramatic possibilities in the story and turned it into a play before George Gershwin immortalized it in 1935 as *Porgy and Bess*. In 2000, Stephen Sondheim was moved to pronounce DuBose Heyward's lyrics to *Porgy and Bess* "the best lyrics in the musical theater."[32]

The Colony was unique in its premise that artists working in different fields could influence one another. In the summer of 1926, Cather expressed interest in seeing Grant Reynard's paintings when she learned that he was a fellow Nebraskan. Over tea in his studio, she told him how her desire to do "fine" writing brought her some acclaim, but that "it wasn't until I suddenly thought of my youth in a great wave of nostalgia for the early Nebraska days that my work took on a new dimension." She advised him, "the crux of this whole art experience is in that word 'desire'—an urgent need to *recreate* a vital life experience which wells up within and must find release in the writing." Reynard's meeting with Cather left him stunned. He recognized that he was "mixed up in arty ambitions" and rethought his whole approach to his work.[33] Cather never returned to the Colony, but her presence was keenly felt the season she was there.

Despite the artistic prosperity of the 1920s, financial security was elusive. A taxi cab accident in December 1922 and a more serious illness in 1927 kept Mrs. MacDowell from fulfilling numerous engagements. The loss of her income was sorely felt, and developing an endowment fund became a top priority. Had it not been for Mrs. MacDowell's

loyal clubwomen, the Colony might well have become insolvent. The New Hampshire Federation of Women's Clubs wanted to help but preferred a tangible goal rather than making a contribution to the endowment fund. So Marian half-jokingly suggested they pay off the mortgage. To her surprise, they agreed, and by the end of 1930, after a blitz of fundraising efforts around the state to which Marian pledged her assistance, the New Hampshire women's clubs had wiped out the $35,000 mortgage on the property. No less stellar were the efforts of the National Federation of Music Clubs, which launched a MacDowell Crusade in 1926 under the leadership of Jessie Stillman Kelley. It captured the country's imagination and turned into a major fundraising drive. Music clubs around the country held concerts, bake sales, and teas. Radio stations and the National Moving Picture Distributors provided advertising free of charge. The week of March 7–14, 1927, was proclaimed MacDowell Week. The federation called it the most popular campaign ever undertaken in the name of music. The drive culminated at the 1927 biennial meeting in Chicago, where Mrs. MacDowell was presented with a check for $10,000 and pledges of more to come.[34]

Conductor, composer, and pianist Ernest Schelling became president of the Edward MacDowell Association in January 1929.[35] He was the first professional performing artist to serve in this role, and his connections in the musical world brought many new friends and supporters into the MacDowell fold. In December 1929, he organized a benefit concert at Carnegie Hall billed as a "Musician's Gambol." It featured twenty-four celebrities who delighted the "brilliant audience" of arts patrons with their musical antics. Schelling and pianist Harold Bauer played on lawn mowers while soprano Lucrezia Bori blew on a tin whistle, all under the direction of John Philip Sousa. There were serious numbers, too. The highlight of the evening was Mrs. Edward MacDowell's performance of the *andante* movement from her husband's *Keltic Sonata*. As she took to the stage and turned to acknowledge the applause, the audience rose to its feet.[36]

1930–39

Virtually every major orchestra in the United States played Edward MacDowell's music in December 1932 to commemorate the silver anniversary of the Colony. The effort was organized by Schelling and included such musical stars as Leopold Stokowski and the Philadelphia Orchestra, Frederick Stock and the Chicago Symphony Orchestra, and Serge Koussevitzky and the Boston Symphony Orchestra.[37] The National Federation of Music Clubs also observed the occasion by urging all affiliated clubs to present MacDowell programs. Good will was abundant, but it could not erase the economic realities of the time.

The Colony faced added uncertainty during the Great Depression due to the loss of income from Mrs. MacDowell's lecture recitals. Her health made it impossible for her to resume her grueling touring schedule. Studios were in need of repair. The dairy and poultry farm that had once enabled the Colony to be self-sustaining were now too costly to maintain. The endowment fund could not keep pace with expenses. Many Colonists now found even the nominal room and board unaffordable. Marian expressed concern to her longtime friend Hamlin Garland after the anniversary season in 1932: "We had a fine Colony — but alas, more brains than dollars — and it has been a hard pull for a good many of its members to pay even the $12-weekly board."[38] It was left to others to take up Mrs. MacDowell's campaign. The Colony's allied members — those who could speak from experience about what the Colony had done for them — rose to the challenge.

Composer Amy Beach was a close friend of Marian MacDowell and a regular at the Colony from 1921 until her death in 1944. She mentored many of the younger women composers who came to Peterborough, encouraging them to call her "Aunt Amy." When the Society for American Women Composers was formed in 1925, half of its founding members were MacDowell Colonists.[39] Beach promoted the Colony whenever she had the chance. In 1932, at the annual meeting of the Music Teachers' National Association, she gave an impassioned speech on the importance of the Colony that rivaled the rhetoric of the best politician: "It rests with us all, who appreciate the value of that to which we have devoted our lives, to see that this flag of our country's art-life never touches the ground!"[40] As a member of the National League of American Pen Women, she reminisced about the Colony at the White House when Eleanor Roosevelt, also a Pen Woman, hosted a league program there on April 17, 1936. Beach composed under her married name, Mrs. H. H. A. Beach. It was at the Colony that she earned the nickname Mrs. "Ha-Ha" Beach, which was reportedly used with varying degrees of endearment and derision as her music gradually fell out of fashion.[41]

Thornton Wilder also stumped for the Colony in the 1930s. His considerable devotion to Mrs. MacDowell is evident in this letter he wrote from Salt Lake City, Utah, where he was to address the local MacDowell Club:

> Leftenant Wilder sends his duty, obedience and affection to Commander-in-chief
> MacDowell and says that he has arranged to see the MacDowellian Garrison
> stationed at Salt Lake City. Leftenant Wilder intends to give them so patriotic a
> discourse on the Colony that they will become dizzy with admiration and loyalty to

At other times, Wilder's obligation to the Colony weighed heavily on him. During a major endowment drive in 1937, he spoke frequently on its behalf. "Ladies 'open their houses' for these things and we colonists make veiled pleas for money," he confided to his close friend Gertrude Stein. "As I 'use' the Colony and very gladly, it's only right I do this, but it's a soiling saddening business."[42]

Wilder turned to playwriting in the 1930s, and in 1937 he put the fictional town of Grover's Corners, New Hampshire, on America's map with *Our Town*. He remained coy about identifying Grover's Corners with any real place, preferring that people relate it to their own town instead.[43] But the belief that *Our Town* was based on Peterborough was inescapable.

Among the newcomers to the Colony in the 1930s were composer Charles Wakefield Cadman and writer William Maxwell. Cadman was so enthusiastic after his first residency in 1934 that he went back to his home in California and organized two Colony benefits in Los Angeles the following year. Maxwell, however, was one of the few who could not abide the strictures of Mrs. MacDowell. "The MacDowell Colony was a beautiful place ruined by an accumulation of rules which it was virtually impossible not to break," he remembered years later. "Without meaning to I broke all of them....Don't do this, don't do that, thank God I can't remember what they were." In spite of this, Maxwell had a productive time in Peterborough and worked through a long-standing writer's block that plagued his work on *They Came Like Swallows*, the book that would establish him as a major literary figure.[44]

David Diamond's first residency at the Colony in the summer of 1935 left him with a vivid memory that he related in 1991, when he returned to Peterborough to receive the Edward MacDowell Medal. An admitted insomniac, he went to his studio shortly after dawn one morning and as he approached through the knee-deep fog he heard the sound of the piano. He found a young woman seated at the keyboard. When he asked her who she was and what she was doing, she stood and walked to the window.

> She looked back at me, and what I remember vividly even now was how lovely she
> was....Her straight eyebrows gave her loveliness a quizzical air as she looked at me
> and said in a soft, clearly articulated almost studied way: "May I stay here?" "Who
> are you?" I asked her, not at all disturbed by her presence....She turned around

VELTIN STUDIO IS ONE OF THE MOST FAMOUS STUDIOS AT MACDOWELL.
HERE THORNTON WILDER WORKED ON *OUR TOWN*, WHICH IS THOUGHT TO
BE BASED ON LIFE IN PETERBOROUGH.

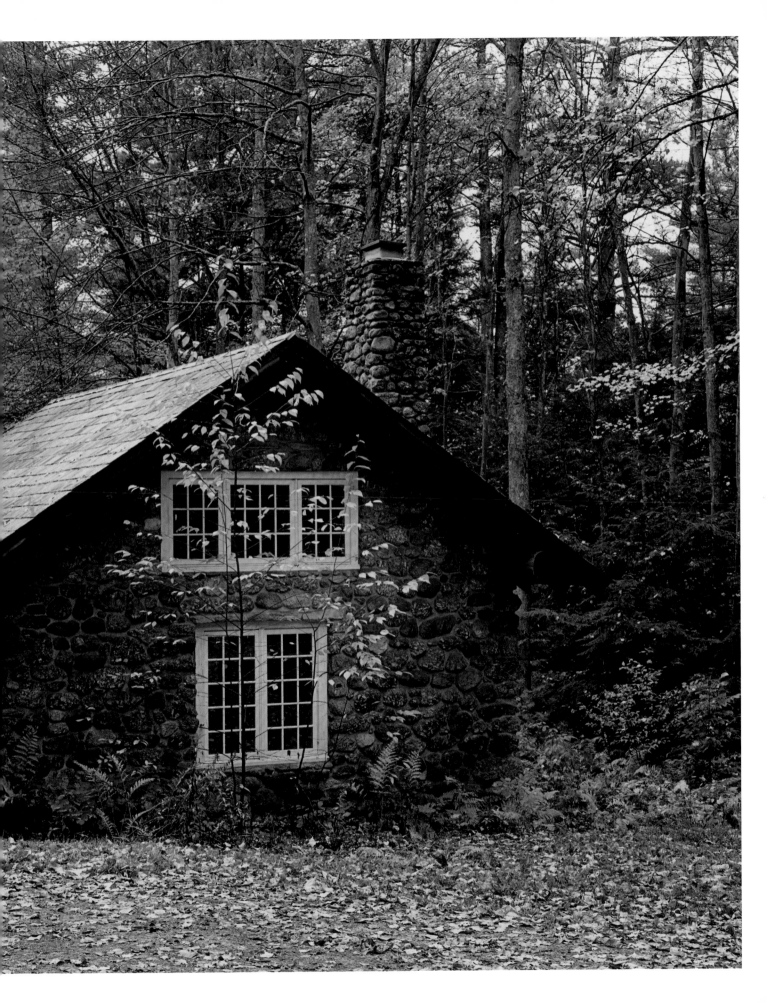

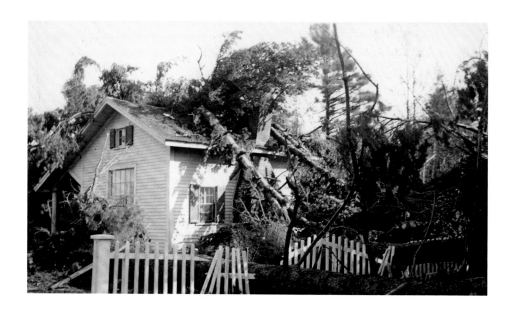

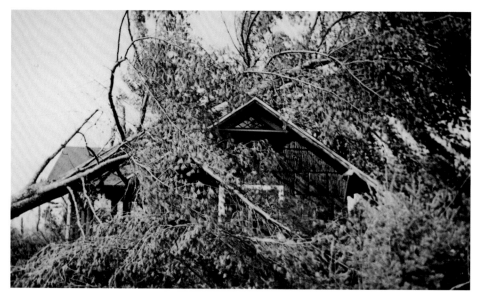

A HURRICANE CUT DIRECTLY ACROSS PETERBOROUGH ON SEPTEMBER 23, 1938. NONE OF MACDOWELL'S MAJOR BUILDINGS WAS DESTROYED, ALTHOUGH THE ROOFS OF WOOD AND MONDAY MUSIC STUDIO (BOTH PICTURED) WERE CRUSHED. THE STORM FELLED 250 ACRES OF TREES AND BLEW AWAY ONE SMALL STUDIO. THE COLONY WAS FORCED TO CLOSE IN 1939 FOR A YEAR, THE TIME IT TOOK TO CLEAR THE DEBRIS. SEVERAL MACDOWELL FELLOWS, INCLUDING AARON COPLAND AND THORNTON WILDER, BANDED TOGETHER TO ASSIST MRS. MACDOWELL IN REOPENING.

quickly, looked down at the music I was orchestrating—a setting of Ezra Pound's
Night Litany—turned slowly back to me, and the lovely profile I remember made me
smile. And then she was gone. Vanished.

News of Diamond's apparition traveled, and soon he was summoned to Hillcrest to tell his story to Mrs. MacDowell. Wilder was present and identified the stranger as Elinor Wylie. Wilder told of Wylie's unhappiness with her studio one summer and how she frequently wandered into other Colonists' studios. She had died of a stroke at the age of forty-three—in 1928.[45]

Robinson succumbed to cancer in the spring of 1935. On September 17, 1938, nearly two hundred friends gathered at Veltin Studio to celebrate the life of the poet who had been a fixture at the Colony for almost twenty-five years. Four days later, a hurricane slammed into Long Island and tore across New England, leaving devastation in its path. There was no warning; forecasters believed the storm would turn out to sea. Sustained peak winds of 121 miles per hour ripped through the Northeast—the recorded peak gust was 186 miles per hour at the Blue Hill Observatory in eastern Massachusetts. An estimated seven hundred people died, close to nine thousand homes and buildings were destroyed, sixty-three thousand people were left homeless, and an unfathomable two billion trees were lost. Due to Mrs. MacDowell's insistence on durable, high-quality construction from the Colony's beginning, its buildings sustained only minor damage. But the forests were hit hard. Downed trees and flooding made roads impassable. Copland was at the Colony during the storm and remembered the area looking like a war-torn swamp afterwards. It took two men with axes more than two hours to cut through the felled trees to get to his studio and rescue his things, including the score for *The Second Hurricane*.[46]

The cost of the hurricane cleanup was estimated at $40,000. Without skipping a beat, Mrs. MacDowell sprang into action, assembled a team of lumbermen, erected a sawmill on the property, and began the arduous clearing of the downed trees. The storm did what no deficit had yet accomplished. In 1939, the Colony was forced to close for the first time in its history.

1940–49

When the Colony reopened in 1940, the hurricane cleanup was still under way. Any semblance of a return to normal was upset when the United States entered the war the following year. The war years brought many changes to the Colony. In 1942, the MacDowell

Club of New York ceased operation, bringing to an end an institution that had helped shape the cultural life of that city for almost four decades, and served as a mainstay of the Colony. In 1943, Emil and Mary Tonieri, who had been managers of Colony Hall from "the day it ceased to be the old Tenney barn," retired after twenty-seven years of service. Some questioned the wisdom of maintaining an arts colony during wartime, but supporters countered, "the artist now, as never before, is the hope of the world of tomorrow."[47] The Colony remained open, but Mrs. MacDowell warned Colonists of possible food shortages and reminded them to bring their ration books.

Many Colonists used their talents in service to the war effort, some in the line of military duty. While on assignment for the U.S. Army's Air Service Command at Wright Patterson Field in Ohio, muralist Stuyvesant Van Veen covered nearly three thousand feet of wall space with wartime scenes. Lewis Daniel was commissioned by the Office of War Information to paint *The Siege of Stalingrad*, which was hung in the Russian embassy in Washington, D.C., and Grant Reynard created on commission a war bond poster. Gail Kubik was music consultant to the film bureau of the Office of War Information from 1942 to 1943 and subsequently joined the First Motion Picture Unit of the U.S. Army Air Corps. He remained there until 1946, gaining a reputation as one of the foremost composers for wartime documentaries. He composed music for the films *Thunderbolt* and *Memphis Belle*—the latter, described as a wartime episode for narrator and orchestra, was broadcast extensively to occupied countries. New Colonists came to Peterborough from war-torn Europe such as poets Yvan Goll, a German-born Jew, and his wife, Claire, grateful for a refuge for their creative work. There had been foreign artists at the Colony before, but this sudden influx brought international attention. An article in the *London Times* in the spring of 1945 concluded, "the only place in the world where ideal conditions for the creative worker are considered is the MacDowell Colony, Peterborough, U.S.A."[48]

Lukas Foss won critical acclaim at the age of twenty-two, in 1944, when his cantata *The Prairie* won the New York Music Critics' Circle Award. The following year, he became the youngest composer to receive a Guggenheim Fellowship. Foss had worked on *The Prairie* at MacDowell at the start of a productive series of residencies that ran from 1943 to 1950. Like many others, he found the Colony an oasis from the disruption caused by the war. "My draft board deferred me till October," he wrote to Koussevitzky in 1947. "I convinced them that we could not win the war unless I finish my cantata and they quite agreed....So here I am at the MacDowell Colony, working hard."[49] A protégé of Koussevitzky, Foss was one of several Colony composers who worked with the conductor at the Berkshire Music Center, which he founded at Tanglewood in 1940.

Koussevitzky was synonymous with the Boston Symphony Orchestra during his tenure as music director from 1924 to 1949. He was an advocate of contemporary music and a particular champion of American composers.[50] He may have heard about the Colony as early as 1925; Copland had finished his *Music for the Theatre* there shortly before its premiere by the Boston Symphony Orchestra that fall. In 1948, Koussevitzky called on Mrs. MacDowell in Peterborough. Olga Koussevitzky reminisced about their visit in a letter to Mrs. MacDowell written in 1953, two years after her husband's death:

> Serge Koussevitzky remembered the visit with you at the Colony as one of the happiest and uplifting experiences. He immediately sensed a spiritual affinity between the intense creative atmosphere of the MacDowell Colony and the heart-beat of "Tanglewood" with its eager, talented youth. And when on the threshold of "Hillcrest" he turned back and said to you: "I don't believe you realize just how important this is. The music written here by resident composers is feeding our orchestras," —he spoke from his heart.[51]

Like Mrs. MacDowell, Olga Koussevitzky was a remarkable woman devoted to continuing the work of her husband. The two women remained friends for life.

The Colony weathered the war, but in the late 1940s it faced a battle of a different sort. Early in 1946, Mrs. MacDowell became seriously ill while wintering in Los Angeles. Her doctors held no hope for her recovery. Faced with the Colony opening in June, the board was forced to take action. In May, they hired Mr. and Mrs. Clarence Brodeur as new managers, a move that essentially divested Mrs. MacDowell of her power.[52] Reports of her impending demise, however, were premature. She recovered and made clear her intent to return to her position at the Colony the following summer. The board thought this inadvisable; Mrs. MacDowell was elderly and in precarious health. It was time for new management. Under pressure, she resigned in November 1946, just before her eighty-ninth birthday. A number of allied members and Colony supporters felt that Mrs. MacDowell had been treated badly. She retained a life interest in Hillcrest and her presence at the Colony under the new management in 1947 was awkward at best. As founder and manager she had enjoyed considerable license in overseeing the day-to-day operations. Without her at the helm the lines of authority were less clearly drawn. Moreover,

OVERLEAF: BANKS (LEFT) AND HEYWARD STUDIO (RIGHT) ARE BOTH HOUSED IN THE LODGE (INITIALLY KNOWN AS THE MEN'S LODGE), ONE OF THREE BUILDINGS THAT PROVIDE ACCOMMODATIONS FOR COLONISTS. WORLD WAR I INTERRUPTED CONSTRUCTION OF THE LODGE, WHICH TOOK ELEVEN YEARS. HEYWARD STUDIO IS NAMED AFTER DUBOSE AND DOROTHY HEYWARD, WHOSE COLLABORATION AT MACDOWELL PRODUCED THE PLAY THAT BECAME THE OPERA *PORGY AND BESS*.

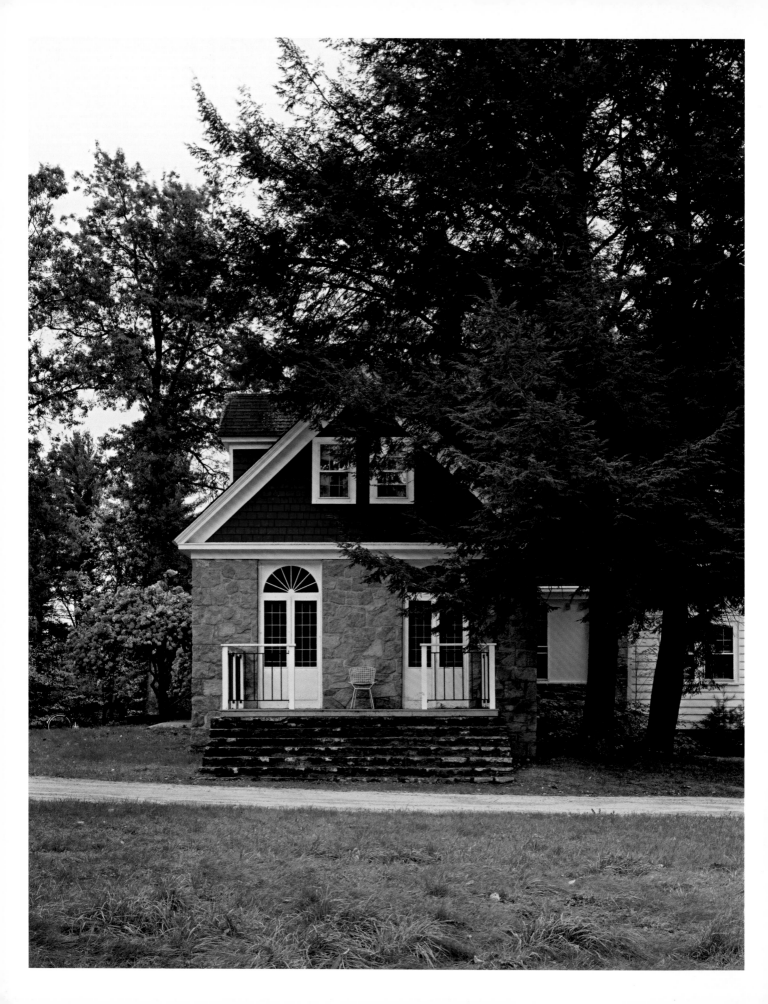

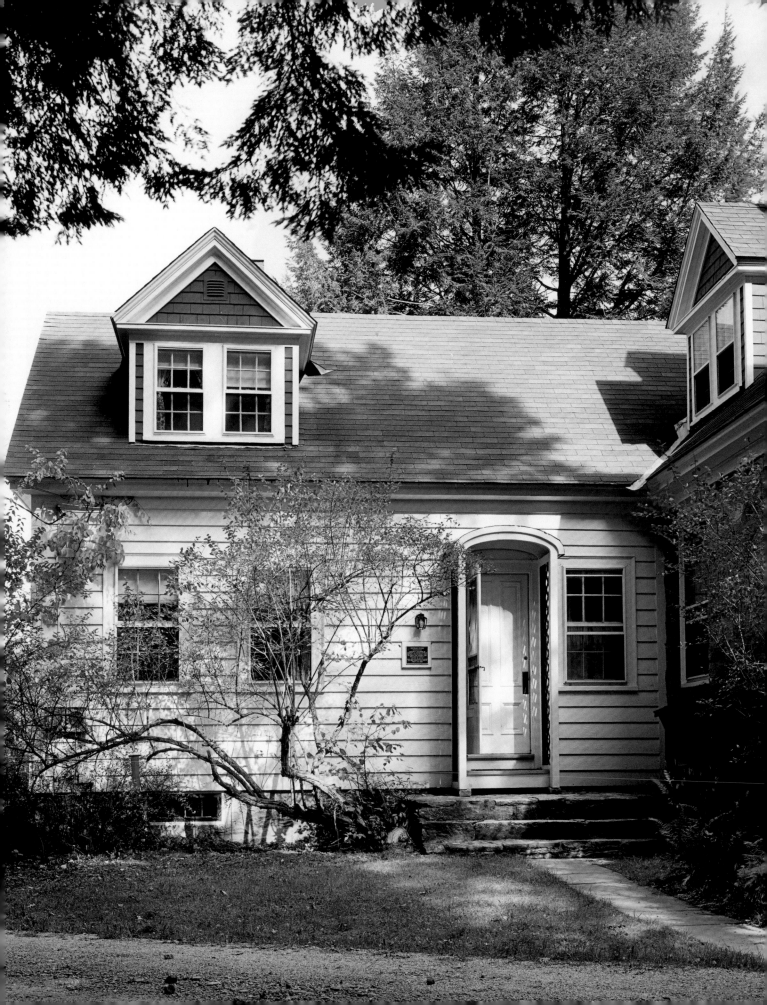

the Brodeurs, unlike Mrs. MacDowell, had to be paid. They soon realized it was a full-time job at a part-time salary. The Brodeurs resigned in January 1948.

Although Marian was no longer manager, she continued her voluminous correspondence with friends of the Colony, and she still delighted in meeting Colonists and showing guests around when she was in Peterborough. Writer Evelyn Eaton remembered a particularly hot summer in the late 1940s when she doffed her clothes to work naked in the privacy of her studio. Suddenly she heard a car drive up. It was Mrs. MacDowell giving a tour to a group of her clubwomen. With no time to dress, Eaton struck a pose with her back to the door next to an easel that had been left by a previous tenant, hoping to create the impression of an unseen artist at work. She heard an old lady gasp, "Oh, I didn't know they worked from *models*." And then they quickly left. Mrs. MacDowell came to Colony Hall that night and discreetly asked how many painters were in residence. They were all enumerated for her, "but she still looked puzzled, her eyes straying vaguely over us."[53]

During one of composer Irwin Bazelon's early residencies, he was assigned to a studio within earshot of Hillcrest. One afternoon Mrs. MacDowell knocked on his door. Her opening line stayed with him years later: "Sire, if Edward could hear the sounds coming from your piano, he would turn over in his grave." Bazelon found her "charming, ebullient, and fun; she was interested in what I was doing, who I was, how I got to the Colony and how I liked it." Bazelon had never liked MacDowell's music. After meeting Mrs. MacDowell, he had the distinct feeling that she was the musical talent in the family.[54]

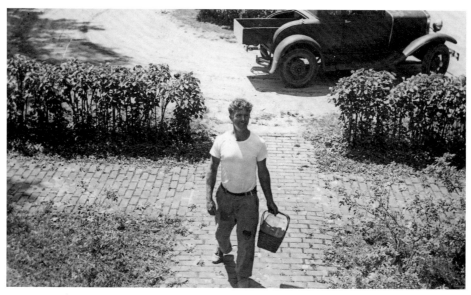

DELIVERING LUNCHES TO THE STUDIOS IN THE 1940S

Louise Fillmore assumed the duties of Colony manager in the summer of 1948. Fillmore was the Edward MacDowell Association's executive secretary in its New York office and had strong ties with the Colony. She was a former Colonist herself, and her late husband, Parker Fillmore, had been with Mrs. MacDowell almost from the Colony's beginning and had served as her chief aide. Louise Fillmore had great affection for Mrs. MacDowell. She kept her informed about business matters and frequently asked her for advice, helping heal the rift between the Colony administration and its founder. There was a faction of regulars, however, who felt that a firmer hand was needed in Peterborough. Some Colonists reported that there was too much socializing going on, and it was disturbing the work of others. Complaints began to circulate that the place was turning into a country club. In the midst of this contentious infighting, *Life* magazine arrived for a photo shoot. The issue of August 23, 1948, featured a photo essay, "*Life* goes to the MacDowell Colony," that depicted smiling Colonists happily at work in bucolic surroundings, with no hint of the conflict that was simmering below the surface.

1950–59

The investigations of the House Committee on Un-American Activities cast a pall on the work of creative artists during the early years of the cold war. Life at the Colony was not immune from its machinations. Whispered rumors of communists and F.B.I. informants fed the paranoia, even when they were nothing more than unsubstantiated gossip. As one Colonist observed in 1951, "in any group such as ours there are likely enough to be one or two people with pinko leanings."[55] Copland was the best-known Colonist whose political activities drew suspicion; he was called to testify before the committee in 1953. Mrs. MacDowell, age ninety-five and still protective of her Colonists, sent him the following words of support: "I heard vaguely that you had had some silly nonsense occur in what has been happening to so many fine people through the methods of one man. Of course, we don't want Communism, but it shouldn't be possible that every man or woman who thinks strongly about Communism should be accused of over-interest in it."[56] The MacDowell Colony, however, was no hotbed of subversive activity. The promotion of American art and artists abroad was an important component of the U.S. government's cold war strategy to counteract Soviet propaganda. The Colony became an ally when, in 1958, it was featured in *Amerika*, a magazine published in Russian by the United States Information Agency for distribution in the Soviet Union.[57]

Sometimes the outside world encroached on the Colony in less tangible ways. When Japanese writer Makoto Oda came to the Colony in 1959, he was asked one evening to

read some Japanese poems and speak on contemporary Japanese poetry. He concluded his talk by reading poems about the atomic bomb. Oda recounted this incident in his book *Nandemo Miteyaro* (I Travel Where I Please), which became a best-seller in Japan in 1960. A "strange and hushed tension" filled the room. He first read the poems in Japanese, and then added his approximation of a translation. The room remained silent. As the gathering dispersed, a poet stopped him and said he wanted to do what he could to publish those poems; he thought "the people in America should know more about this." Back at his room Oda found a composer waiting who told him about his wartime experiences. The composer had survived Okinawa and had come to despise Japan and the Japanese. He said that listening to Oda's reading, he was finally able to overcome this feeling. Later that night an artist knocked on his door to ask forgiveness for Hiroshima. "And in this way," concluded Oda, "each response took a quiet form."[58]

The Colony witnessed many innovations and milestones during the 1950s. In 1954, Colonists officially became Colony Fellows, a term that was applied retroactively to all who had been in residence there. Work began on wiring the studios for electricity in the fall of 1955, a move greeted with enthusiasm by resident artists. Artificial light allowed greater flexibility in working hours—Colony Fellows could now labor through the night if they chose. It also enabled the first year-round program in 1955, which proved immensely popular. In 1957, the year of its fiftieth anniversary, the Colony accommodated 108 applicants, the largest number in its history. When Mrs. MacDowell could no longer make the arduous cross-country trip to Peterborough, renovations were made to Hillcrest, and in 1956 it was used to house two distinguished visiting artists who came to the Colony by special invitation: the French artist Marcel Duchamp in July, and the Chilean composer Domingo Santa Cruz in August. A prominent figure such as Duchamp brought certain prestige to the Colony, but Duchamp also benefited from his time there. His visit coincided with the residency of Milton Avery, who taught him how to play pool in Colony Hall. Reportedly delighted with his new skill, Duchamp joked that he was going to have calling cards printed that read: "Marcel Duchamp—pupil of Milton Avery."[59]

In 1953, what Vladimir Ussachevsky and Otto Luening called "the first composition anywhere in the world for tape recorder and orchestra" was created in Watson Studio. Ussachevsky reported that they had "a constant fight with a fluctuating voltage" but they took it in stride, calling it "a necessary part of any pioneering effort!"[60] In the summer of 1954, Pauli Murray and James Baldwin were the first African-American writers to work at the Colony. Murray was a lawyer and civil rights activist who in 1977 would become the first black woman to be ordained an Episcopal priest. Her residency at MacDowell

offered her a break from the demands of her career to write her memoir, *Proud Shoes*. Baldwin had come on the recommendation of his friend Sol Stein, who was also there that summer and was instrumental in convincing Baldwin to publish *Notes of a Native Son*.[61]

Padraic and Mary Colum came to the United States from Ireland in 1914 and had a long association with the Colony that began in the 1920s. They were lifelong friends of James Joyce, who once said that Padraic Colum possessed "that strange thing called genius."[62] Mary Colum, known to her friends as Molly, became a distinguished literary critic. She was outspoken and known for her sharp tongue. Artist Elizabeth Sparhawk-Jones remembered her from the Colony as "one of the most interesting women I ever met in my life." Padraic "never would read his poetry before Molly," Sparhawk-Jones recalled. "She was the critic. Never! Never! She wouldn't leave him strength to toddle after her."[63]

The debate over the Colony's management that had begun when Mrs. MacDowell resigned in 1946 continued in 1950. The Colums were vocal critics of Louise Fillmore. Unbeknownst to Mary Colum, she was accused of disturbing several Colonists that season and keeping them from their work. When the Colums reapplied for admission in 1952, Mary Colum, with no chance to defend herself, was blackballed. Mrs. MacDowell heard the news and fired off an angry missive from Los Angeles. Privately, some board members admitted that the situation had been handled badly. They backpedaled. Without singling out any individual, they instituted a rule that limited the number of seasons an artist could hold residencies to ten, effectively making both of the Colums ineligible.[64]

Fillmore's death in November 1951 brought the managerial controversy to a head. The board was painfully aware that the future of the Colony depended on finding a successful replacement for Mrs. MacDowell—a feat they had yet to achieve. This time they chose George Kendall, a longtime Peterborough resident. As former director of a local boarding school he was well versed in dealing with unruly children. He proved to be a perfect fit. Some say that Kendall—judicious, impartial, and total in his dedication—saved the Colony. He managed it for the next twenty years.

Kendall showed great respect for Mrs. MacDowell, and during his first season as manager he became the driving force behind Marian MacDowell Day, a ninety-fifth-birthday celebration for the Colony's founder held on August 15, 1952. Nearly six hundred people turned out on the lawn of Hillcrest on a picture-perfect summer's day to honor Mrs. MacDowell. The crowd included many of America's most celebrated creative artists, two U.S. senators, and a former governor of New Hampshire, as well as Peterborough

neighbors and scores of loyal clubwomen. Seated in a place of honor on the veranda with Mrs. MacDowell were Padraic and Mary Colum. No one expected that when Mrs. MacDowell stood to acknowledge the audience, she would proceed to speak extemporaneously on the history of the Colony for the next twenty minutes. The crowd pressed close to hear her, many of them misty eyed. When she finished speaking, the assembled group, overcome with emotion, began to sing "Auld Lang Syne."[65]

The love and admiration shown to Mrs. MacDowell in the waning years of her life were remarkable. In 1954, she was the subject of a *Hallmark Hall of Fame* television drama, "Lady in the Wings." Starring Rosemary DeCamp as Marian, it concluded with a brief appearance by the real Mrs. MacDowell. It was the era of live television, and DeCamp remembered that after her numerous costume and make-up changes, she felt as if *she* was ninety years old next to Mrs. MacDowell, who appeared on screen looking fresh as a daisy.[66] Colony Fellows continued to dedicate their works to Marian to show their appreciation. Novelist Alec Waugh had been skeptical of an artists' colony, but on meeting Mrs. MacDowell during his first residency in 1951 he told her that he had been looking all his life for such working conditions. He wrote his novel *Islands in the Sun* at the Colony and dedicated it to her.[67] It was named a Literary Guild Selection in 1956. Composer Ernst Toch felt similar indebtedness. He honored the Colony's founder with his fourth symphony, which was not only dedicated to Mrs. MacDowell but also written *for* her. "It is an inner dedication," Toch declared. "The music is simply an expression of my gratitude to a great woman of the American cultural scene."[68] Marian MacDowell worked for The MacDowell Colony until she drew her last breath. After her death, several people received letters from her written the morning of August 23, 1956 — the day she died.

1960–69

Leonard Bernstein once said that Aaron Copland was often called the Dean of American Composers. "I guess it's supposed to mean that he's the oldest," Bernstein joked, "but he isn't the oldest — he's just the best." Copland's association with MacDowell was long and distinguished. He first came to Peterborough in 1925, fresh from his studies with Nadia Boulanger at the American School in Fontainebleau. At the Colony, he first came into contact with artists working in other disciplines, an experience that gave him new insight into art in America.[69] He returned eight times as a Colony Fellow between 1925 and 1956, and supported the Colony throughout his life, most notably by serving as president from 1962 to 1968. He was honored by the Colony in 1961, when he became the second recipient of the Edward MacDowell Medal.

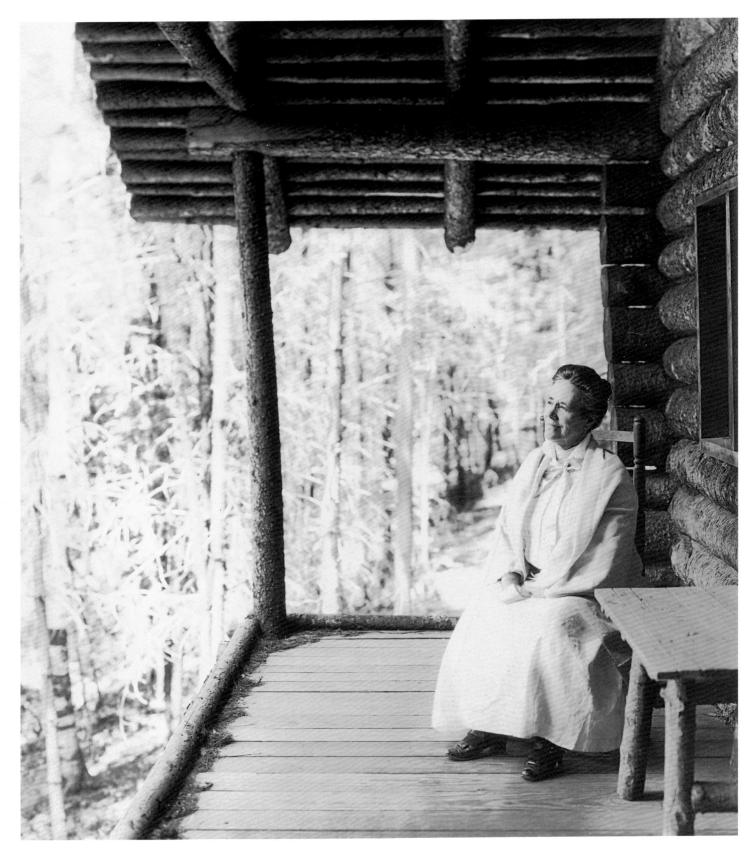

MARIAN MACDOWELL ON THE PORCH OF EDWARD'S STUDIO

The Edward MacDowell Medal was established in 1960 to commemorate the one hundredth anniversary of Edward MacDowell's birth. It is awarded annually to an American creative artist who has made an outstanding contribution to this country's cultural heritage. While residency at the Colony is not a requirement, the first two awards went to artists with close ties to it: Wilder in 1960 and Copland the following year. Recipients of the MacDowell Medal hold it in especially high regard because it is an honor bestowed by a jury of one's peers. In 1987, medal winner Bernstein explained its significance: "It's not some board of directors of a university offering you an honorary degree for reasons that may be pure, or not so pure; but it's other composers getting together and saying this is the man, or this is the woman, that we choose to honor."[70] Festivities on Medal Day, which is held in the summer, have attracted more than a thousand people. It is the only time the Colony is completely open to the public and visitors may call on artists-in-residence in their studios.

Long acknowledged for its role in the creations of its resident artists, The MacDowell Colony itself was recognized as a place of historic importance when it was designated a National Historic Landmark in 1962, and named to the National Register of Historic Places in 1966. As the oldest artists' colony in America, MacDowell's unique physical plant had developed solely for the purpose of giving artists the opportunity to work in solitude. Its buildings were all of architectural interest and their rustic setting provided

AARON COPLAND, WHO COMPOSED PARTS OF HIS BALLET *BILLY THE KID* AT THE COLONY, WAS THE VICE PRESIDENT, PRESIDENT, THEN DIRECTOR EMERITUS OF MACDOWELL'S BOARD FROM 1959 TO 1990.

a fundamental piece of the MacDowell experience. Colony Fellows were guaranteed daily contact with the wild, and nature became muse to many who worked there.

But the Colony was not for everyone. There was the abstract artist who "nearly went nuts with all that green" and fled back to Manhattan, and the writer who could not stand the quiet, needing the stimulation of the city and his daily trip to his local coffee shop in order to work.[71] For those who stayed, however, the Colony could be magic. Surrealist painter Vernon Fimple was profoundly affected by his Colony experience in the mid-1960s:

> I've learned a great deal about color and form by watching the light through the trees, and I try to spend part of each evening in my studio at sundown watching the sky change colors. Nature puts on the most heart-rending display each evening as though it were saying farewell to the sun and light that had made it perform a heroic task during the day. I don't believe I've ever experienced such serenity in all my life as when I sit here at dusk and watch the forest gradually grow dark.[72]

Not everyone was enamored with the night woods. James Baldwin found the darkened forest unnerving. When he was in residence in the winter of 1960 he met writer Kay Boyle. They were like-minded social activists and formed a strong and lasting friendship. He was grateful for her company when Boyle walked him to his studio after dinner each evening. One night upon reaching his studio, she confessed that she, too, was afraid of the dark. After a few drinks, Baldwin accompanied her back to her studio, but he could not bear to return to his own alone. They laughed about the dilemma and waited for dawn, talking the night away. Boyle never forgot that night in the New Hampshire woods, with Baldwin "dancing about in the snow in his fox-fur hat, laughing, and singing." Her poem "For James Baldwin" recalls "blizzards in New Hampshire when you wore a foxskin cap, its tail red as autumn on your shoulder."[73]

Composer Louise Talma once said that the Colony had been everything to her. "It revolutionized my life," she claimed. "The first year I came I met Lukas Foss, and year by year I've made friends and professional colleagues who have made my career as a composer possible." Talma holds the distinction of having the most residencies of any Colony Fellow. For forty-three years between 1943 and 1995, she came to work at the Colony. She allegedly played a mean game of "cowboy pool," a variant of pocket billiards popular at MacDowell, and during the 1960s she kept a pet chipmunk named Igor. She met Wilder there in 1952 and the two became close friends. He convinced her to collaborate with him on an opera, *The Alcestiad*. It was based on his play of the same name,

THE GRAVES OF EDWARD AND MARIAN
MACDOWELL ARE LOCATED ON THE COLONY'S
GROUNDS.

with a completely new libretto in free verse that Wilder wrote specifically for the music. *The Alcestiad* premiered at the Frankfurt Opera in 1962. It received a twenty-minute ovation, during which the audience shouted repeatedly, "Louise! Louise!" The critics, however, were less kind. The work has never been performed in America.[74]

The death of Mrs. MacDowell left not only a void but also the realization that the Colony's chief source of contributions had been the remarkable national affection for its founder. It was feared that without her, the loyal network of women and women's clubs would disband. After the fiftieth-anniversary celebration in 1957, contributions fell and the deficit soared. In a *New York Times* article of August 27, 1961, composer and Colony Fellow Lester Trimble admitted that MacDowell was "in some difficulty, and one measure of its seriousness is that people responsible for managing the institution are even willing to speak of it."[75] Copland's stature in the musical world helped considerably in raising new funds for the Colony when he became president in 1962. He shepherded the Colony through its latest financial crisis, a critical juncture as it made the transition to life without Mrs. MacDowell.

As the Colony explored alternative funding sources, it came to view artists with name recognition as valuable assets when applying for foundation grants. Some expressed concern that a Colony residency might become solely a reward for established artists rather than an incentive for new artists. One could not deny the impression made by stars like Bernstein, who first came to the Colony in 1962 to work on his *Kaddish Symphony*, a piece that became a memorial to President John F. Kennedy. But the Colony had an impressive track record of supporting unknown artists who ultimately made names for themselves. In the 1960s, they included writers Alice Walker, who first came to Peterborough in 1967 at the age of twenty-three, and Leonard Gardner, whose reputation rests on his one and only novel, *Fat City*. Gardner's vivid depiction of the world of boxing earned him glowing reviews and a National Book Award nomination in 1969. In 2002, *Sports Illustrated* named it one of the best one hundred sports books of all time.[76]

Over the years, the Colony has provided important encouragement for those starting out in their careers. The young artists in Peterborough in 1966 who were getting their first chance to work full-time at their art led one Colony Fellow to comment:

> It would be so simple for the Colony to accept only well established artists who
> could pay their own way and would add prestige to the Colony. But instead of that,
> the Colony is always going out on a limb and taking chances on unknown and
> sometimes undeveloped people. As we sometimes say about an exceptionally good
> painter—"He's an artist's artist." Well, the MacDowell Colony is an artist's colony in

the same sense. The outside world can be pretty brutal at times, but a few weeks or months here can help to establish a foundation to weather some bad storms.[77]

To this day, the Colony strives to maintain a balance, reaching out to artists of exceptional talent to ensure that the best candidates at all stages of their careers may benefit from the opportunities it has to offer.

1970–79

The *Saturday Review* of February 28, 1970, was devoted to "The Business of Culture." It contained an article titled "The Artist as Uneconomic Man" by Russell Lynes, president of The MacDowell Colony, reporting on a recent study of former Colony Fellows that documented how artists made their living. "The concept of support of the living arts…as a community responsibility, and not just a rich man's indulgence," Lynes wrote, "has changed the complexion of patronage and, in some degree, the public attitude toward the artist." But he went on to lament that the number of grants to individual creative artists had not changed in about two decades. Lynes concluded, "Artists may be better off on paper and socially more acceptable, but except for a very few who make headlines or who are artists on the side, their scale of living is nearer that of the untrained laborer than that of the craftsman—nearer to the car-washer than to the electrician or bricklayer or plumber."[78] It was a sobering commentary on the challenges artists faced in America. The need for the Colony was greater than ever.

While individual artists were suffering from a dearth of funding opportunities, the Colony was successfully beginning to cultivate foundation support. In 1970, it received its first matching grant from the National Endowment for the Humanities, which was followed by a grant from the Rockefeller Foundation. Composer William Schuman played an important role at MacDowell during this decade. He had received the MacDowell Medal in 1971 and became an enthusiastic supporter of the Colony. He became the Colony's first chairman of the board when the position was created in 1974, facilitating the receipt of a $250,000 grant from the Norlin Foundation, whose board he also chaired.[79] It was the first grant awarded by the foundation, which had been recently organized by the Norlin Corporation, one of the largest distributors of musical instruments in the country. The grant was used to establish fellowships for composers in honor of Copland's seventy-fifth birthday in 1975. Schuman served as chairman of the MacDowell board until 1984.

Elodie Osborn was the first director of traveling exhibitions at the Museum of Modern Art in New York and had long been interested in the filmmaker's art. She joined the

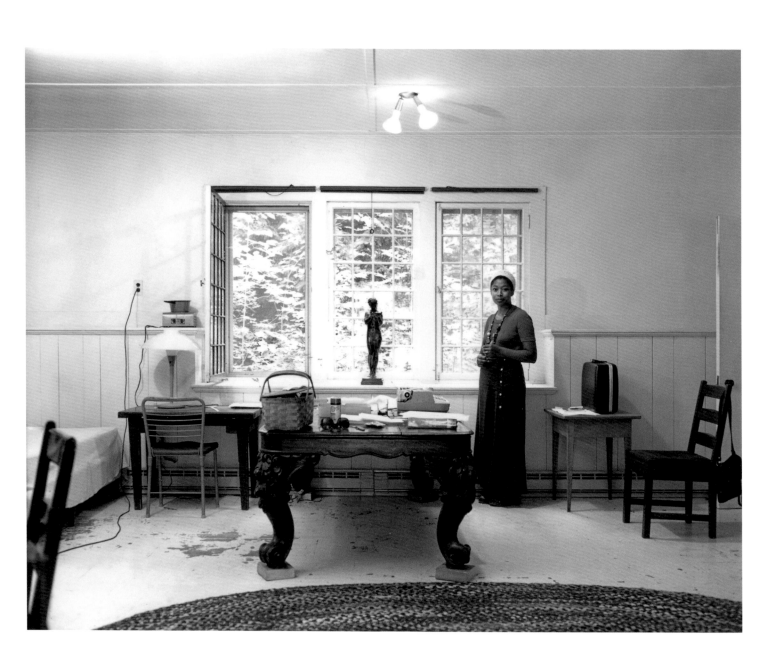

AUTHOR ALICE WALKER EARNED A MACDOWELL FELLOWSHIP EARLY IN HER CAREER. SHE WAS AN
ARTIST-IN-RESIDENCE IN 1967 AND 1974, WHEN SHE WORKED ON HER FIRST AND SECOND NOVELS,
THE THIRD LIFE OF GRANGE COPELAND AND *MERIDIAN*.

MacDowell board in 1969 and immediately began lobbying to make filmmakers eligible for fellowships at MacDowell. "Setting frame by frame on moving film involves the same process as putting paint on canvas, placing notes on a musical staff, or writing one word after another," she eloquently argued. The first filmmakers were admitted in 1971 and heralded a new era for visual artists at the Colony. The first photographer-in-residence, Mary Ellen Andrews, followed in 1973. Her studio that year was a space in the barn with a tiny makeshift darkroom attached. All other equipment, including an enlarger, was hauled to New Hampshire from New York. The old pump house was soon converted into a graphics workshop containing better-equipped studios for a printmaker and a photographer. When it opened for occupancy in 1974, Andrews was invited back to be the first to use the new photography studio with its spacious darkroom, multiple counters and sinks, and a big new enlarger.[80]

The summer of 1974 would be remembered as the summer of Watergate. "Most Colonists struggled with their consciences about watching the TV obsessively," novelist Doris Grumbach recalled. When President Richard M. Nixon resigned from office, "dinner was eaten in constant motion from the dining room to the tiny TV room."[81]

Grumbach was in Baetz Studio that summer. She had come to work on a novel, though progress was slow. Every morning she sat on the cot in her studio and read the plaque over the fireplace that dedicated the building to Anna Baetz, the nurse who took care of Edward MacDowell during his final illness and became a devoted friend to Marian MacDowell. Grumbach spent more and more time thinking about Baetz and the MacDowells and began inventing stories about them. Eventually she abandoned her novel and in a month had written the first half of *Chamber Music*, a fictionalized account of a composer's widow who starts an artists' colony in his memory.[82]

Others who came to the Colony in the 1970s included Josephine Jacobsen, who from 1971 to 1973 served as consultant in poetry at the Library of Congress. This position was an early incarnation of poet laureate and has been held by seven Colony Fellows throughout its history.[83] Composer David Del Tredici worked on *In Memory of a Summer Day*, which won a Pulitzer Prize in 1980. "My musical niche was unusual," Del Tredici explained in an interview years later. "I'm a tonal, neo-romantic composer, and when I started, taking conventional harmony and bringing it back, I was a revolutionary. A place like MacDowell allowed me to do it."[84] Abstract Expressionist painter Lawrence Calcagno completed his series titled *MacDowell*, which the Smithsonian Traveling Exhibition Service organized as the exhibition *Permutations: Earth, Sea, Sky*. It traveled to twelve venues in eight states from 1973 to 1975. In the booklet that accompanied the show, the

writer remarked, "It is refreshing to find, in an age when some of the deteriorative effects of progress have taken their toll on the landscape, that it still can be the major source of inspiration for a contemporary artist."[85]

By 1977, the Colony was receiving more than twelve hundred applications for its approximately two hundred spaces each year. Because so many were being turned away and the need was so great, the Colony pledged to foster new and existing artists' colonies around the country. Its success made it a model for others throughout its history. The earliest record of its influence dates from 1916, when Mrs. Alice Weister started the Nehalem Colony near Portland, Oregon. The local paper explained, "lovely as is the MacDowell Colony, it is out of reach for most of us of the far West."[86] Also citing a need for a colony on the West Coast, the Huntington Hartford Foundation opened an artists' retreat in Rustic Canyon in Pacific Palisades, California, that operated from 1950 until 1965. Closer to Peterborough, Yaddo opened its doors in Saratoga Springs, New York, on the estate of Spencer and Katrina Trask in 1926. By the 1970s, artists' colonies were flourishing. MacDowell provided guidance to many of them, including the Virginia Center for the Creative Arts, which opened in 1971, the Ossabaw Island Project in Georgia, and the Millay Colony at Steepletop, the home of Edna St. Vincent Millay in Austerlitz, New York, which began operation in 1974. It was a noted phenomenon in the 1970s that an artists' colony in the neighborhood increased property values and attracted prospective buyers. They were considered something of a natural resource. As one real estate agent put it, "You can plant corn or crops. Or you can plant poems and plays. Either way, the land is producing."[87]

1980–89

There exists in Celtic mythology the concept of "thin places," where the natural world and the spiritual world, the temporal and the eternal, intersect. It is not hard to imagine The MacDowell Colony as such a place. A palpable energy lingers there. It is expressed in different ways. One Colony Fellow observed that she dreamed more at MacDowell than anywhere else. Another wrote of "the creative energy and struggle that hangs in the Colony air." Reminiscing in 1987 about his past residencies, Bernstein recalled "all of those times I was writing works which had, at least in intent, a vastness, which were dealing with subjects of astronomical if not mystical and astrological dimension. This vastness is inherent somehow in this place."[88] Time seems suspended for those who

ALEXANDER STUDIO

come to work at MacDowell, as they in turn make their contribution to the collective creativity of those who have gone before them.

The Colony experience often sends artists in new directions. Faith Ringgold came to Peterborough in June 1982, shortly after the death of her mother. It was a time of mourning, during which she wanted "just to paint and not think about what or why." Until then her art had always reflected certain people or issues. That summer she embarked on a new period characterized by what she called "painting the inside of my head." The freedom artists enjoy at the Colony frequently inspires them to experiment, to play, and to dream. Nature is always a willing collaborator. "I painted my first landscapes there," Anne Tabachnick recalled in 1983. "They were timid, bad landscapes. But in the utter privacy of my studio, I could be totally unself-conscious." Michael Blumenthal, who described himself in 1980 as "a poet of relatively public events and human-to-human relationships," was amazed to be writing these lines while he was in residence:

> Outside my window, maple leaves loom large
> and the all-too-brief attention scatters
> through the cracked glass and the screen
> into a circle of sunlight between the trees....

They became the opening lines of a longer poem he called "Grace," which he completed at the Colony that summer. May Stevens for many years believed that painting at MacDowell meant not letting the landscape seep into her work. In 1988, she related: "I went each time with my themes already under way; they were urban, political, historical. But the green light that shone through my studio windows entered. I am now working on *The Garden*, a sequence of six panels, a single figure advancing and retreating in that rich green light. All winter long my studio in Cambridge has been glowing like summer. I have brought MacDowell with me, and allowed it into my most secret private place, the place of my paintings."[89]

Colony Fellows invariably remark on the distortion of time that they experience while in residence. "It's almost like you leave the twentieth century," said one poet. Many claim they get more work done at MacDowell than anywhere else. After a residency in the mid-1980s, writer Barbara Tuchman reported, "Cheney, my studio in the woods, was a kingdom of happiness where I completed more work than I ever have before in a comparable period." A month can seem like six months or a day like a season.[90]

The strongly felt presence of past Colonists contributes to the sense of timelessness. In a tradition dating back to the Colony's beginnings, artists sign and date a wooden board in their studio at the end of each residency. Every studio has a collection of these boards, referred to as "tombstones" for their shape and, as one Colonist put it, "for the very good reason that they function as intimations of mortality." Some find the idea of sitting in the same spot where Wilder wrote *Our Town* intimidating. It can "put you off your aim," a writer once confessed. Long before *Our Town*, however, Wilder one summer signed his board "Just a tired teacher." Poet Monica Raymond was inspired by the idea that composers and writers had been putting pen to paper in her studio for the last eighty years. She thought of it as a kind of "labor movement" of artists. "I saw us as workers, and myself doing a little piece of work that stretches over a long series of generations." Another writer took comfort in the unknown names: "It was the columns of unfamiliar signatures that filled the room with vibes of quiet productivity and made me feel I belonged there, too."[91]

On any given day at MacDowell new history is being made, which no doubt will inspire future Colony Fellows. The 1980s brought recognition to the still relatively new Colony disciplines of photography and filmmaking when the first MacDowell Medals in those fields were awarded to photographer Lee Friedlander in 1986 and filmmaker Stan Brakhage in 1989. The number of disciplines supported by MacDowell grew again in the 1980s as artists began to expand the parameters of their practice. The list of Colony Fellows for 1987 featured writers, visual artists, composers, filmmakers, and "others not so easily categorized." The following year, the latter became those "who crossed the boundaries of two or three disciplines." Composer Meredith Monk held residencies in 1987 and 1988, and was one of those "not so easily categorized" who led to the acceptance in 1989 of a new discipline, "interdisciplinary artists." Among others who came to work at the Colony in the 1980s were composers Richard Danielpour, Barbara Kolb, and Bright Sheng, poet Galway Kinnell, and filmmaker Skip Blumberg. In 1988, Spalding Gray worked on a novel, *Impossible Vacation*; the next year, he played the role of the Stage Manager in the Broadway revival of *Our Town*. Oscar Hijuelos was writing a novel about Latin musicians in New York during a residency in 1987. It became his *Mambo Kings Play Songs of Love*, and won the Pulitzer Prize in 1990.

During Medal Day ceremonies in August 1989, board president David Heleniak launched the Campaign for MacDowell with the introduction of the campaign's newly appointed chairman, former Colony Fellow and board member William N. Banks. With a goal of $3 million, the campaign was the most ambitious fundraising drive in the Colony's history.

The Colony had successfully earned foundation support and government support in the past and it continued to do so. But grant money easily led to a false sense of security. The Campaign for MacDowell was intended to raise both capital and endowment funds to ensure that the Colony had a sound financial foundation as it entered the twenty-first century. A National Endowment for the Arts challenge grant of $250,000 provided an important catalyst to the effort. By the end of 1990, the drive was only $150,000 short of its goal. By its close, the campaign had exceeded its goal by several hundred thousand dollars. The amazing success of the Campaign for MacDowell was in large part due to the untiring resolve, humor, and unfailing good grace of chairman Banks. It enabled the Colony to go forward with its aggressive agenda for the 1990s to improve the existing infrastructure and make the Colony's opportunities available to a wider, more diverse population.

1990–99

During his Medal Day speech in 1993, Colony board chairman Robert MacNeil remarked, "If every institution in this society were functioning as efficiently and smoothly, and were fulfilling its mission as splendidly and unpretentiously as MacDowell, we would be in paradise indeed."[92] He had good reason for such confidence. The Colony was serving more artists in a greater variety of fields than ever before. A Campaign for the Studios was in progress, enabling a vigorous program of renovations and improvements to proceed. And special initiatives were developed to reach out to artists from a wider variety of cultural and geographic backgrounds as well as to those with disabilities. The plans that had taken form in the 1980s to ensure the Colony's future security in the next century were coming to fruition.

Central to the success of these efforts was the spirited leadership of Mary Carswell, executive director of the Colony from 1987 to 1996. Carswell renewed the Colony's commitment to its philosophy that "the sole criterion for acceptance is talent." Her goal was to eliminate as much as possible financial, geographic, discriminatory, and accessibility barriers so that the most qualified artists would be invited for residency. During her tenure, an endowment was established to provide travel grants for artists, and accessibility for the handicapped was improved. In 1987, the ten-year limit on repeat residencies was officially abolished. Now all applications were rigorously evaluated by a panel of

DESIGNED TO RESEMBLE A GERMAN COUNTRY COTTAGE, BAETZ STUDIO WAS FUNDED BY THE SISTERS OF ANNA BAETZ, EDWARD MACDOWELL'S NURSE. ITS RESIDENTS HAVE INCLUDED SPALDING GRAY AND JAMES BALDWIN.

experts in the applicant's field and assigned a score. A new admissions policy instituted in the 1990s gave first-time applicants precedence over those who had previously been to the Colony if their admissions panel scores were equal. The policy noticeably increased the number of new Colony Fellows. Carswell was also responsible for bringing Cheryl Young on as the Colony's director of development in 1988. Under Young's guidance the endowment more than tripled. She would succeed Carswell as executive director in 1996. MacDowell had never before enjoyed such a solid financial foundation. It was essential for the many improvements undertaken in the 1990s.[93]

In 1991, MacDowell announced that for the first time since 1936 a new studio would be built on Colony grounds. Nef Studio, made possible by a gift from Evelyn Stefansson Nef, houses a state-of-the art photographic facility. Applications from photographers multiplied after it opened in 1993. A new writers' studio was added in 1999, endowed by Stanford Calderwood. He not only funded the construction of the building but also endowed its future in perpetuity, including fellowships for the writers who would work there. A highlight of the Campaign for the Studios, chaired by board president Tom Putnam, was the conversion of the old icehouse into the Drue Heinz Studio for Sculpture in 1996. Designed for artists working on a large scale, it provides a two-story interior space with an overhead hoist and an outdoor work area. By the end of the 1990s, all the public buildings and twenty-seven studios had been refurbished. The addition of these three studios brought the total number to thirty-two.

The Colony celebrated the one hundredth anniversary of the MacDowells' purchase of Hillcrest in 1996 with a New Hampshire MacDowell Celebration. More than fifty arts organizations across the state collaborated in events during the year-long festivities. The Currier Gallery of Art in Manchester organized an exhibition of paintings and sculpture titled *Community of Creativity: A Century of MacDowell Colony Artists*. It traveled the following year to the Wichita Art Museum, Kansas, and the National Academy of Design in New York. The works of MacDowell composers were featured on the programs of the New Hampshire Symphony during its 1996 season. Ballet New England performed "Extremes," choreographed by Mihailo Djuric to music by Colonist Barbara Kolb. The New Hampshire Historical Society mounted an exhibition documenting the history of the Colony complete with a replica of Edward MacDowell's log cabin.

Throughout the Colony's history, resident artists have given generously of their time and talent to the local community. In 1996, a formal educational outreach program called MacDowell in the Schools was implemented to allow students to experience the creative process firsthand through direct contact with MacDowell Colony Fellows. Colonist and

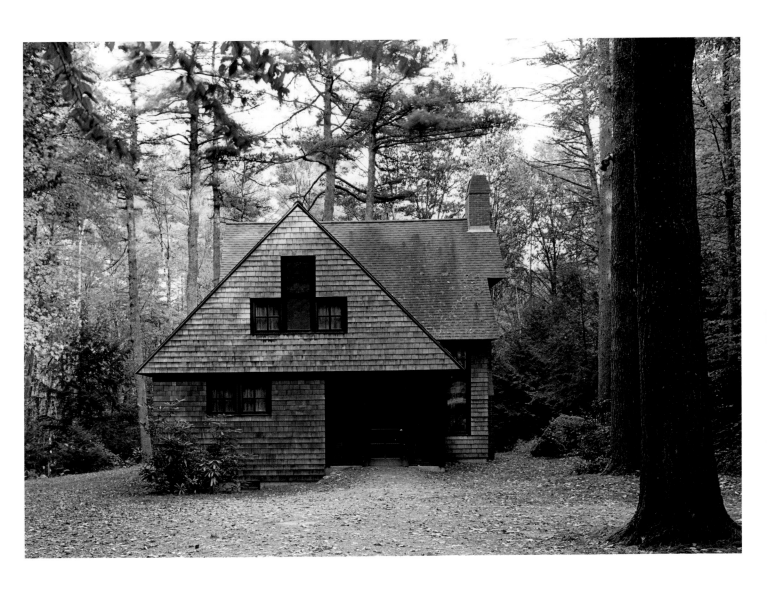

NEF STUDIO WAS FUNDED BY COLONY FELLOW AND BOARD MEMBER EVELYN STEFANSSON NEF AS A DEDICATED SPACE FOR PHOTOGRAPHERS.

structural engineer Leslie Robertson illustrated the laws of physics for a math class at Peterborough Elementary School and showed slides of buildings he had helped construct, including the World Trade Center. Filmmaker Donna Cameron invited a fourth-grade class to her studio to view one of her films and learn about the process of making them. Before they left, class members drew on pieces of stock to be used by Cameron in her next project. Bertha Rogers led juniors and seniors at Peterborough's Conval High School through a creative writing exercise and talked about her experiences as a writer. Teachers have unanimously praised the program, and resident director David Macy, who oversees the outreach programs in Peterborough, reports that some participating Colonists find it the highlight of their residency. To make similar encounters available to the general public, MacDowell Downtown was launched in 2002. Artists currently in residence present their work at the Peterborough Historical Society in an "open studio" format, reading from a work in progress, giving a performance, or screening a film.[94]

Despite the many "extracurricular" activities at the Colony in the 1990s, it remained true to its mission of providing a quiet place to work for those in residence. Photorealist painter Robert Cottingham worked on his series *An American Alphabet* during the 1993 season. In 1996, Jonathan Franzen wrote portions of his third novel, *The Corrections*, which won a National Book Award in 2001. Composer Eric Moe tried out his latest work-in-progress before a group of writers, poets, and visual artists in the Colony's Savidge Library in 1999. Moe held residencies throughout the 1990s and considered the feedback from other Colonists, the opportunities for collaboration, and feeling part of a larger community of artists to be important secondary benefits of Colony life. He once substantially rewrote the ending of a composition based on comments he received at MacDowell.[95]

In a ceremony held at the White House on September 29, 1997, The MacDowell Colony was awarded the National Medal of Arts for "outstanding contributions to the excellence, growth, support and availability of the arts in the United States." The highest recognition given to artists and arts patrons by the United States government, the event marked only the fourth time in the award's twelve-year history that an arts organization had been honored. The Colony was cited for "nurturing and inspiring many of this century's finest artists" and offering outstanding artists of all disciplines "the opportunity to work within a dynamic community of their peers, where creative excellence is the standard."[96]

HEINZ STUDIO

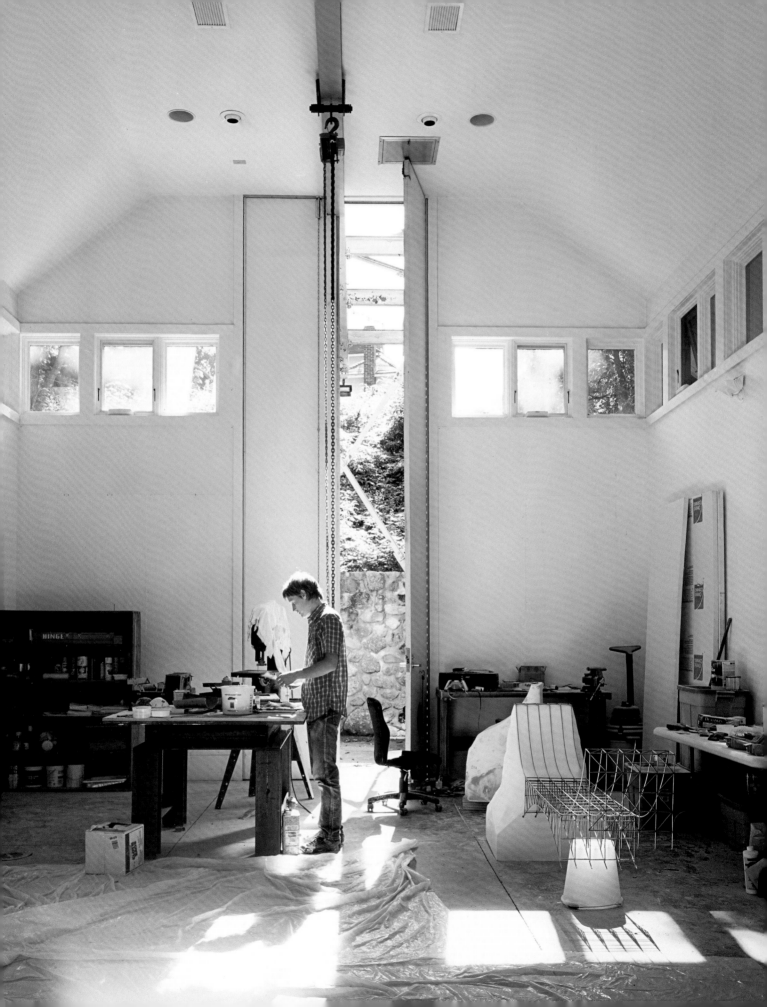

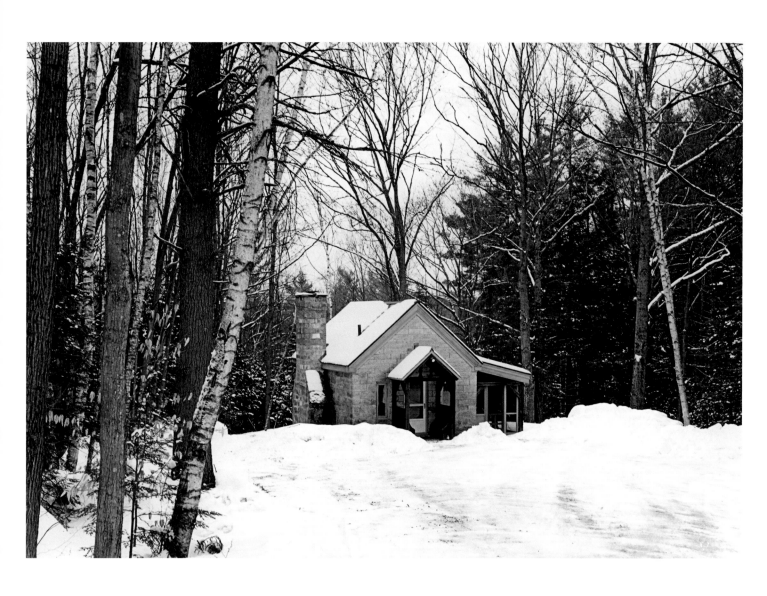

SOROSIS STUDIO IS NAMED FOR THE NEW YORK CAROL CLUB OF SOROSIS, A MUSICAL ORGANIZATION.

The Twenty-first Century

On September 11, 2001, the day that became known as simply 9/11, Colony tradition was broken and news of the terrorist attacks was delivered to Colony Fellows in their studios one by one. Some sought the company of their fellow residents, while others retreated to the solitude of their studios. In a collective expression of mourning, Colonists gathered to form a peace circle, a tradition in many cultures that symbolizes connection, hope, and renewal. The circle was marked with stones, and later the surrounding field was planted with a dozen saplings. It has become a memorial and a place of meditation. "MacDowell was an oasis in this time of fear and tragedy," Colonist Helène Aylon recounted. "Somehow, life went on, the day-to-day creative act restored balance." None of the more than one thousand Colony Fellows who live in New York and Washington, D.C., perished in the attacks, but some lost friends, loved ones, homes, studios, or workplaces. In an unprecedented response, the board of directors voted to designate a portion of the annual winter benefit for financial support to those Colonists most in need. "Thank you is too thin a thought to hang all of my feelings on," wrote one grateful recipient.[97]

Colony Fellow Suzanne Williamson was instrumental in organizing one of the first artistic responses to 9/11. Photographs made by professional photographers, amateurs, and members of the general public were exhibited together without attribution in a SoHo gallery about fifteen blocks north of Ground Zero. Titled *Here Is New York: A Democracy of Photographs*, the mosaic-like collection of shots depicted all aspects of the day from all angles and was commended for its "unusually inclusive vision." Interdisciplinary artist Topiary had watched from her roof as the Twin Towers fell and later said, "My very first thought was about the symbolism." Three years later, that symbolism inspired her show *The Icarus Project*, which she developed at MacDowell. The media performance uses the Greek myth of Daedalus and Icarus to explore the historical legacies of New York and the World Trade Center.[98]

It was a lucky twist of fate that brought photographer Mark Woods to the Colony the same summer that Robert Frank was awarded the MacDowell Medal in 2002. During Woods's formative years, Frank was his favorite photographer. He remembered waiting at the Whitney Museum of American Art for "one second of eye contact with Frank during an opening reception for his retrospective exhibition there circa 1996." Now, six years later, Frank was in his studio at MacDowell. "His eyes had looked through his camera to make some of my favorite photographs. My eyes had looked for many hours at those photographs. Now, standing in Nef, my eyes were looking into his eyes; his were looking

into mine; his eyes were looking at my photographs." It was a visit, Woods admitted, that "mattered to me more than I can explain."[99]

In the early years of the twenty-first century, the Colony continues its one-hundred-year tradition of excellence. Colony Fellows have won more than sixty-five Pulitzer Prizes, ten MacArthur Awards, and scores of Rome Prizes, Guggenheim Fellowships, National Book Awards, Sundance Awards, and Academy Awards. Works of art created by artists while in residence are exhibited in galleries and museums, and filmmakers' art has been screened around the world. At the Colony, there are plans for a new interdisciplinary studio and a much-needed addition to the library. The American classics on the MacDowell family tree continue to propagate. In 2005, composer and Colony Fellow Ned Rorem completed an opera based on Wilder's *Our Town*.

In the summer of 2001, composer Paul Moravec added his name to the tombstones that line the walls of Barnard Studio, one of the Colony's oldest. There he composed his *Tempest Fantasy*, which won a Pulitzer Prize in 2004. History can be read on the boards in this studio. A little farther down the list is the name of Michael Chabon. He was there in 1997 while writing *The Amazing Adventures of Kavalier & Clay*, another Pulitzer Prize winner. On an older board one finds the name of DuBose Heyward and the date 1924, when Heyward read his novel-in-progress, *Porgy*, to fellow Colonists in Barnard. The first board is darkened with age. At the top one can make out the year 1910. The name, barely legible, is that of George Pierce Baker, pageant master.

If Edward and Marian MacDowell were alive today to see the results of their efforts, they would be well pleased. Edward would be delighted that photographers and architects are welcome at the Colony, and fascinated by the filmmakers and interdisciplinary artists. Marian would marvel at the new studios and the evident care that has been given to the buildings and the grounds. She would be touched and gratified that many organizations from the Colony's early days continue to provide assistance. Contrary to popular expectations at the time, Marian MacDowell's club network did not entirely disappear after her death. Professional fraternities Alpha Chi Omega, Delta Omicron, Phi Beta, and Sigma Alpha Iota, along with the New Jersey State Federation of Women's Clubs and the New York Carol Club of Sorosis, all funded new buildings in the Colony's formative years and maintain their generous support today. Thirteen MacDowell Clubs are still in existence, including two of the oldest, the Cincinnati MacDowell Society and the MacDowell Club of Allied Arts of Oklahoma City. The National Federation of Music Clubs continues its support as well.[100]

When sculptor Helen Farnsworth Mears, one of the first Colonists, died in poverty in 1916, Marian MacDowell was deeply affected. Writing of the tragedy years later, she

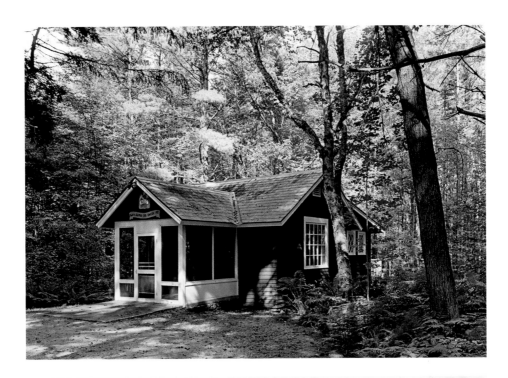

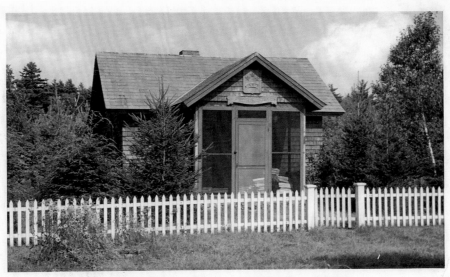

ALPHA CHI OMEGA STUDIO MACDOWELL COLONY

AN EARLY POSTCARD OF ALPHA CHI OMEGA STUDIO (ABOVE) SHOWS THE BUILDING NOW COMMONLY
REFERRED TO AS STAR STUDIO (TOP). THE WOODS AROUND THE STUDIO WERE BADLY DAMAGED
DURING THE HURRICANE OF 1938, BUT MRS. MACDOWELL PLANTED A GARDEN TO RESTORE THE
ORIGINAL SETTING.

acknowledged: "One of the hard things in my life is to see the eternal struggle of so many fine artists. We all believe in democracy, but there was one good side to the old autocracy. With all its faults, it had a personal feeling of responsibility for art and artists. Not always, but enough to have given us much that would have otherwise been lost. So it has to be the individual or the organization in our democracy that must help along our creative worker."[101]

Marian's words are as true today as they were when she wrote them. The MacDowell Colony holds its preeminent place in the art world because so many care deeply about it. The artists who come to work, the supporters who donate time and money, and the unique group of people who oversee the Colony are dedicated in their stewardship. Those at the helm as MacDowell celebrates its centennial—board chairman Robert MacNeil, president Carter Wiseman, executive director Cheryl Young, and, in Peterborough, resident director David Macy, have each been serving in their respective positions for ten or more years. MacDowell exists—and thrives—because the need for it is great. Its continuing success reflects the responsibility that Americans feel for the cultural life of their country.

Notes

1. Richard Grant White, "Music in America," *Century Magazine* 27 (Apr. 1884), 948.
2. Alan H. Levy, *Edward MacDowell: An American Master* (Lanham, Md.: Scarecrow Press, 1998), 25.
3. *Musical Courier* 17 (Oct. 10, 1888), 254.
4. The critics were Philip Hale of the *Boston Post* and Henry Finck of the *New York Evening Post*. Quoted in Lawrence Gilman, *Edward MacDowell: A Study* (New York: John Lane, 1909), 36–37.
5. Marian MacDowell, "Writings," Edward and Marian MacDowell Collection, Music Division, Library of Congress (hereafter EMMC).
6. Upton Sinclair, "MacDowell," *American Mercury* 7 (Jan. 1926), 51.
7. For a thorough discussion of MacDowell's Columbia years, see Margery Morgan Lowens, "The New York Years of Edward MacDowell" (Ph.D. diss., Univ. of Michigan, 1971).
8. In a letter from Charles McKim to Henry Higginson, May 16, 1905, McKim refers to Mrs. MacDowell's letter, "written during the temporary illness of her husband." Papers of Charles Follen McKim, Manuscript Division, Library of Congress.
9. T. P. Currier, "Edward MacDowell as I Knew Him," *Musical Quarterly* 1 (Jan. 1915), 49.
10. Minutes of the MacDowell Club, Oct. 29, 1905, EMMC.
11. Under the leadership of portrait artist John White Alexander, the club made headlines in 1911 with its revolutionary open exhibition policy, a radical departure from the normal juried exhibitions. Many of the American works in the famous Armory Show of 1913 were first seen under the auspices of the MacDowell Club. See Tom Wolf, "The MacDowell Colony: The Genesis of an Art Colony," *American Art Review* (Nov. 1996), 151.
12. Marian MacDowell, "Writings," EEMC.
13. Deed of gift between Marian MacDowell and the Edward MacDowell Memorial Association, EMMC.
14. Marian MacDowell, "Writings," EEMC.
15. Many have speculated on the nature of MacDowell's illness and some believe it was tertiary syphilis. The strongest argument for this comes from his death certificate, which lists his cause of death as "Paresis (Dementia Paralytica)." See Lowens, "The New York Years of Edward MacDowell," 363n.97. While today this diagnosis is synonymous with syphilis, it is not clear that in 1908 such a diagnosis was understood so exclusively. The disease suffered by a man with a spinal cord injury could well have come under its purview. MacDowell's attending physician at his death, Dr. Loomis L. Danforth, was a homeopath and may have had yet another interpretation of this diagnosis.
16. "An American Pageant at an American Bayreuth," *New York Times*, Aug. 7, 1910.
17. Mary Mears, "The Work and Home of Edward MacDowell, Musician," *The Craftsman* 16 (July 1909); MacDowell's students in residence in 1908 and 1909 are listed in The Allied Members of The MacDowell Memorial Colony, Bulletin No. 1 (Peterborough, N.H.: Oct. 1915), EMMC.
18. George P. Baker, "The Peterborough Pageant as the Producer Saw it," *New Boston* 1 (Oct. 1910), 256, 261.
19. Ibid., 259.
20. "An American Pageant at an American Bayreuth," *New York Times*, Aug. 7, 1910.
21. Edwin Arlington Robinson to Louis V. Ledoux, Aug. 14, 1911, in *Selected Letters of Edwin Arlington Robinson* (1940; Westport, Conn.: Greenwood Press, 1979), 72.
22. Quoted in Constance Herreshoff, "Colony's Shrine to Mrs. MacDowell," *San Diego Union*, Sept. 4, 1956; "Whole Town Keeps Silence During MacDowell Service," *New York Herald Tribune*, Aug. 30, 1956, from Marian MacDowell's obituary file, EMMC.
23. Wisner Payne Kinne, *George Pierce Baker and the American Theatre* (New York: Greenwood Press, 1968), 155.
24. The Tenney farm purchase is recounted in Marian MacDowell, *The First Twenty Years of the MacDowell Colony* (Peterborough, N.H.: Transcript Printing, 1951), 11–13.
25. The history of all the Colony's buildings is recounted in *The MacDowell Colony: A History of Its Development and Architecture* (Peterborough, N.H., 1981, repr. Aug. 1988).
26. Edward MacDowell Memorial Association, annual report, 1913.
27. Minutes of meeting of Allied Membership, July 22, 1911. Records of the MacDowell Colony, Manuscript Division, Library of Congress (hereafter RMC).
28. Ida Clyde Clarke, "Mrs. Edward MacDowell and Her Great Work for America," *Pictorial Review* (Mar. 1925), 98.
29. Chard Powers Smith, *Where the Light Falls* (New York: Macmillan, 1965), 10.
30. Eric A. Gordon, *Mark the Music: The Life and Work of Marc Blitzstein* (New York: St. Martin's Press, 1989), 37; Jack B. Moore, *Maxwell Bodenheim* (New York: Twayne, 1970), 88; and Mary Howe, *Jottings* (Washington, D.C.: Mary Howe, 1959), 100.
31. Smith, *Where the Light Falls*, 23.

32. DuBose Heyward was not convinced that *Porgy* would work as a play. Dorothy was secretly drafting a script when George Gershwin's interest in the book forced her hand. See Hollis Alpert, *The Life and Times of Porgy and Bess: The Story of an American Classic* (New York: Knopf, 1990), 45. Mark Eden Horowitz, *Sondheim on Music: Minor Details and Major Decisions* (Lanham, Md.: Scarecrow Press in association with Library of Congress, 2003), 170.

33. Grant Reynard, "Willa Cather's Advice to a Young Artist" (Museum of Nebraska Art, Kearney: n.d., typescript).

34. The MacDowell Crusade is covered extensively in the *Official Bulletin, National Federation of Music Clubs*. See especially the issues from Nov. and Dec. 1926 and Jan. through Apr. 1927.

35. The Edward MacDowell Memorial Association became the Edward MacDowell Association in 1920. Some thought the word "memorial" contributed to the erroneous belief that the organization's purpose was to promote the music of Edward MacDowell.

36. "Musicians' Gambol by 24 Celebrities," *New York Times*, Dec. 31, 1929.

37. Edward MacDowell Association, annual report, 1932.

38. Marian MacDowell to Hamlin Garland, Nov. 11, 1932, Hamlin Garland Papers, University of Southern California.

39. The founding members of the Society for American Women Composers who were MacDowell Colony Fellows were Marion Bauer, Amy Beach, Gena Branscombe, Ulric Cole, Mabel Daniels, Ethel Glenn Hier, Mary Howe, Marion Frances Ralston, Helen Sears, and Louise Souther. A complete list of founding members may be found in Adrienne Fried Block, *Amy Beach: Passionate Victorian* (New York: Oxford University Press, 1998), 366n.23.

40. Mrs. H. H. A. Beach, "The Twenty-fifth Anniversary of a Vision," in Karl W. Gehrkens, ed., *Proceedings of the Music Teachers National Association* (Oberlin, Oh.: The Association, 1932), 48.

41. Block, *Amy Beach*, 261.

42. Thornton Wilder to Marian MacDowell, n.d., RMC. Although the letter is undated, Mrs. MacDowell mentions a visit Wilder made to Salt Lake City in her letter to Mrs. Perkins, head of the Salt Lake City MacDowell Club, Feb. 23, 1936, EMMC; Thornton Wilder to Gertrude Stein, May 3, 1937, in Edward Burns and Ulla E. Dydo, eds., *The Letters of Gertrude Stein and Thornton Wilder* (New Haven: Yale University Press, 1996), 141.

43. John W. Stevens, "Talk with Wilder," *New York Times*, Aug. 21, 1960.

44. The Charles Wakefield Cadman anecdote is reported in a letter from Mrs. MacDowell to Mrs. Perkins, Mar. 2, 1935, EMMC; Maxwell's comments are published in Barbara Burkhardt, *William Maxwell: A Literary Life* (Urbana: University of Illinois Press, 2005), 62.

45. David Diamond's recollection of this incident is drawn from remarks he delivered on Medal Day in 1991, reprinted in *MacDowell Colony News* (fall/winter 1991).

46. Aaron Copland and Vivian Perlis, *Copland: 1900 through 1942* (New York: St. Martin's/Marek, 1984), 282.

47. Edward MacDowell Association, annual report, 1943; Edward MacDowell Association, annual report, 1941.

48. Quoted in Edward MacDowell Association, annual report, 1945. Attempts to locate this article in the *London Times* have proven futile. The *Times* went through several editions daily and some articles from earlier editions were dropped from later ones. Copies of the *London Times* in U.S. libraries tend to be final editions. It is believed that this article may have appeared in one of the earlier editions that are not readily available in the U.S.

49. Lukas Foss to Serge Koussevitzky, July 14, 1947, Serge Koussevitzky Archive, Music Division, Library of Congress.

50. Other Colony composers whose works Koussevitzky programmed included Leonard Bernstein, Mabel Daniels, David Diamond, Roy Harris, Nikolai Lopatnikoff, and Gardner Read.

51. Olga Koussevitzky to Marian MacDowell, June 15, 1953, EMMC.

52. Marie Brodeur was a pianist and former secretary of the American School at Fontainebleau. Clarence Brodeur was an artist and taught at several local colleges.

53. Evelyn Eaton, *The Trees and Fields Went the Other Way* (New York: Harcourt, Brace, Jovanovich, 1974), 293–94.

54. Irwin Bazelon to Arnold Schwab, May 10, 1972, Arnold T. Schwab Collection, Music Division, Library of Congress.

55. Margaret to MacDowell Association president Carl Carmer, Sept. 24, 1951, Arnold T. Schwab Collection, Music Division, Library of Congress. The author's last name is not identified.

56. Marian MacDowell to Aaron Copland, July 6, 1953, Aaron Copland Collection, Music Division, Library of Congress.

57. The Colony was featured a second time in *Amerika* in 1987. *Amerika* ceased publication in 1994 due to budget constraints and the end of the cold war.

58. *MacDowell Colony News* (Dec. 1962).

59. The information is drawn from Edward MacDowell Association, annual reports, 1955–57. Duchamp is quoted in Barbara Haskell, *Milton Avery* (New York: Whitney Museum of American Art in association with Harper & Row, 1982), 148. Edward MacDowell bought his pool table at a bargain price in Boston when a local billiard parlor was raided and all its contents sold. The money came from a small inheritance left to him by a Quaker aunt, a detail that amused him greatly.

60. *The MacDowell Colony: A History of Its Development and Architecture* (Peterborough, N.H.: 1981), 79.

61. African-American composer Julia Perry was also in residence the summer of 1954; James Baldwin and Sol Stein, *Native Sons* (New York: One World, Ballantine Books, 2004), 15.

62. "Padraic Colum," in *Dictionary of American Biography, Supplement 9: 1971–1975* (New York: Scribner, 1994). Reproduced in *Biography Resource Center* (Farmington Hills, Mich.: Thomson Gale, 2005), http://galenet.galegroup.com/servlet/BioRC.

63. Elizabeth Sparhawk-Jones, interview by Ruth Gurin, Apr. 26, 1964, Smithsonian Archives of American Art, http://www.aaa.si.edu/oralhist/sparha64.htm.

64. The rule remained on the books until 1987, although it was not rigidly enforced. Several Colonists held more than ten residencies between 1952 and 1987, notably Louise Talma, who logged 28 seasons at the Colony during that time.

65. Mrs. MacDowell's real birthday was November 22. See "Mrs. MacDowell's 20-Minute Talk Thrills 600 at Pre-Birthday Party," *Peterborough Transcript*, Aug. 28, 1952.

66. Rosemary DeCamp, *Tales from Hollywood* (Lomita, Calif.: Cambria Spoken Words, 1991), cassette tape.

67. Alec Waugh, *My Brother Evelyn* (London: Cassell, 1967), 298; and Alec Waugh to Mrs. MacDowell, Apr. 19, 1955, EMMC.

68. Toch's *Symphony No. 4, op. 80* includes words in the form of a poem about Marian MacDowell intended to be recited between the movements. The recitation of the words caused controversy, and when Antal Dorati premiered the work with the Minneapolis Symphony Orchestra in 1957, it was performed without the text against the composer's wishes. See Constanze Stratz (Susan Marie Praeder, trans.), notes accompanying CD of Ernst Toch, *Symphonies 1 & 4*, Berliner Rundfunk-Sinfonie-Orchester, Alun Francis, conductor, CPO Records 999 774-2, 2004.

69. Bernstein quoted in Aaron Copland and Vivian Perlis, *Copland Since 1943* (New York: St. Martin's Press, 1989), 368; interview with Aaron Copland during intermission of New York Philharmonic broadcast, May 5, 1957, MacDowell Colony audio material (LWO 15821), Motion Picture, Broadcasting and Recorded Sound Division, Library of Congress.

70. Bernstein, quoted in MacDowell Colony, annual report, 1987.

71. Lawrence M. Bensky, "Ideal for Work...," *New York Times*, Aug. 20, 1967.

72. Vernon Fimple to Miss Woodward, June 30, 1966, RMC.

73. David Leeming, *James Baldwin: A Biography* (New York: Knopf, 1994), 173; Kay Boyle, "For James Baldwin," in Sandra Whipple Spanier, *Kay Boyle: Artist and Activist* (Carbondale: Southern Illinois University Press, 1986), 212–13.

74. Talma quoted in Barbara Grizzuti Harrison, "The MacDowell Colony, with Ghosts," *New York Times Book Review*, Jan. 23, 1983; Paul Moor, "Louise Talma's 'The Alcestiad' in Premiere at Frankfurt Opera," *New York Times*, Mar. 2, 1962.

75. Lester Trimble, "Beneath the Quiet Surface," *New York Times*, Aug. 27, 1961.

76. "The Top One Hundred Sports Books of All Time," *Sports Illustrated* (Dec. 16, 2002), 130.

77. Fimple to Woodward, June 30, 1966.

78. Russell Lynes, "The Artist as Uneconomic Man," *Saturday Review* (Feb. 28, 1970), 79.

79. "$250,000 to MacDowell to Mark Copland's Day," *New York Times*, Nov. 13, 1975.

80. Elodie Osborn's remarks were recalled at Medal Day in 1989, when filmmaker Stan Brakhage received the MacDowell Medal; she is quoted in *MacDowell Colony News* (fall/winter 1989). Mary Ellen Andrews reminisced about her residency as the first photographer in MacDowell Colony, annual report, 1986.

81. Doris Grumbach's regular column, "Fine Print," in *New Republic* (Aug. 31, 1974), 35.

82. The story of how *Chamber Music* came to be written is recalled in Grumbach's memoir, *Coming into the End Zone* (New York: Norton, 1991), 214–15.

83. The consultants in poetry and poets laureate who were MacDowell Colonists are Louise Bogan, Robert Fitzgerald, Anthony Hecht, Josephine Jacobsen, Stanley Kunitz, Louis Untermeyer, and Reed Whittemore. "Poetry at the Library of Congress," *Library of Congress Information Bulletin* 63 (Nov. 2004), 219–24.

84. M. R. Montgomery, "A Composer in Wonderland," *Boston Globe*, Aug. 20, 1996.

85. Quinton H. Hoglund, *Permutations: Earth, Sea, Sky* (Washington, D.C.: The Smithsonian Institute, 1973), quoted in *Journey Without End: The Life and Art of Lawrence Calcagno* (Albuquerque: The Albuquerque Museum, 2000), text accompanying pl. 48.

86. Quoted in "Nehalem Colony," *Peterborough Transcript*, Aug. 10, 1916.

87. Luisa Kreisberg, "Artists' Colonies Dot More of Countryside," *New York Times*, May 4, 1975.

88. Grizzuti Harrison, "The MacDowell Colony, with Ghosts"; Ted Piltzecker quoted in MacDowell Colony, annual report, 1988; Bernstein quoted in MacDowell Colony, annual report, 1987.

89. Faith Ringgold, *We Flew Over the Bridge: The Memoirs of Faith Ringgold* (Boston: Little, Brown, 1995), 79; Anne Tabachnick, quoted in Grizzuti Harrison, "The MacDowell Colony, with Ghosts"; Michael Blumenthal, "Back to the Garden: Life at the MacDowell Colony," *The Cultural Post* 6 (Sept./Oct. 1980), 10; May Stevens quoted in MacDowell Colony, annual report, 1988.

90. D. Quincy Whitney, "MacDowell Colony a Place of the Heart for Poet Vaeth," *Boston Globe*, Aug. 9, 1992; Barbara Tuchman quoted in MacDowell Colony, annual report, 1988.

91. Grizzuti Harrison, "The MacDowell Colony, with Ghosts"; Helene Hanff, *Underfoot in Show Business* (New York: Harper & Row, 1962), 137; Eaton, *The Trees and Fields Went the Other Way*, 296; Raymond quoted in MacDowell Colony, annual report, 1988; Anthony Tommasini, "A Studio of One's Own: MacDowell Memories," *Boston Globe*, Feb. 23, 1992.

92. *MacDowell Colony News* (fall/winter 1993).

93. MacDowell Colony, annual report, Apr. 1995–Mar. 1996.

94. *MacDowell Colony Newsletter* (fall 1999, winter 2002).

95. Judith H. Dobrzynski, "Togetherness in Solitude: A Fertile Chemistry," *New York Times*, Sept. 25, 1999.

96. Quoted in MacDowell Colony publicity brochure, 2004.

97. MacDowell Colony, annual report, 2001–2; *MacDowell Colony Newsletter* (spring 2002, winter/ spring 2002).

98. *MacDowell Colony Newsletter* (spring 2002, winter 2004).

99. *MacDowell Colony Newsletter* (winter 2002).

100. "The Legacy of the MacDowell Clubs," *MacDowell Colony Newsletter* (winter 2002).

101. Marian MacDowell to Mrs. Hammett, Nov. 25, 1928, EMMC.

OVERLEAF: HEINZ STUDIO

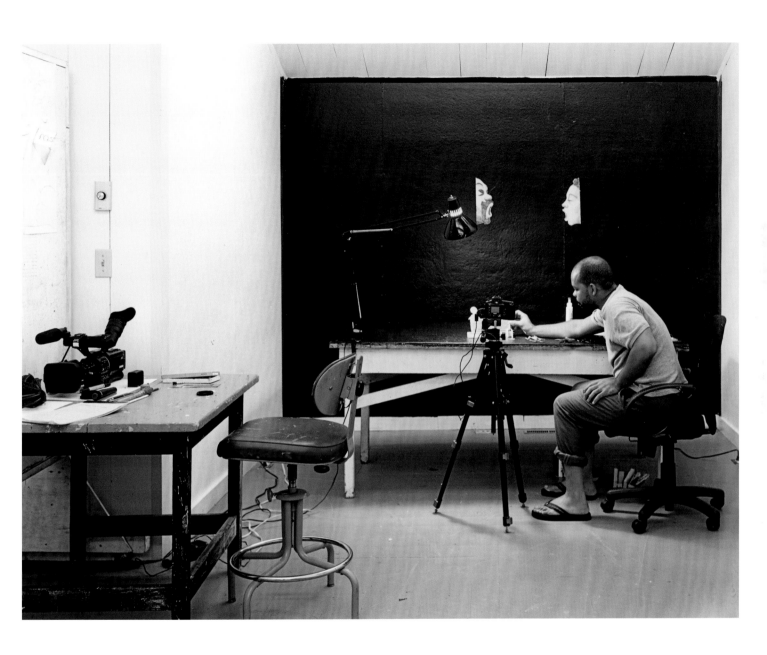

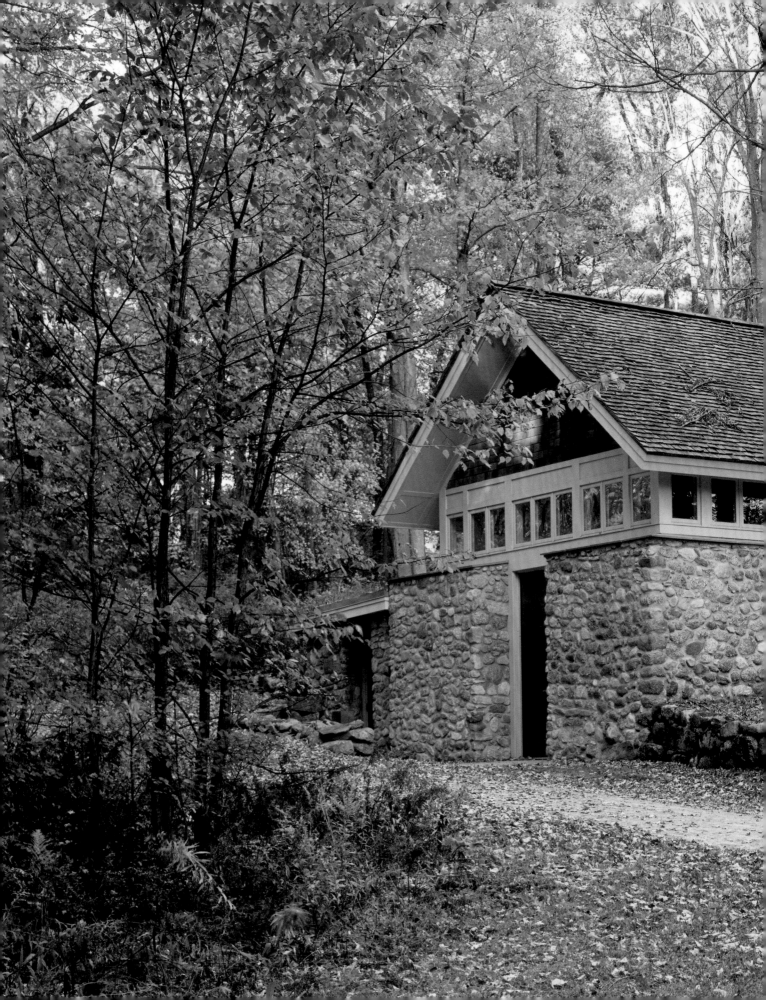

THE MAKING OF ART

On Fire, and Not
Carol Diehl

Last night at the dinner table at MacDowell, an artist mentioned that more than any of the paintings she'd done, she wished she could leave the legacy of a children's book to future generations. When asked why she didn't do it, Lorna answered, "I don't have any ideas for a children's book." Her tablemates responded, practically in unison, with the advice she might have given anyone but herself: "That's because you haven't done it. If you actually did it, you'd get ideas; it would just happen."

I suspect this is what stops most people from making art even before they start—they don't realize that, most of the time, the ideas come from the act of making, not the other way around. Even experienced artists, myself included, can forget that it's about beginning somewhere, anywhere, and seeing where it takes you.

It took me a long time—the years between ages twenty and thirty that I spent muddling around with the figure and landscape before I discovered abstraction—to find ideas that really got me going, and I think the delay was simply because I wasn't in a broad enough environment. I wasn't exposed to the art that would light me up. But once I was introduced to the work of Sam Francis, discovered raw canvas, acrylics, and traded in my brushes for sponges, I was off. It didn't matter that my first few paintings looked almost exactly like Francis's; they gave me a place to start, and after a while I was making changes—adding a grid, cutting the canvases up and sewing them back together—that made my paintings completely my own. If you were to see my paintings now, you'd never guess that's where I started.

The saying, adapted from Thomas Edison's statement about genius and reiterated by art teachers, that art is "1 percent inspiration, 99 percent perspiration," is true. You make the first mark, which leads to another mark, and another and another. Each idea generates the next idea until you have something…or you don't. You're driven by curiosity, always asking, "I wonder what would happen if I did such-and-such?" and then making choices. Regardless of the success of each step, you've learned something. You learn as much from making an unsuccessful mark or an unsuccessful painting as from a successful one. "Everything," as a friend once told me when I was in a state of artistic stage fright, "is a dress rehearsal for something else."

When I think about the mysterious ways art unfolds, I remember my experience working on what I privately think of as my Canterbury Cathedral painting. During my many visits to that historic English landmark, present in my mind, but unarticulated, was the desire to paint something that would re-create the sense of complete peace and awe that overcomes me when I stand in the dim light of the cathedral's vaulted nave. It was a fleeting response that would disappear as soon as the church doors closed behind me—until one day when I was working on a painting for which I had intended the opposite effect. This painting was going to be hot and fiery, roiling golds and oranges almost too rich to take in, like looking at the sun. I worked on the underpainting for weeks, preparing for the moment when I would glaze it with a paint I'd newly discovered: a bright, transparent alizarin orange, which would provide the final, gleaming touch.

It was a great idea, but sadly the reality—after I completely covered the canvas with orange—was awful. Worse than awful. The alizarin glaze was artificial and garish, hardly the effect I was striving for. Frantic, I wiped it off, but that made things even worse. Alizarin colors are essentially dyes, and the pigment had stained everything an indelible turmeric-like yellow. I was desperate, thinking of all the work I'd already put into this painting. What could I do to save it? Remembering that a friend had once encouraged me to make paintings that suggested the four elements—fire, air, earth, and water—I thought perhaps I could put the fire out by going over it with yet another glaze, this time a watery, oceanic blue. At this point I wasn't really thinking about the ultimate outcome; I was willing to try anything just to obliterate the heinous yellow, which was now beginning to remind me of dog pee in snow. I found a dark, transparent indathrone blue and with a large brush, swirled it over everything as quickly as I could.

When I stepped back I was in for a surprise. It was gorgeous. Even better than the over-the-top gold painting that had appeared in my mind's eye. But the intriguing thing was that on its own the blue glaze would've been flat and dull. It only worked now because I'd applied it over the yellow stain, and it was the warm glow peeking out from under the blue that made the painting come alive. I played with it a little more, wiping certain parts back and bringing others up, and as I worked it began to look strangely medieval and the layers of glazes looked like sunlight shining through blue stained glass. I realized this was not about fire or water, but that it was my Canterbury Cathedral painting.

It's all a matter of trust and time. As I sit here in the pristine whiteness of Adams Studio, hearing only the dripping of melting snow, the occasional hum of a plane overhead, and the tapping of my fingers on the keyboard, the days seem as long as they did in childhood—at least my childhood—and I realize how, in my everyday life, I so rarely

give myself reflective time. Yet sometimes you have to go almost to the point of boredom, of time that stretches out so long you don't know how to fill it, before things start to percolate. Like my laptop battery, which my computer guy says will last longer if I let it run down completely before recharging, my brain doesn't benefit from being constantly plugged in. It can be an uncomfortable state, that of not knowing what to think or do next, and here at the Colony, sequestered among the pine trees, the sameness of each day can weigh on you. I've often thought that being at MacDowell is like the film *Groundhog Day*, in which Bill Murray is forced to repeat the same day over and over until he gets it right. But learning to be okay with stuff not happening is one of the ways to get it to happen.

Our culture, however, doesn't support the concept of unstructured time, nor any endeavor where the end result isn't immediately evident. So rather than recognizing that art, like everything, is the result of trial and error, we talk about "creation" or "invention"—words that imply that art springs to life out of nowhere like the Immaculate Conception, to be revealed through "inspiration," a fickle commodity available only to the anointed few lucky enough to have been born with a special conduit to God. In this romantic perception the artist is hit by an idea as if by lightning, then stays up nights drinking coffee and smoking cigarettes to feverishly execute this "stroke of genius" before it runs out. If inspiration should capriciously desert him (I say "him" because most of the artists in the history books are men), the antidote is to drink alcohol and have sex with as many women as possible until finding the "muse" who will get it going again. This is a convenient excuse for excessive behavior and certainly makes for more compelling books and movies than the idea of laboring at the same idea until progress is made. I try to imagine a film about J. M. W. Turner, the English master of landscapes and seascapes who, when he died in 1851, left London's Tate Gallery some three hundred oil paintings and around twenty thousand drawings and watercolors. That's pretty impressive, especially considering that those figures refer just to the stuff he had left over and don't even take into account the pieces he sold or gave away, or those that inevitably—and there must have been some—landed in the waste bin. Probably only Andy Warhol could've carried off a film about Turner, because the first, second, third, and every scene after would find J. M. W. on the beach with his easel and brushes, squinting at the ships and the ocean. It may be unromantic, but the bottom line is that when you do that many paintings, some of them have to be good.

While it's true that you might not want to stop working on something when you're on fire, and there are definitely times when you're on fire and times when you're not, ideas

don't come bounding into our brains from the outside, but are a response to our experience, our interaction with the world. As we work, our intuition or unconscious draws on the various parts of our lives, often causing us to put them together in new and different ways. Therefore the process of making art can be compared to dreaming, where the elements are familiar but reassembled to reveal things we were thinking and feeling that wouldn't have shown up in a waking state. I use painting and writing to access the hidden recesses of my mind, to identify and explore thoughts, ideas, and emotions I'd otherwise never have known I had. I didn't have a clue, for instance, when I sat down to write this that I'd end up writing about dreams, but here it is. Our job, therefore, isn't to invent ideas — the ideas are already there — but to put ourselves in a situation where we can be present to them, where they can be accessed, developed, and put to use.

Two nights later, around the fireplace, Lorna happened to mention she'd made a good start on her children's book. We weren't surprised.

"TOMBSTONES" IN NEW HAMPSHIRE STUDIO

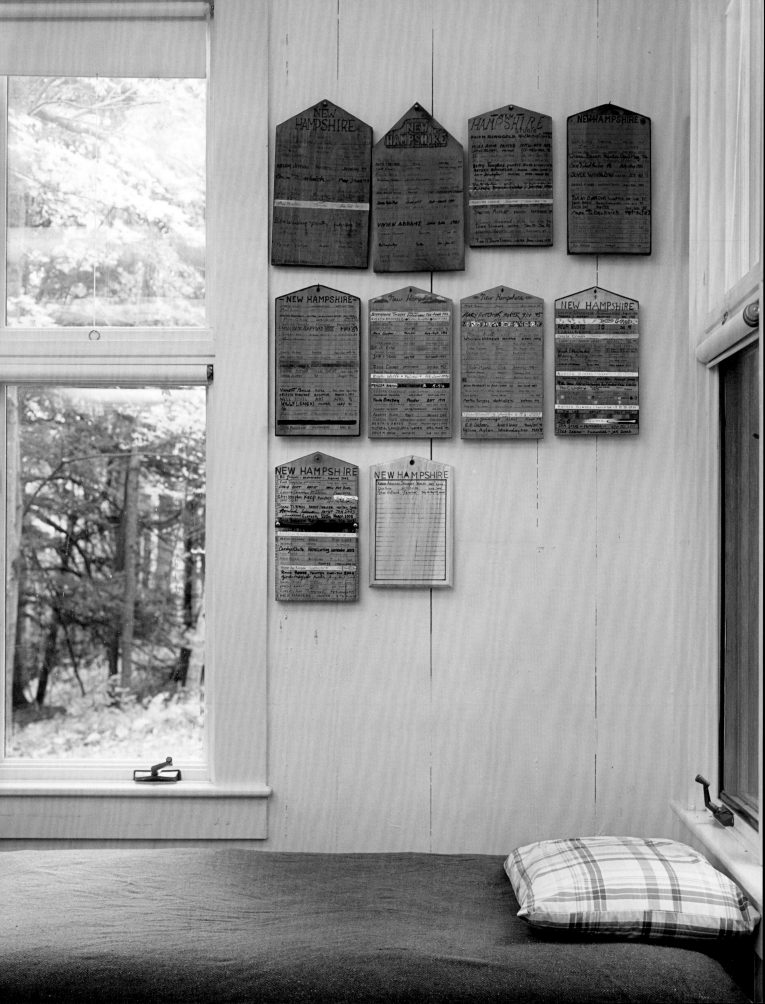

Peace and Buzz
Wendy Wasserstein

During my everyday writing life, I promise myself that tomorrow I will get up at 5 A.M., take a run in Central Park, come home, answer my e-mails, get my daughter up at 7, make her homemade oatmeal for breakfast, get her to school, walk to my office, answer more e-mails, return phone calls, write at least a thousand words, cut at least a thousand words, rewrite a thousand words, return more calls, talk to one or two agents, regret my talk with one or two agents, talk to a producer about rewriting my show, regret talking to a producer about rewriting my show, avoid carbohydrates for lunch, go to the gym, take my daughter to piano, and pass out before 4 P.M.

Though I am never able to achieve this exact schedule, it does occur to me that for a functioning writer and mother, it seems the ideal. Except, there is absolutely no time to think, to wonder, or even, that most ideal part of the creative process, to lie idle. In most writers' urban lives, the pressure to produce, to stay in the game, to know intimately not only your own work but the business of everyone else's work, becomes overwhelming. There is so much external and internal noise that has absolutely nothing to do with art or creativity and everything to do with distraction.

I had been a board member of The MacDowell Colony for around twelve years, before I was ever there as an artist. I joined the board because, theoretically, I believed artists should have a quiet place to work and be supported. But my own life was so full of deadlines, productions, and commitments to speak at the Book Clubs of New Jersey that I never found time for myself to go there. I would instead, under the crunch of the deadline, check into a hotel and knock out the final revisions of a play or film.

The year my father died, after a prolonged illness, I decided that I spiritually and emotionally needed to go to MacDowell. It wasn't that I had a specific novel to finish at the time, though I did have a deadline for a children's book. It was more a yearning to be in a community of artists and at one with my thoughts. I needed very much to hear my own voice, unfiltered by New York noise that would say, "What are you working on?" "Are you going to write about your father?" "Do you think Lincoln Center will do it?" or "Have you read the reviews of the new Tony Kushner play?"

THE FIRE POND LIES AT THE EDGE OF COLONY PROPERTY NEAR CHAPMAN STUDIO. IT WAS ONCE USED AS A WATER SOURCE IN CASE OF EMERGENCY.

That first visit to the Colony, I was in Veltin Studio, and would sit at my desk every morning and simply think. After a few hours, I would begin work on a children's book that was meant to be a sequel to one I had already written. This book was not an idea of mine, but rather that of a publisher. Interestingly, during that time in Veltin, I realized that I had to get back to my own voice and not try to appease a publisher's sensibility.

Every afternoon that summer, I took a walk from the studio through the Colony and into the town of Peterborough. I had forgotten how very much I loved New England and the many walks I had taken when I was a student at Mount Holyoke College, in Massachusetts. The joy of wandering on a beautiful day and freeing my mind to think about plays I'd like to write, and the calm of solitude, were healing, both for my grief and for my sense of myself as an artist. When one is too involved in daily life, one loses touch with that core that has been the source and will be the source of one's work.

As I'd walk into Peterborough every day on my way to the Twelve Oaks Delicatessen for a coffee, I'd inevitably think of Thorton Wilder, Milton Avery, and Aaron Copland and all the future artists from MacDowell finding their way into town for a coffee or a printer cartridge.

Oddly, the most fruitful times for an artist can be when there isn't anything immediately on paper or on canvas to show for it. Both the solitude at The MacDowell Colony and the knowledge of a community of artists working outside your cabin can open your heart and mind to the possibility of inspiration. After all, good writing isn't just produced, like fabric, by the yard. There is some dialectic of time, inspiration, and work.

I have a habit, from my days as a travel writer, of going to any town and compulsively reading every travel book about it. During one of my outings in Peterborough, I got my hands on at least five guides to New Hampshire, including one detailing the oldest inns. As far as I could make out, in nearby Hancock was not only one of the oldest inns, but one with one of the oldest murals. My travel writer instincts told me it was a must-see, so I gathered a few friends and we drove to Hancock for a night's outing. The main dining room of the refurbished inn seemed a little grand for us, so we happily settled into the tavern.

We were served that night by an athletic-looking twenty-year-old waiter, with whom we struck up a conversation.

"Do you live around here?" I asked him.

"No," he said. "My folks do. I was supposed to do an internship that fell through. I go to college in Connecticut."

"Do you like it?"

"No," he said. "I got accused of plagiarism four times."

"Did you do it?" my friend Michael asked.

"No," he answered again, quite pleasantly. "They just accuse me because of who I am. I'm a jock and I went to prep school, so I'm not politically correct. If I went to a state university, this would've never happened to me." Then he smiled again and said, "I'll be right back with your drinks."

I turned to my friend Michael and said, "That's a play."

He looked at me askance, and said, "What?"

I said, "That's a play. It's reverse discrimination."

The waiter came back to the table with our drinks, and I said to him, "You don't seem like a very angry man. You're so nice."

He answered, "I learned what it was like to be the other. Anywhere else, I would be the norm. But because of this, I understood what it was like to be the object of prejudice."

When I went back to The MacDowell Colony, I began writing a play called *Third*, about a young wrestler and a feminist professor. It wasn't exactly about this college student waiter, but this young man sparked something that had been fermenting during all those walks at MacDowell. During my time sitting at the desk in Veltin Studio, I had thought very much about how I wanted to write a new play. Somehow, meeting that waiter and being at MacDowell fulfilled for me, as an artist, the old Aristotelian unities of the right time, place, and action.

As I continued work once I left MacDowell, I realized the play that I now call *Third* was in fact what I was writing about the death of my father. I gave the feminist professor a father who had Alzheimer's disease. Her father declines throughout the course of the play, and ultimately his death has a profound effect on her relationship with the college student. It took time to evolve to make itself clear, but if I hadn't been at MacDowell I don't think I would've given myself the space and time to find it.

The first production of *Third* was at Theater J, in Washington D.C., directed by Michael Barakiva, who was at my first meeting with that waiter. The play opened to excellent notices in the Washington press, and a bit of surprise that I was so interested in wrestlers.

As a playwright, one often comes across situations where someone says, "You should really turn this into a play." Every taxi driver, divorce lawyer, and friend has a story that "you've just gotta write." I know, frankly, I will never write any of them, and if I met a waiter in a New York restaurant who told me he had been accused of plagiarism,

my mind would be so full of distractions and phone calls to return, deadlines to meet, and school play dates to schedule that I wouldn't even listen. I know the play *Third* exists because I was rejuvenated as an artist by the quiet, the peace, and the silent buzz of creativity at The MacDowell Colony.

OPPOSITE: THE PHONE BOOTH IN COLONY HALL. OVERLEAF: NEW HAMPSHIRE STUDIO

Reunion
Paul Moravec

When Edward and Marian MacDowell started the Colony a century ago, a principal aim of their mission was to assemble a community of artists from several disciplines with the idea that interaction among the arts could enhance the creative experience for all concerned. Their enlightened vision extends at least as far back as classical Greece. The ancients imagined the muses as sisters, daughters of Mnemosyne, the goddess of memory. While maintaining their separate identities, the arts all sing in their various ways, like Yeats's golden bird, "of what is past, or passing, or to come." And occasionally the muses sing as a single voice, as when Orpheus displays his mastery of both music and poetry, indissolubly united. Taken together, the various muses present a comprehensive view of human existence beautifully realized. The integration of the arts encourages integration of the mind, both individual and in cooperation with other minds in a civilized community.

Though increased artistic sophistication and technical expertise have benefited our culture immensely over time, the inevitable concomitant specialization has resulted in a woefully disintegrated cultural landscape. The contemporary arts too often regard each other in mutual ignorance or incomprehension, and such loss of mutual support undermines their composite role in society as a whole. But MacDowell has offered a corrective by facilitating family reunions among the sister-muses for a century now. Through the Colonists' evening presentations of their work, studio visits, and chats over meals, artists of all kinds come away from their residencies with an increased awareness across disciplines. And I like to think that this makes us more sophisticated both as practitioners and advocates.

As a contemporary non-pop composer, I am all too familiar with a sense of societal marginalization. But it has always been accompanied by a kind of cognitive dissonance, because I naturally regard the artist's mission as thriving at the very center of the human condition. For those who have dedicated their lives to creative activity, art is not a marginal luxury, but an indispensable response to some of humanity's most deeply felt needs and instincts.

The nature of the wide-ranging transformations in America's cultural condition over the past century have given special urgency to the MacDowells' mission in ways they

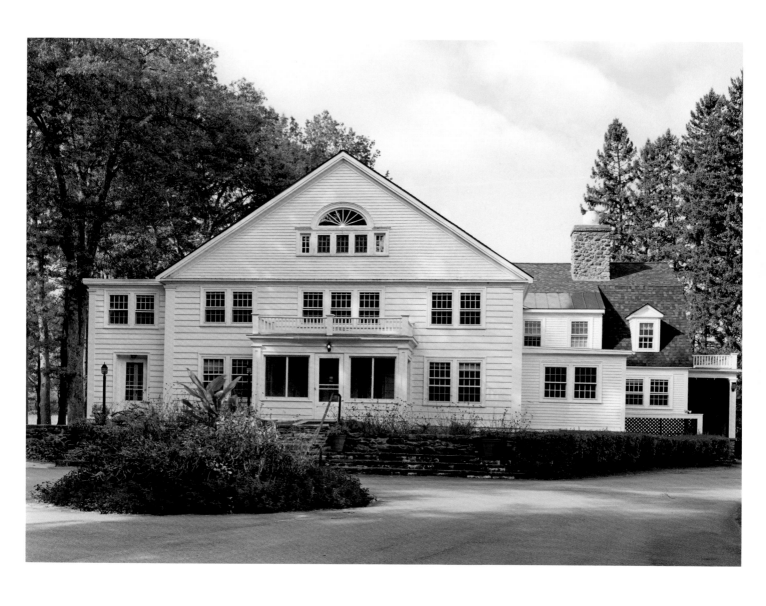

IN 1913, A YEAR AFTER THE COLONY PURCHASED THE TENNEY FARM, THE CONVERSION OF ITS LARGE HAY BARN BEGAN. ACCORDING TO MRS. MACDOWELL'S WISHES, THE BARN WAS REDESIGNED TO BE A "GREAT COLONIAL HALL."

might scarcely have imagined. As more and more of our culture is sucked into the insatiable maw of the mass entertainment industry, the Colony as a creative haven for artists is ever more necessary. It's one of the few places in twenty-first century America still recognizing the essential, qualitative distinction between art and entertainment.

Further, America's tendency toward obsessive neophilia and cultural amnesia serves to highlight the MacDowells' original commitment to all the muses as the daughters of memory. As an artist and professor I wince whenever I hear such phrases as "Oh, that's *history*!" or "That's *sooooo* last year!" as it reflects an ephemeral culture without perspective or position in the stream of time. As the Colony enters its second century of contemplative operation, it continues to engage T. S. Eliot's famous question: "Where is the wisdom we have lost in knowledge?/Where is the knowledge we have lost in information?"

Much of the Colony's value manifests itself in serendipity. For instance, a fruitful contemporary operatic partnership was formed when, one day during his 1989 residency, the composer Daron Hagen took a phone call in Colony Hall for an opera commission. Lacking a librettist, he stuck his head out of the phone booth, spied the poet Paul Muldoon sitting on the couch reading the paper, and asked him if he was interested.

The Colony's fortuitous magic extends far beyond the woods of Peterborough through its world-wide diaspora of Fellows, Medalists, patrons, and friends. For example, I met my wife, the writer and editor Wendy Lamb, through MacDowell connections, though our respective Colony residencies never overlapped. And MacDowell graced my life in another unexpected way that crucially influenced my future. In the summer of 1995, I was hospitalized for clinical depression and given two weeks of electro-shock treatments. An essential part of my gradual recuperation in the fall was my reading of William Styron's *Darkness Visible: A Memoir of Madness.* His masterly prose uncannily articulated for me important aspects of my own experience with the disease, providing terra firma on which to continue my journey back to health. In December of that year, I happened to meet Styron at the annual MacDowell benefit in New York. I expressed my admiration and gratitude for his work and mentioned one passage in particular: "a storm —a veritable howling tempest in the brain, which is indeed what a clinical depression resembles like nothing else." Styron graciously spoke of his history and lent a sympathetic ear to a young man still haunted by the shame and embarrassment that seems, unfairly, to cling to mental illness. His wise comments and advice gave me an urgently needed sense of confidence. It was one of the more memorable conversations in my life, a landmark that helped keep me on course as I reinvented my life and my work.

Several years later, during a two-month Colony residency in the summer of 2001, I conceived and began composing a multi-movement chamber piece inspired by various aspects of Shakespeare's *The Tempest.* While I was consciously transmuting elements of the play through my aural alchemy, there was another, unconscious impulse guiding the work's creation: my need musically to come to terms with the memory of my "howling tempest in the brain" and its aftermath. I was inclined to identify with Prospero in his trajectory from despair to hope, from catastrophe to eventual success. With the language, characters, and metaphors of my silent literary partner as a point of departure, I made audible the workings of my central nervous system. Through the arduous, ordinary miracle of music notation, I worked to compose a document reflecting W. H. Auden's description of music's special place among her sister-arts: "You alone, alone, imaginary song/Are unable to say an existence is wrong/And pour out your forgiveness like a wine."

Every Colony residency has its own "vibe," and the summer of 2001 was especially happy and convivial—and quite possibly the zaniest in living memory. Setting the summer's freely imaginative tone, the unclassifiable artist Pat Oleszko coordinated such happenings as "The Lincoln Brigade," in which a dozen bike-riding Colonists identically decked out as cartoon versions of the Great Emancipator descended on Peterborough's municipal Fourth of July celebration. I fondly remember particularly thoughtful, vibrant conversations with the writers Fenton Johnson and Agata Tuszynska and the visual artist Eve Laramee among others too numerous to list here. For a composer, visiting the realms of word and image are at once a respite and a revitalizing force. We worked and played hard and just had a great time. The *craic* was good, as the Irish say.

It's always been difficult for me to leave the Colony at the end of a stay. That summer the goodbyes were particularly poignant because of our especially pleasant experience. Happily, in the first week of September, we were summoned by Pat to her apartment in lower Manhattan, a stone's throw from the World Trade Center, for a kind of finale to the summer's festivities. Colony Fellows in the New York diaspora showed up, boisterously reuniting as though we'd been separated for ages. And sipping wine up on the apartment roof, under the immense Twin Towers illuminated in the twilight, we spoke again in our various ways of what was past, or passing, or to come.

THE MAIN SPACE OF COLONY HALL IS KNOWN AS BOND
HALL IN MEMORY OF CHARLES H. BOND, THE HUSBAND OF
ISABELLA BACON BOND, WHO FOUNDED THE PETER-
BOROUGH PLAYERS, A THEATER TROUPE BASED NOT FAR
FROM THE COLONY. OVERLEAF: THE EAVES VIEWED FROM
THE MEADOW

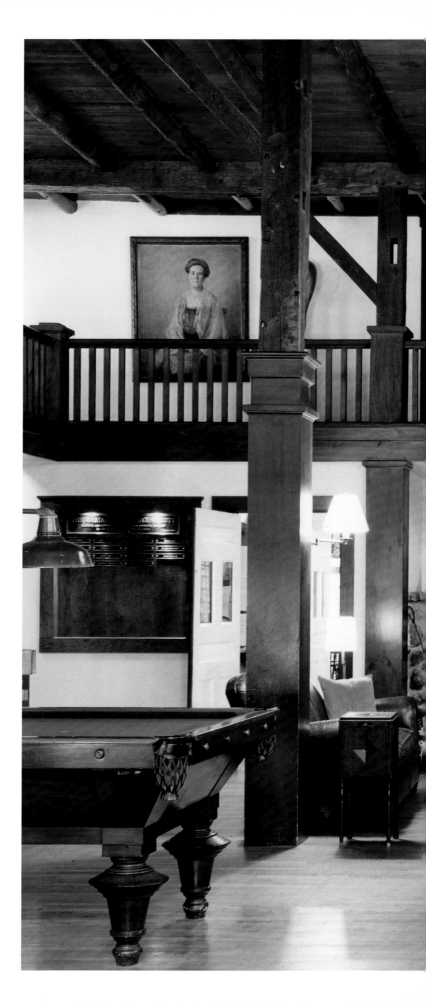

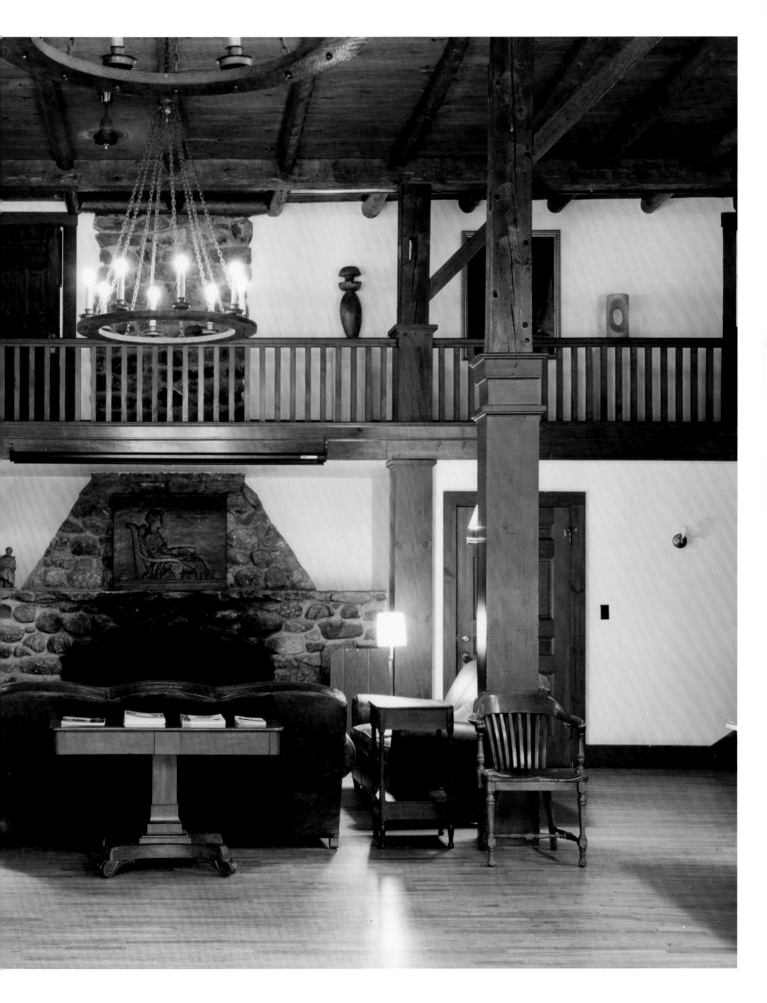

MARKS OF DISTINCTION

The Edward MacDowell Medal

The Edward MacDowell Medal was established in 1960 and is awarded annually to a creative artist whose works have made an outstanding contribution to the national culture. It is presented every summer at a public ceremony at The MacDowell Colony. To confer the Medals, the Colony selects authorities in the Medalists' disciplines with special knowledge of their work. The following are excerpts of selected presentation speeches given since 1960.

Thornton Wilder, playwright
Introduced by Edward Weeks, writer and editor, 1960

"The Colony will always feel that it has a vested interest in *Our Town*; for it's their town and their mountain which Thornton must have had in his inner gaze as he wrote it. In this act of possession you will, of course, be disputed by every other state in the Union. It is part of the durable beauty of this play that every audience believes it was written about them. And this is true not only of America, but of the Western world."

Alexander Calder, sculptor

Introduced by Meyer Schapiro, art historian, 1963

"He is a fortunate artist who found a vein that he has been able to exploit freely for a lifetime without exhaustion and without being distracted by the discoveries of others. He has carried on with strength, with grace and humor, and with an exacting attention to quality. What he does is well-rooted in his own being and is in such harmony with his surroundings that he has enjoyed in the esoteric art of sculpture a popular success rarely won by an original artist in our time. His work takes its place in modern buildings with an air of predestined fitness, as the old massive figures in the stone architecture of the past."

Louise Nevelson, sculptor
Introduced by John Canaday, critic, 1969

"When I say that Louise Nevelson's sculpture is, for me, an affirmation of faith, you put it that she has taken much of the detritus of our civilization and has not simply recombined it; she has completely transformed it. You may recognize a balustrade, you may recognize a moulding, a dowel, plans of wood, etc.; but they are so transformed that their original function is simply no longer there. They are forms. They are forms transformed from detritus into what I would call a spiritual expression."

Norman Mailer, writer

Introduced by John Leonard, critic, 1973

"Mailer is a weird combination of Dickens and D. H. Lawrence, the reporter and the prophet. His past work is full of clues to the future, simply because he paid close attention. Power, in fact, has always been his principal subject; and the two bastard children of power—money and paranoia—in the marketplace, in the bedroom, in the head. He continues to command our attention because there isn't a writer in this country with his nineteenth-century appetite for social reality in all its forms and deformations—his splendid long-windedness on politics, sports, movies, war, technology, eros—and his willingness to risk himself in the digestion."

Lillian Hellman, writer
Introduced by John Hersey, writer, 1976

"Rebelliousness is an essence of her vitality—that creative sort of dissatisfaction which shouts out, 'Life ought to be better than this!' Every great artist is a rebel. The maker's search for new forms—for ways of testing the givens—is in her fierce rebellion against what has been accepted and acclaimed and taken for granted. And a deep, deep rebellious anger against the great cheat of human existence, which is death, feeds her love of life and gives bite to her enjoyment of every minute of it."

Mary McCarthy, writer
Introduced by Elizabeth Hardwick, writer, 1984

"I do not see in any of her work a trace of despair or alienation but instead rather romantic expectation. She always expects better of persons and of the nation. She seems to believe in love, and her heroines are ready to rush out to it again and again. To me this writer from Seattle, New York, Paris, and Maine belongs to the line of cranky, idealistic American genius."

Lee Friedlander, photographer
Introduced by John Szarkowski, curator, 1986

"I am still astonished and heartened by the deep affection of those pictures, by the photographer's tolerant equanimity in the face of the facts, by the generosity of spirit, the freedom from pomposity and rhetoric. One might call this work an act of high artistic patriotism, an achievement that might help us reclaim that word from ideologues and expediters."

Leonard Bernstein, composer
Introduced by Ned Rorem, composer, 1987

"Lenny is the only major musical figure in our world who demonstrates that the living creator is the center of his art. Of Bernstein the pacifist, the Socratic rabbi, the un-chic radical, the family man who laughs and reads and loves and dies, it is Bernstein, the composer's interpreter, who is most urgent, for he knows that the composer *is* his music, just as music *is* the composer. He alone grasps the ontology of the art. Whatever Bernstein does is right, even when it's wrong; the composer is always right, because he is the originator."

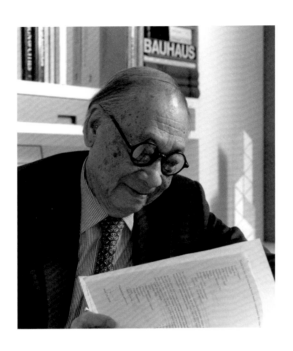

I. M. Pei, architect
Introduced by J. Carter Brown, museum director, 1998

"His sense of *bridging* is what moves me about I. M. Pei. He has a sense of the past and, as we come to the millennium, of the future. He has a sense of the East *and* the West. He said to me once when I was harrumphing about something that I thought was too much of a design—I said, 'You know, you're not going to see that, I. M.' He said, 'Ah, but Carter, architecture must have integrity, like a friend.'"

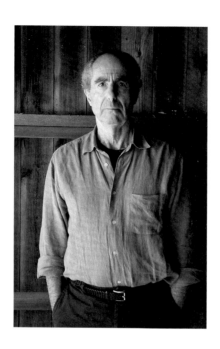

Philip Roth, writer

Introduced by William Styron, writer, 2001

"He has been one of the most penetrating witnesses to the flagrant disasters and precious conquests of our boisterous era. He has conveyed his vision in ever shifting modes of hectic comedy and somber tragedy, delighting countless readers even as he mercilessly rattled their bones, and they've deserved both. But at last, more importantly, he has caused to be lodged in our collective consciousness a small, select company of human beings who are as arrestingly alive and as fully realized as any in modern fiction."

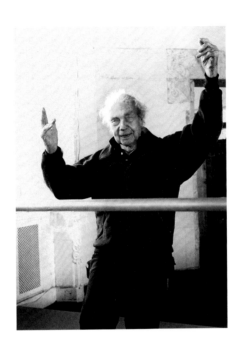

Merce Cunningham, choreographer

Introduced by Meredith Monk, interdisciplinary artist, 2003

"Whenever I go to a concert of Merce's dances, the first thing I notice is that the walls of the theater seem to disappear. There are no boundaries to the stage; the action seems to be going on beyond the frame. Merce's pieces reflect the asymmetry and complexity of nature. We witness an ongoing process unfolding with no beginning and end. If there is a curtain and it comes down, it is just like an eye blinking...there is a sense that the action will continue forever."

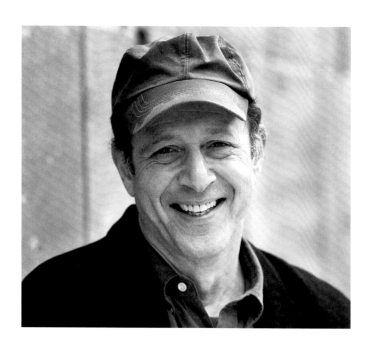

Steve Reich, composer
Introduced by Richard Serra, sculptor, 2005

"He starts out with a seemingly simple premise: a found voice, a sentence uttered. But as he subjugates this found language to his structure of overlays, as it is repeated again and again, the detail of the detail begins to resonate. I find that I am drawn into the infinitesimal, the infinitely subtle moving variations. It's then that I realize that I am lost in the infinite vastness of the whole. As the voices spin out they become something other than language. The words are transformed by rhythm into emotion. Words sing as sounds, and as they reach the end of the path they trace through their phased diversions and combinations the result is music, not language."

The Edward MacDowell Medal

Year	Medalist	Discipline	Introduction
1960	Thornton Wilder*	Writer	Edward Weeks
1961	Aaron Copland*	Composer	Irving Kolodin
1962	Robert Frost	Writer	Aaron Copland*
1963	Alexander Calder	Visual artist	Meyer Schapiro
1964	Edmund Wilson	Writer	Aaron Copland*
1965	Edgard Varèse	Composer	Milton Babbitt
1966	Edward Hopper	Visual artist	Lloyd Goodrich
1967	Marianne Moore	Writer	Glenn Wescott
1968	Roger Sessions	Composer	Edward T. Cone
1969	Louise Nevelson	Visual artist	John Canaday
1970	Eudora Welty	Writer	Elizabeth Janeway
1971	William Schuman	Composer	Aaron Copland*
1972	Georgia O'Keeffe	Visual artist	Eric Larrabee
1973	Norman Mailer	Writer	John Leonard
1974	Walter Piston	Composer	Michael Steinberg
1975	Willem de Kooning	Visual artist	Dore Ashton
1976	Lillian Hellman	Writer	John Hersey
1977	Virgil Thomson*	Composer	Alfred Frankenstein*
1978	Richard Diebenkorn	Visual artist	John Canaday
1979	John Cheever	Writer	Elizabeth Hardwick
1980	Samuel Barber	Composer	Charles Wadsworth
1981	John Updike	Writer	Wilfred Sheed
1982	Isamu Noguchi	Visual artist	William Lieberman
1983	Elliott Carter	Composer	Michael Steinberg
1984	Mary McCarthy	Writer	Elizabeth Hardwick
1985	Robert Motherwell	Visual artist	Varujan Boghosian
1986	Lee Friedlander	Photographer	John Szarkowski
1987	Leonard Bernstein*	Composer	Ned Rorem*
1988	William Styron	Writer	George Plimpton
1989	Stan Brakhage	Filmmaker	John Hanhardt
1990	Louise Bourgeois	Visual artist	Robert Storr

Year	Medalist	Discipline	Introduction
1991	David Diamond*	Composer	Joseph Polisi
1992	Richard Wilbur	Writer	Richard Howard
1993	Harry Callahan	Photographer	Anne Tucker
1994	Jasper Johns	Visual artist	Kirk Varnedoe
1995	George Crumb	Composer	Christopher Rouse
1996	Joan Didion	Writer	Elizabeth Hardwick
1997	Chuck Jones	Filmmaker	John Canemaker
1998	I. M. Pei	Architect	J. Carter Brown
1999	Ellsworth Kelly	Visual artist	James Cuno
2000	Lou Harrison	Composer	Dennis Russell Davies
2001	Philip Roth	Writer	William Styron
2002	Robert Frank	Photographer	Philip Brookman
2003	Merce Cunningham	Interdisciplinary artist	Meredith Monk*
2004	Nam June Paik	Visual artist	John Hanhardt
2005	Steve Reich	Composer	David Lang* and Richard Serra
2006	Alice Munro	Writer	Virginia Barber

* Residency at The MacDowell Colony is not a criterion for selection. Asterisks identify MacDowell Colony Fellows.

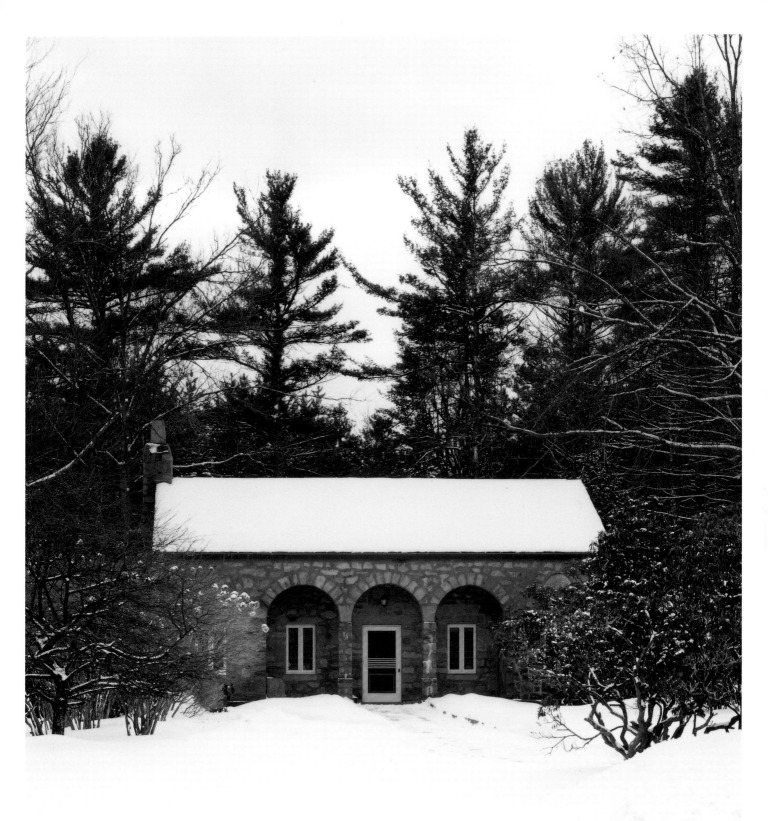

A COMMON GOOD

Art and Freedom
Robert MacNeil

A few years ago, a Japanese artist, Tamiko Kawata, was a Colony Fellow at MacDowell. She had been living in the United States for nearly forty years and had married here but never wanted to change her citizenship. She had attended other artists' colonies and observed that "each place treated the artists as though we were the most important people in the world," but it was at MacDowell that she decided to take the plunge, because she wanted to be a citizen of a country that could offer something like this.

She said: "My thoughts of wanting to belong to this country that can offer this life were growing gradually but the MacDowell experience, the studio condition, and the energy that other residents create made my final decision to become a U.S.A. citizen despite the fact that Japan does not recognize dual citizenship. I felt a bit homesick soon after I became a citizen in 2004, but I was happy to cast my vote on election day."

Her story gave MacDowell a wider dimension in my thinking, reminding me that the contribution the Colony makes is not just to art but through art to the nation. In the many faces America presents to the world, those of its creative people are as valuable as any others and often endure longer. In a time of aroused, often competitive patriotism, art has a national value, not to be ignored when we focus so heavily on the force of our arms and the weight of our economy. Art, in fact, may be an important weapon in the so-called war on terrorism. That struggle is ultimately a war of ideas and values, and American artists can be powerful messengers of our values.

During the cold war, the arts were considered vital to national security, with government support essential to promote them overseas, to counter the intellectual appeal of communism and communist disinformation. Even while Senator Joseph McCarthy's anti-communist witch-hunt stifled some creative people in the U.S., Washington overtly and covertly became a major patron of American artists abroad.

Overtly, through the United States Information Agency (USIA), the American government opened and stocked libraries around the world with American literature. The USIA opened the first free, open-shelf lending library in Lahore, Pakistan, in 1951. It offered five thousand books and at its peak in the 1980s and '90s had more than ten thousand registered members. Through the libraries and often contiguous "America Houses," the agency dispensed American films, mounted exhibitions, and arranged tours by writers as distinguished as William Faulkner and John Steinbeck, both Nobel Prize winners. These

WORK IN PROGRESS IN ALEXANDER STUDIO

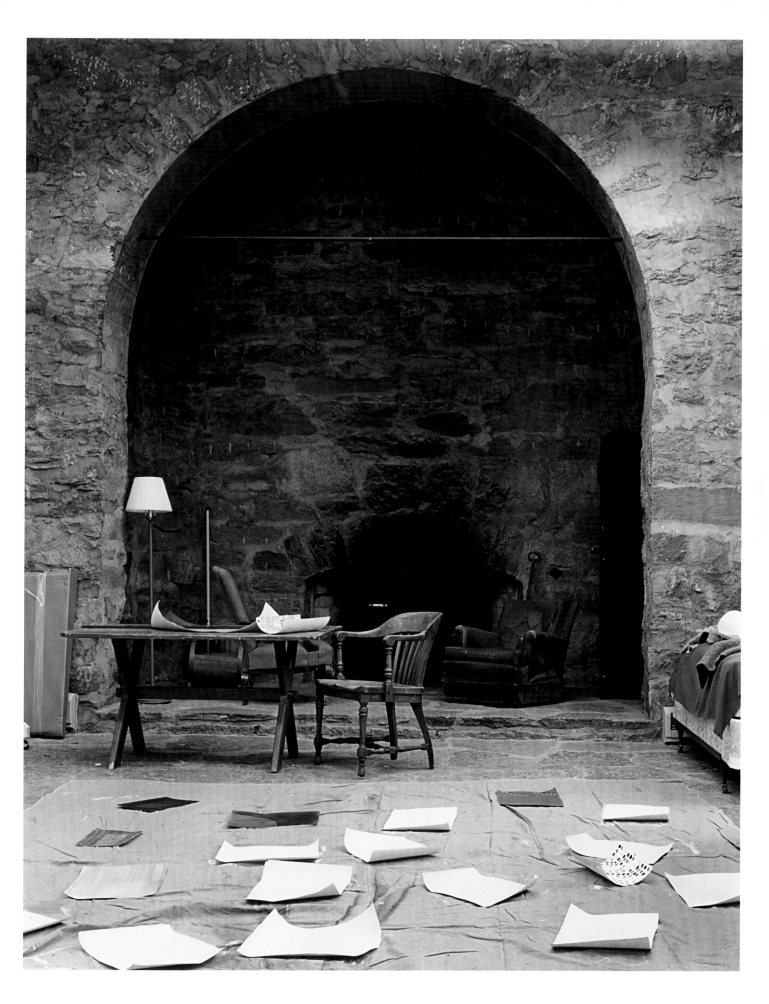

talented ranks included many MacDowell Colonists, among them Milton Avery, Leonard Bernstein, Aaron Copland, and Thornton Wilder.

The USIA sponsored tours by orchestras and popular musicians, dance and theater companies. It published translations of more than twenty thousand books and persuaded American publishers to donate to book fairs. The USIA mounted U.S. pavilions at trade fairs. It was at one such event in Moscow in 1959 that Vice President Richard Nixon and Soviet leader Nikita Khrushchev conducted their public "debate" in a model American kitchen. The USIA published magazines such as *Amerika*, which had limited but eagerly sought circulation within the Soviet Union, while the Voice of America broadcast throughout the communist world. Although heard clandestinely, VOA announcer Willis Conover became a national celebrity in the Soviet Union for his jazz program, *Music USA,* which ran for thirty years.

These efforts were augmented by scholarship programs, chiefly the Fulbrights, under which many thousands of students, teachers, union officials, and artists, American and foreign, lived overseas to enrich their own careers and increase cross-cultural understanding. As a young man, the late Senator Daniel Patrick Moynihan was a Fulbright scholar, as was the poet Sylvia Plath. Among the foreigners given Fulbrights in the U.S. was F. W. de Klerk, ultimately the South African president who released Nelson Mandela and began the country's transformation to a multiracial democracy. De Klerk later said that his USIA-sponsored visit to America was the defining event that changed his ideas about blacks and whites living together. The British historian Arnold Toynbee said, "The Fulbright program is one of the really generous and imaginative things that have been done in the world since World War II."

Covertly, the CIA funded cultural diplomacy through fronts like the Congress for Cultural Freedom. It subsidized periodicals such as *Encounter,* the *Partisan Review,* and the *Kenyon Review*. According to Frances Stonor Saunders in *The Cultural Cold War,* the CIA subsidized the publication of thousands of books, including the *The New Class,* by Milovan Djilas, the Yugoslav dissident who revealed the wealth and corruption among the new communist leadership. The agency also paid for European tours by the Boston Symphony Orchestra and provided the money to make films of George Orwell's books *1984* and *Animal Farm*. The effort was handled subtly enough, often with the complicity of foundations such as Ford and Rockefeller, that the artists did not know they were in effect government agents, although some suspected as much. That many of the writers especially were of the non-communist left gave the effort legitimacy to many, even after the subterfuge was disclosed.

So, overseas, the U.S. government took entirely to heart Winston Churchill's warning in 1943 that "the empires of the future are empires of the mind" and went all out to occupy the world mind, with art given a major role.

At home, even as it confronted the most perilous moments of the cold war over Berlin and Cuba, the White House gave American artists new visibility and celebrity. President John F. Kennedy offered a perspective to balance the militarist hawks of his time: "I am certain that after the dust of centuries has passed over our cities, we too will be remembered not for victories or defeats in battle or in politics, but for our contribution to the human spirit."

Two years after Kennedy's death, President Lyndon Johnson supported the creation of the National Endowment for the Arts (NEA) and the National Endowment for the Humanities (NEH). Johnson said: "Our civilization will largely survive in the works of our creation. There is a quality in art which speaks across the gulf dividing man from man and nation from nation, and century from century. That quality confirms the faith that our common hopes may be more enduring than our conflicting hostilities. Even now men of affairs are struggling to catch up with the insights of great art. The stakes may well be the survival of civilization."

The next decades saw a significant leap in government support for the arts at home and consequent growth in arts institutions. With the Public Broadcasting Act of 1967, noncommercial television began to offer American homes commercial-free performances by first-class orchestras and dance, opera, and theater companies. Stimulated in part by funds from the NEA and the NEH, there was an eruption of nonprofit arts organizations: between the years 1966 and 1996, the number of symphony orchestras grew from 58 to 230; professional theaters from 22 to 420; dance companies from 37 to 250; and opera companies from 27 to 120.

Indeed, so great was the increase that some critics now believe there was an over-building boom, of capacity expanding beyond demand. According to Adrian Ellis, a management consultant, this "fundamentally and adversely altered the ratio of fixed to variable costs," creating a chronic and competitive scramble for funding. This complaint arises in an atmosphere in the arts world decidedly different from the hubris of the 1970s and 1980s, an atmosphere of retrenchment and anxiety driven by a changed political climate.

The outcry in Congress over an exhibition of sadomasochistic photographs by Robert Mapplethorpe and an Andres Serrano show that presented a crucifix submerged in urine symbolized the new era. To survive at all, the NEA had to adopt a "decency

CONSTRUCTED FROM GRANITE QUARRIED ON COLONY GROUNDS,
SAVIDGE LIBRARY HOUSES WORKS BY MACDOWELL FELLOWS AND
SERVES AS AN INFORMAL PRESENTATION SPACE FOR ARTISTS IN
RESIDENCE.

clause," forcing artists accepting endowment funds to agree they would not be used to promote, disseminate, or produce materials "which may be considered obscene." When President Bill Clinton nominated the actress Jane Alexander to be the NEA's chairman, she visited Senator Strom Thurmond. His first question was, "You gonna fund pornography?" To fight off congressional efforts to kill the endowment altogether, Alexander's NEA had to swallow a 40 percent cut in funding and eliminate all but a few grants to individual artists whose work might provoke more political wrath. Deciding after four years that "life was too short to be playing these idiotic games about the value of art," Alexander returned to her distinguished career and, incidentally, joined MacDowell's board of directors.

On public television, when some local stations objected to the "adult" nature of the series *Tales of the City*, stories of San Francisco life by the writer Armistead Maupin, PBS dropped the second season. In that moment, public broadcasting effectively ceded the frontiers of adult taste to commercial cable television.

Taking today's nonprofit arts world as a whole, Alexander's successor as NEA chairman, Bill Ivey, argues that nonprofits are more inclined to compromise with commerce than for-profit arts companies. He told an Internet symposium in 2005: "I think it's been many years since the nonprofit sector has been able to claim any real across-the-board, categorical, artistic superiority when compared to for-profit arts companies. . . . There are always sparklers that light up here and there, but it's pretty hard to characterize the nonprofit sector as a bastion of experimentation and creativity these days." Ed Sherin, for many years executive producer of *Law & Order* on NBC, said that in terms of controversial subject matter, "We took far more risks on *Law & Order* than we ever did in nonprofit theater."

In 2004, the Rand Corporation concluded after a major study, "As late as the 1960s and 1970s, the value of the arts was still a given for the American public. By the 1990s, however, the social and political pressures that culminated in what became known as the *culture wars* put pressure on arts advocates to articulate the public value of the arts." After reviewing all the literature attempting to justify public investment in the arts, compared with such needs as health care and education, Rand concluded that the arguments for the arts promoting social good, community building, and nourishing the values essential to a democracy were difficult to prove. It recommended that the arts community concentrate on selling itself by the "intrinsic" benefits of exposure to the arts for individual enrichment, and argued that more such exposure would build audience and demand.

At the Internet symposium, Midori, the celebrated violinist, exclaimed: "Why do we have to advocate for the arts in the first place? Why do we have to validate ourselves? Why do we continue to struggle to find a meaningful argument in support of the arts? How did we arrive at this slump?"

The arts arrived there because public support, which seemed obvious politically a generation ago, did not seem obvious to the political majority as America moved through the 1990s and into the twenty-first century.

It is true that financial support for the arts from corporations, state art agencies, foundations, and local governments all increased slightly from 1992 to 2000. Yet these sources together represented a tiny fraction of the expenses of nonprofit arts organizations—corporate support representing 0.85 percent, state arts agencies 0.21 percent, foundations 1.9 percent, and local government 0.41 percent.

Indeed, by 2000, local, state, and federal governments were contributing a total of $3 billion to the arts each year but receiving eight times that amount ($24 billion) in tax revenues. Yet nonprofit arts had become a $134 billion industry—$53.2 billion in annual spending by arts organizations plus $80.8 billion in event-related spending by audiences.

In *Arts and Economic Prosperity,* the study that produced these figures, Americans for the Arts, a Washington-based advocacy group, said the message was: "Support for the arts does not come at the expense of economic development." In 2002, the U.S. Conference of Mayors endorsed the study and urged mayors to invest in nonprofit arts organizations "as a catalyst to generate economic impact, stimulate business development, spur urban renewal, attract tourists and area residents, and to improve the overall quality of life in America's cities."

Still, the business community remains wary. American business contributed a record $3.32 billion to support the arts in 2003, mostly at the local level, the most common reason being, "it's a good thing to do." Yet the Business Committee for the Arts, created by David Rockefeller in 1967, reported that 29 percent of the companies surveyed said they were increasingly concerned about evaluating the "return received" for their support for the arts.

So, surveying the arts field at home, artists feel embattled and perplexed at being required to prove their value, even as their industry employs more people (4.9 million) in full-time equivalent jobs—a greater percentage of the U.S work force than accountants, lawyers, physicians, or computer programmers—and produces eight times in taxes what it costs government.

OVERLEAF: FIRTH STUDIO

Where does all this leave MacDowell and some three hundred other residential colonies that have blossomed since Marian and Edward MacDowell founded theirs in 1907? One reality is that we exist at one degree of separation from this cultural warfare. On the most practical level, we shelter artists from political storms. Collectively all American colonies support eight thousand to nine thousand artists a year in all disciplines, a far greater number than are supported by governments, foundations, or corporations. In any case, many such institutions dropped individual artist support from their charitable mission statements after the controversies of the 1990s.

Our colonies provide a heat shield for artists and for people who wish to support artists, without forcing them to pass tests of cultural purity or social acceptability. Artists who receive MacDowell fellowships have to pass through no scanners for impiety, no urine tests for political correctness. The only screening they undergo is from committees of their peers; the only criterion for acceptance is the extent of their talent.

In these colonies, "the arts" are irrelevant: the colonists come to make art. Some may produce great art, and generations beyond us will know their names. Others will not. Some will doubtless be welcomed out in the world for what they say about the condition of being human, of being American, and the freedom of the American mind. Here they can work for a time behind the front lines of the culture wars, away from the noise and stink of the political battles about how to prove the value of the arts.

At MacDowell, artists can avoid the institutional safety and risk-aversion endemic in funding-starved nonprofits. To be creative is to take risks. They may encounter caution later when they offer their plays, stories, poems, paintings, films, or interdisciplinary work in the marketplace, but there is no need to be risk-averse here, at the creation. The genius of the colony system, which MacDowell pioneered, is that it gives artists the freedom to take risks, the freedom to explore their own talent and daring.

Meanwhile, overseas, with the end of the cold war, the United States has beaten a disorderly retreat. If it wasn't the "end of history," to borrow Francis Fukuyama's phrase, it was an end of the largely bipartisan consensus on foreign affairs. Before September 11, 2001, policy makers looked inward, leading media cut their foreign staffs, and cultural diplomacy became almost extinct.

Overseas, the U.S. libraries shut down or greatly reduced their programs. America Houses were closed and the USIA, with its direct access to the President, was folded into the State Department in 1999, its staff of twelve thousand (in the 1960s) reduced by half. The annual number of academic and cultural exchanges fell from forty-five thousand in 1995 to twenty-nine thousand in 2001. Joseph Nye, writing in *Foreign Affairs,* said,

"When Washington discounts the importance of its attractiveness abroad, the U.S. pays a steep price."

In effect, cultural diplomacy, which often promoted "high art," or "the fine arts," was displaced by the growing dominance of American popular culture in world markets, for example, the penetration of American movies into foreign theaters. In 1985, Hollywood movies accounted for 41 percent of the tickets bought by Western Europeans; by 1995, the proportion was 75 percent. According to Toby Miller of New York University, "Europe is Hollywood's most valuable territory."

By 1996, sales of film, music, television, software, journals, and books had become America's largest export, ahead of aerospace, defense, cars, and agriculture. Culture exports were not only big business but produced a surplus in the balance of payments, helping to reduce the chronic trade deficit.

This dominance provoked interesting reactions. In general terms, foreigners, especially the young, liked the American product. Surveys by the Pew Research Center for the People and the Press found that majorities in most countries said they enjoyed American entertainment. The exceptions were Russia and several Muslim countries, with the most vehemently negative being Pakistan, Washington's important ally in the war on terrorism. Kim Campbell, formerly prime minister of Canada, remarked, "images of America are so pervasive in this global village that it is almost as if, instead of the world immigrating to America, America has emigrated to the world, allowing people to aspire to be Americans even in distant countries." Intellectual elites may bemoan the economic and cultural imperialism they see behind this penetration of their cultural space, but there is little they can do in a free-trade world to stop their public from gobbling up the American product. Even when authoritarian regimes erect barriers, in the digital age their young sneak through them with ease.

The huge success of American popular culture in the business sense disturbs some Americans, who fear that exporting it provokes hostility among foreign opinion leaders and does not represent the best of America. A study for the Center for Arts and Culture, a citizens' group in Washington, D.C., said, "These products cannot suffice as a reflection of U.S. culture, particularly in an increasingly polarized world where such free-market expressions risk offending and shutting down attempts at reciprocal communication."

At the same time, opinion surveys showed a distressing rise of anti-American sentiment around the world, particularly virulent in Muslim countries, but also evident among longtime allies and friends of the United States, for example, in Western Europe. It was

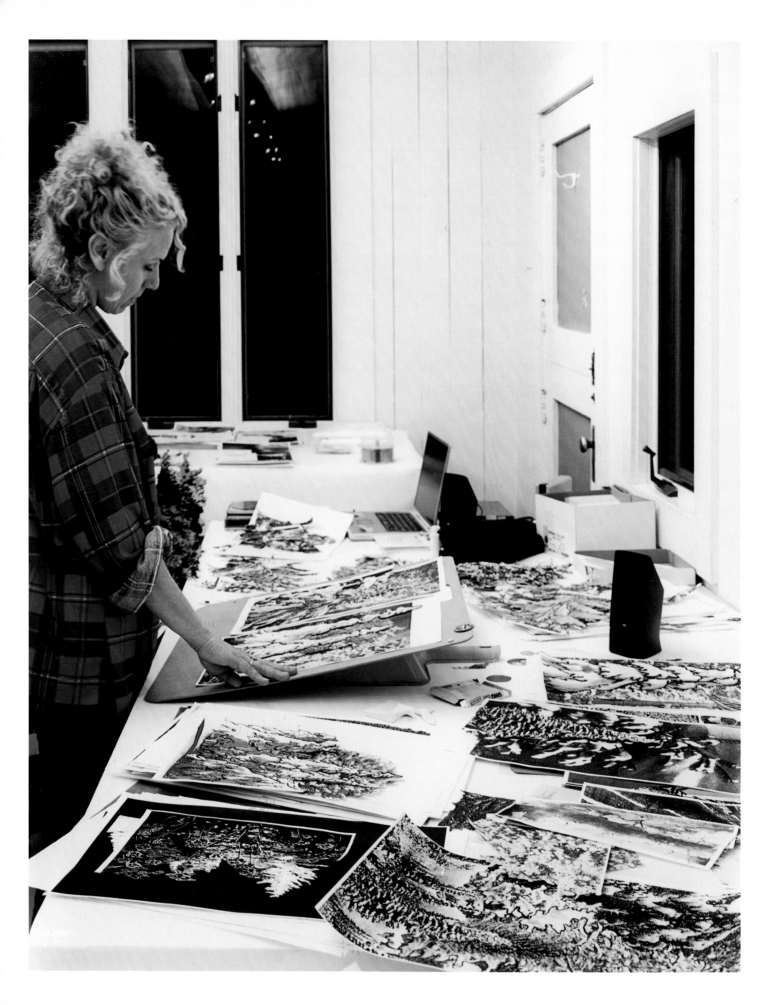

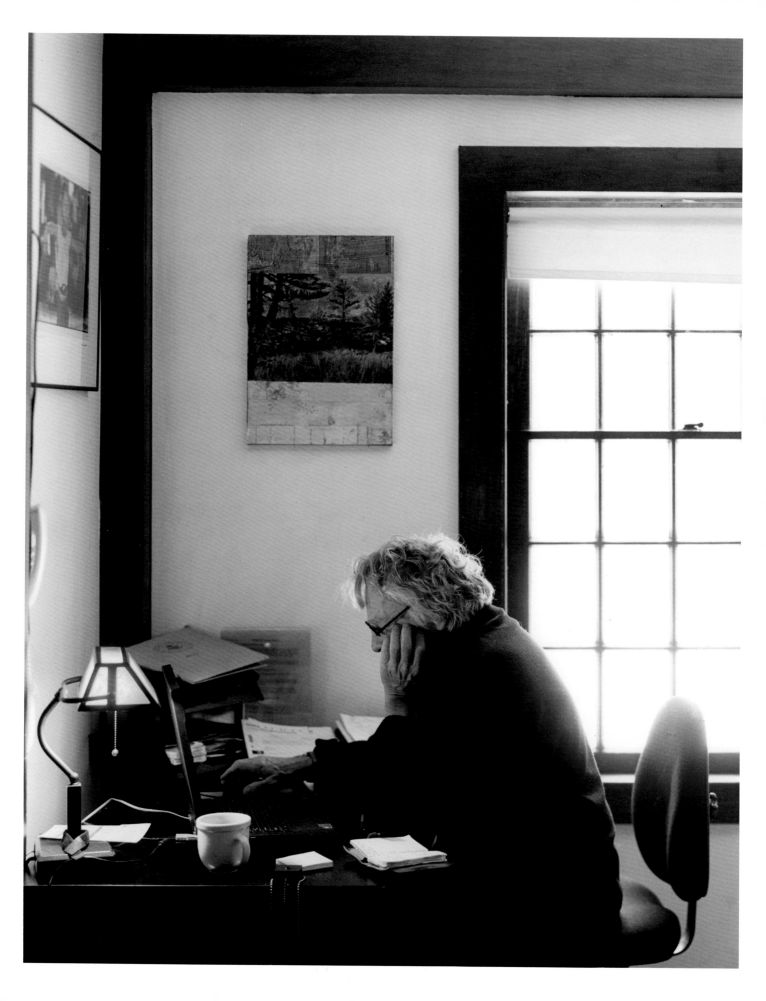

attributed to many factors, led by opposition to the invasion of Iraq in 2003, but the result was that the enormous upwelling of pro-American feeling just after the Al Qaeda attacks of September 11, 2001, dissipated rapidly. Leslie Gelb, now president emeritus of the Council on Foreign Relations, wrote that negative opinions of the U.S. and its policies had "metastasized" due to a "fundamental loss of goodwill and trust from publics around the world."

A survey of teenagers in twelve countries by Margaret H. DeFleur and Marvin L. DeFleur of Boston University, entitled *The Next Generation's Image of Americans,* found that, with variations among countries, "these youngsters think they know a lot about us":

> They are convinced, for example, that we are violent, materialistic and want to dominate other people. . . . They believe that we do not respect "people like us," are not generous, are not concerned about the poor, that we lack strong family values and are not peaceful. They also believe that we engage in criminal activities and many American women are sexually immoral. So what is there to admire or respect about such people?

> That from watching American movies and television!

By the year 2000, official America began to worry that it had cut back too far. Helena Kane Finn, former acting assistant secretary of state for educational and cultural affairs, told a conference on cultural diplomacy, "When America became the sole superpower, everyone wanted American blue jeans and Coca Cola, so why bother with libraries and dance troupes? Our stunningly isolationist Congress, an amazing mismatch for our new leadership role, challenged the idea that we would want to disseminate information about the United States through cultural centers and libraries."

In March 2000, the Clinton White House convened a conference with writers and performers from around the world. The Aga Khan pleaded for greater contact with the Muslim world, eighteen months before September 11. After the 2001 attacks, the acute need to find common ground with the Islamic world inspired instant programs to train more Arabic speakers and to create TV and radio stations beaming the American message into Arabic-speaking countries.

In many conferences and symposia, members of the foreign policy community, congressional committees, and citizens' groups began calling for a revival of public and cultural diplomacy. After widely criticized efforts by two Bush appointees, former

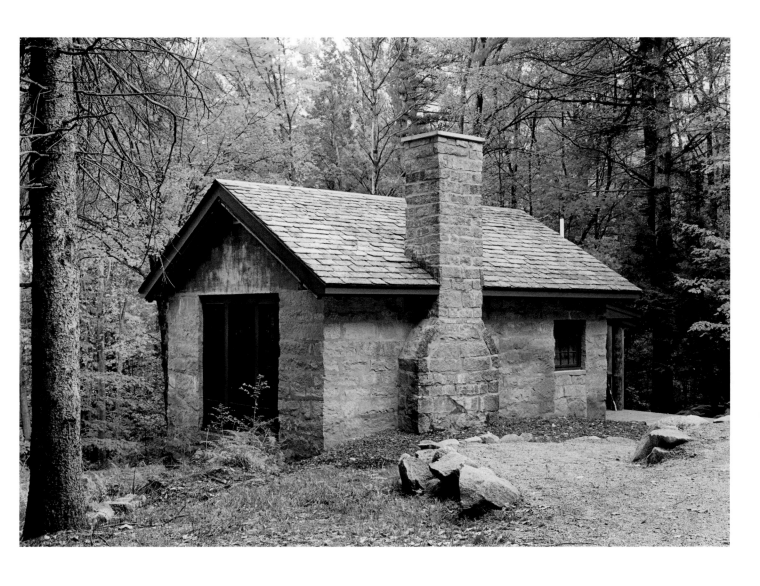

DESIGNED BY F. WINSOR, JR., THE SAME ARCHITECT RESPONSIBLE FOR SAVIDGE LIBRARY, MIXTER STUDIO WAS RENOVATED IN 2004 TO ACCOMMODATE FILMMAKERS.

advertising executive Charlotte Beers, and Margaret Tutwiler, former aide to James Baker, President George W. Bush signaled a new level of importance by appointing one of his closest advisers, Karen Hughes, as under secretary of state for public diplomacy. Her job was to combat negative views of the U.S. and promote U.S. values — democracy, tolerance and pluralism — particularly in Islamic countries.

One of the strong advocates for renewing cultural diplomacy is Cynthia Schneider, former U.S. ambassador to the Netherlands, now at Georgetown University. In her paper "Diplomacy That Works: 'Best Practices' in Cultural Diplomacy," Schneider says that cultural diplomacy "in all its variety provides a critical, maybe even the best, tool to communicate the intangibles that make America great: individual freedom, justice and opportunity for all; diversity and tolerance."

Congress authorized a Cultural Diplomacy Advisory Committee. The State Department launched a program entitled Culture Connect and appointed ten cultural ambassadors with the goal of strengthening relationships among diverse cultures of the world, especially among younger people.

There are those who argue that public/cultural diplomacy, in the words of pollster Andrew Kohut, director of the Pew Center, "can only affect attitudes toward the United States on the margin, given the magnitude of the problem." Kohut told a conference at Columbia University, "It's what we do, not our style, not our culture. It's not the messenger, it's the message."

Those who urge more cultural as well as public diplomacy base their case on several realities beyond the hostility toward the U.S. A study published by the NEA in 2000 showed that the United States was last of twelve developed (OECD) countries in government expenditure on the arts. U.S. government support — federal, state, and local — represented $6 per person, or 0.02 percent of gross domestic product. Germany spent $85 per person (0.36 percent of GDP) and France $57 (0.26 percent of GDP). While the study acknowledged that the American tradition was different, depending heavily on private-sector support, the comparisons showed a very different order of public priorities. Germany and France have long made government-financed cultural exchanges an important tool of diplomacy.

In the revived discussion of public diplomacy, one of the recurrent arguments is that exposure to American art — music, literature, painting, sculpture, any medium — carries a message of freedom. The intellectual freedom American artists represented, the freedom to agree or disagree with their own government, was a powerful lesson in American values. Arthur Miller's plays, often more admired abroad than at home, could speak of

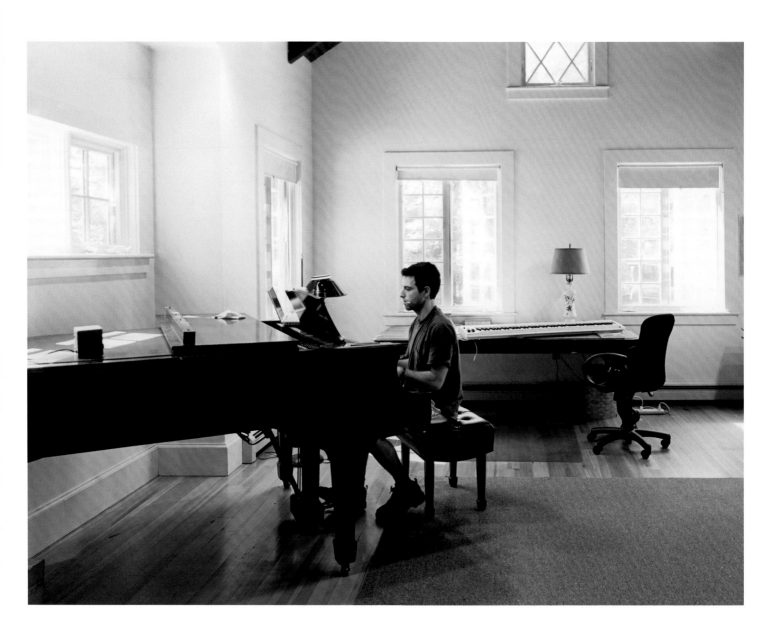

disillusionment with the American dream (*The Death of a Salesman*) or the right of an American citizen to speak and think freely in the face of McCarthyism (*The Crucible*). All this had credibility among foreigners that few speeches by ambassadors could match.

The State Department's efforts could also produce ironic or hypocritical messages. The most successful sponsored trips by far were by jazz musicians such as Louis Armstrong, Duke Ellington, and Dizzy Gillespie. In her book *Satchmo Blows up the World: Jazz Ambassadors Play the Cold War*, Penny M. Von Eschen says that the tours were a deliberate campaign to counter worldwide criticism of American racism, when the country was still a Jim Crow nation.

In some art forms—dance, painting, music, and literature—American artists had a particularly compelling international cachet: in the twentieth century they had regularly broken new ground, and the avant-garde—in painting, for example—moved from Paris to New York.

The recent effort to justify art as public good has resurrected other arguments, in particular its value to democracy itself. In *Cultivating Humanity: A Classical Defense of Reform in Liberal Education,* Martha Nussbaum wrote that democracies needed citizens who can think for themselves rather than deferring to authority, citizens with "an ability to see themselves not simply as citizens of some local region or group but also, and above all, as human beings bound to all other human beings by the ties of recognition and concern."

The Rand study talked of "the ways aesthetic experiences can shape an individual's moral understanding, and, likewise, how such experiences can help develop the sympathetic imagination so important in a democratic, pluralistic society." The receptivity to unfamiliar people, attitudes, and cultures that art requires, the report said, "can be unsettling and provocative, and can lead us to question our routine and conventional perceptions of the world, forcing us to look with fresh eyes on private and public questions involving sexuality, love, marriage, family, spirituality, slavery, segregation, gender, ethnicity, colonialism, and war, just to name a few of the more obvious."

These are precisely what fundamentalists—religious or cultural, American or foreign—do not want their followers to question. The issue is at the heart of the culture wars we face both at home and abroad.

It is interesting to speculate where the new concern for the role of culture in shaping our image in the world will lead. One might argue that the threats the nation faces are not as dire as the nuclear terror of the cold war, yet they have been considered grave enough to transform homeland security, foreign policy, intelligence gathering, and the

role of the military. As the cold war demonstrated, not only our hard power but our soft power, our appeal to shared values and common decency in humanity, eventually prevailed and, in prevailing, our artists were on the front lines. A major effort to put them there again—on the scale of another program like Fulbright—would cost little compared to military budgets and homeland security. And if the arts were again considered vital to national security, this attitude would have to reflect on the American artists who produce it. It might then occur to some that if art is good in promoting democracy and American values abroad, so it is at home.

That is apparently what Thomas Jefferson had in mind in 1792 when he wrote to James Madison from France: "You see, I'm an enthusiast on the subject of the arts, but it is an enthusiasm of which I am not ashamed as its object is to improve the taste of my countrymen, to increase their reputation, to reconcile them to the respect of the world, and to procure them its praise."

A new theme to emerge is that the United States risks losing its competitive edge in the world unless it creates a new climate for creativity. Arts advocates say that in many fields, but particularly in education, the creative state of mind that artists inhabit can be replicated. Originality can be encouraged, creativity stimulated.

This new anxiety is fed by awareness that the stream of highly talented foreign students who used to come in large numbers to graduate schools in the U.S. is slowing, due in part to anti-American political attitudes and by immigration restrictions imposed to prevent terrorists from entering the country. Also, nations such as China and India are competing effectively for these graduates and offering them better futures at home.

Some believe that in creative terms the U.S. has passed its peak, that its high noon, as one author put it, is over, due to the newly competitive global economy. John Brown, a former Foreign Service officer now at Georgetown University, argues that even in the mass entertainment field, "America is increasingly perceived as an old new world, with few remaining sparks of cultural originality." India and other countries have learned how to ape American moviemaking techniques so that movies made in Calcutta can reach even more people around the world than Hollywood's product.

In the *Harvard Business Review*, Richard Florida has written that the U.S. must begin to think of creativity as a common good, like liberty or security. Ranked by the percentage of its workers in what he calls the "creative class," the U.S. is eleventh in the world. Florida notes, "The data create an unsettling picture of a nation that's allowing its creative infrastructure to decay. Add to that greater security concerns and a highly politicized scientific climate, and it's easy to see why the nation is becoming less and less

attractive to the world's brightest minds." He concludes that unless the U.S. invests the equivalent of a G.I. Bill in its creative infrastructure, "over time, terror is less a threat to the U.S. than the possibility that creative and talented people will stop wanting to live within its borders."

The U.S. was the first great nation self-consciously to create itself, and it has lived ever since in a ferment of creativity—social, scientific, technological, and artistic. To remain so in a far more competitive world, Americans will have to restimulate the creative spirit in all fields. For that, no more inspiring model exists than The MacDowell Colony, which for a hundred years has guaranteed the freedom to create and, we trust, will do so for the next hundred.

OVERLEAF: MONDAY MUSIC STUDIO

THE PERMANENCE OF CREATIVITY

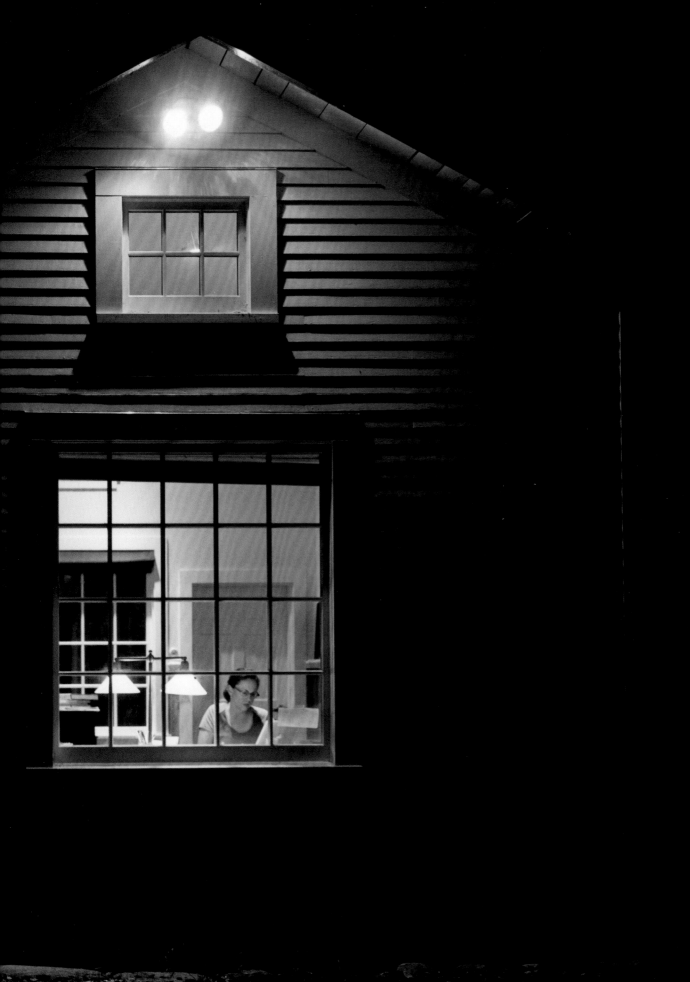

Extended Ownership
Peter Cameron

While Marian MacDowell was alive, I'm sure she felt that The MacDowell Colony was hers. And I'm sure it felt that way to others—it was, after all, her land, her idea, and her tireless campaigning that first formed and later sustained the miracle that is MacDowell. It makes a certain sense that the Colony prospered under Marian's stewardship—organizations with vital leaders often do. But it is the rare organization that suffers the loss of its founder's guiding hand with the relative grace with which MacDowell has progressed through the past fifty years. This is no doubt partly due to the purity and simplicity of Mrs. MacDowell's vision and MacDowell's subsequent purpose: the needs it serves have neither changed nor abated, and its way of meeting those needs has required little adjustment over the years. Because MacDowell deals in the most elemental commodities—time and space—its modus operandi is, in every essential way, constant: Providing a studio. A basket lunch. A fireplace. A screened porch. Bed, and meals. Inspired, and inspiring, companionship.

From those early groups of settlers who ventured out onto the prairie or into the wilderness to create communities of perfect accord, to the modern communes that attempted to transcend barriers of gender, race, religion, and class, Americans have always had a dream of creating communities that succeeded in ennobling every one of their citizens. Yet few, if any, of these communities have prospered, let alone survived. And then there is MacDowell, which is celebrating its centennial.

I think there are many reasons why MacDowell has prospered while other planned communities have failed. For one thing it is not a fixed or insular community—in fact, it is a community in constant flux: the Colony Fellows change with what sometimes seems to be farcical frequency, the staff evolves, and its large board of directors is constantly renewing itself. And I think, for the most part, people—Colonists, staff, directors—bring their very best and most ardent selves to MacDowell. There are, of course, disturbances (financial, administrative, meteorological), but these occur in a biosphere where, however violently shaken, the snow always settles perfectly and prettily. And I mean that

OPPOSITE: PHI BETA FRATERNITY FOR THE CREATIVE AND PERFORMING ARTS PROVIDED THE FUNDS FOR PHI BETA STUDIO IN 1931. FILMMAKER JESSICA YU, PLAYWRIGHT SUZAN-LORI PARKS, AND NOVELISTS AMY BLOOM AND ANN PATCHETT HAVE ALL WORKED IN PHI BETA.

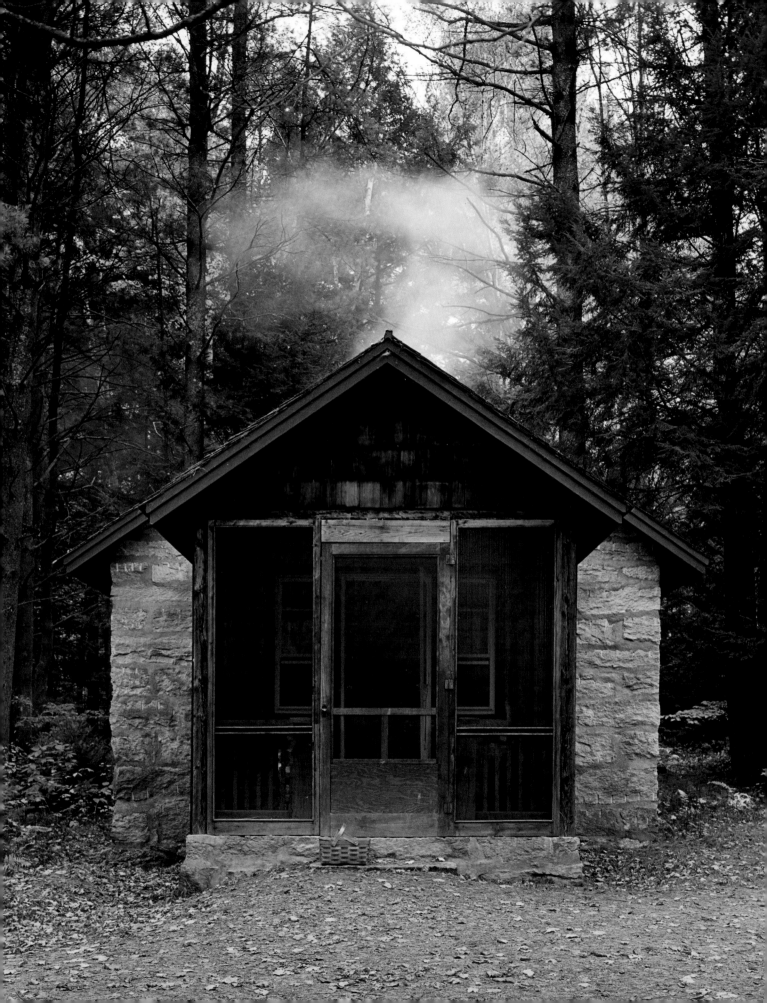

literally as well as figuratively, for it is impossible to walk across a wildflower-flecked summer meadow or down a pristinely snow-covered dirt road on a starlit winter night, and not give into that greater good that the physical world of MacDowell so relentlessly, and persuasively, insists upon.

Ownership is usually closely allied with power—it is often about exclusion, privilege, commerce. Yet ownership means something quite different at MacDowell. It is neither fixed nor concentrated—it is, in the truest sense, communal. MacDowell is owned by those who invest themselves in the place by either working at it or for it. But at the end of every day—all 365 of them—the people who own MacDowell most surely are the people who are in residence there.

This is made clear to me every time I arrive at MacDowell. No matter how many times I have been there before, no matter how surely I think my many memories make the place in some way mine, it becomes immediately clear to me that the first night at dinner that this is not so: the artists who have preceded me, whether by a day or a month, are the ones who own this place. For the MacDowell I last knew and thought I owned is gone—MacDowell is reinvented daily, weekly, with the arrival of each new Colonist. Even the studios I've worked in, where I have felt at home in the deepest possible way, are mine only fleetingly: to revisit them on another stay, and see someone else's books, papers, life strewn about, is to realize that the tombstones that line the wall record not only who has worked and lived in this space, but who has possessed it, by dint of inhabiting it at sacred or desperate moments. It is like those hotel rooms you once made thrilling love in—it is impossible to imagine anyone else inhabiting that space in a comparable way, but if the walls could talk, they would set you straight. "I should like to bury a pot of gold at every place I was ever happy," Sebastian Flyte tells Charles Rider as they lounge beneath a tree, having finished a picnic of champagne and strawberries, in the early idyllic days of their friendship. Buried gold, one's name tattooed onto a wooden plaque—these are the ways we stake the ground of our heavens on earth.

But MacDowell can be Hell. For an artist, there are few fates worse than being stuck in a cabin in the woods with a putrefying canvas, or manuscript, or idea. There are only so many walks (and naps) you can take, books you can read, only so many times you can check for mail or messages—you must keep returning to the small lonely room that seems to contain only your inept mediocrity. And knowing that the woods are alive with the sounds of artists creating, creating, creating is enough to drive you mad. I have had a few stays like that, and they are not pretty, but I have learned they are valuable, and time well (if difficultly) spent, for they move me faster toward the time and place where I

finally see the light glittering in the ruined darkness, like something precious at the bottom of a well.

I mention this because I think these moments of despair are as much a part of an artist's life as the moments of fantastic inspiration, when everything finally comes together, and the bicycle pedals you euphorically downhill. These moments of joy and despair are the rare extremes of an artist's life, but they are common at MacDowell, for nowhere else in the world are we given the opportunity of living so intensely with our work.

It can get a bit creepy, late at night, looking at the names on those wooden plaques bearing former Colony Fellows' names, some disappearing beneath the bruise of time. So much of art is futile—unappreciated or unacknowledged, forgotten or unseen. But, oh —to be given a place to be alive in and create art, a place in the woods, a fireplace, a screened porch, a window, a birch tree iridescent in a stand of pines, a field of snow.

What happens to a place, to a certain four hundred acres, when people have been ceaselessly creating, endeavoring to express the best and truest aspects of themselves over one hundred years? I think something extraordinary happens. If battlefields—those places that witness and absorb our most violent and destructive tendencies—are sacred, and if graveyards belong to the dead, then I think MacDowell is no less sacred, and as surely owned. Owned by the artists who are alive and creating there at this very moment, and will be in the centuries to come.

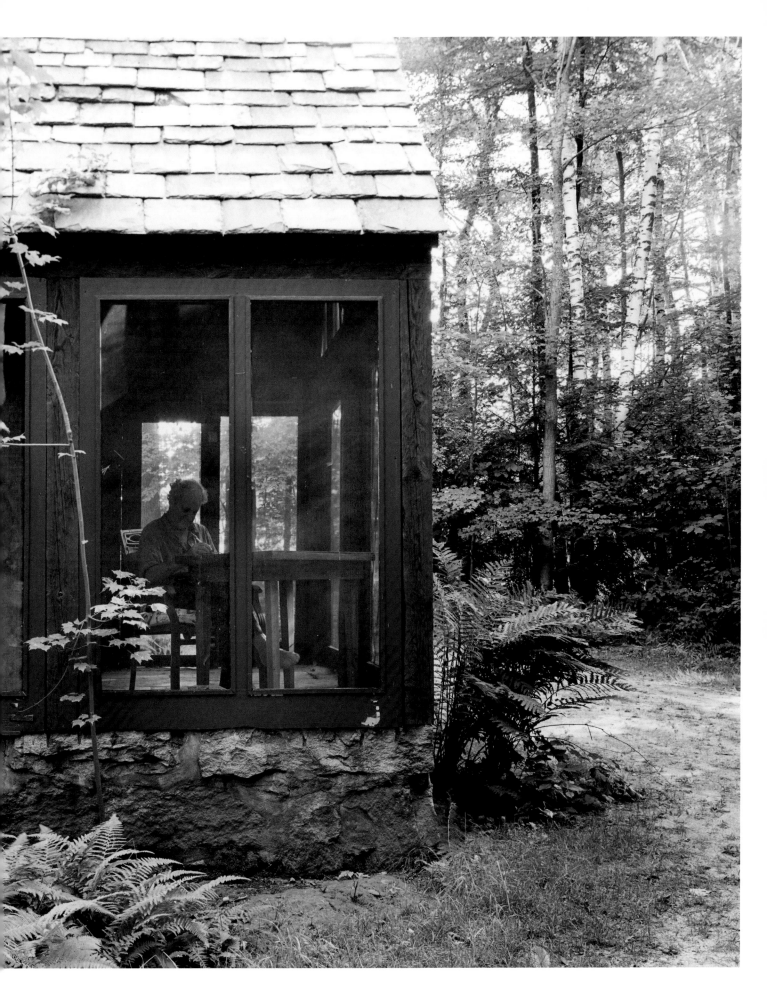

The Ghosts That Provoke
Michael Chabon

It was too hot in Eaves. It was too hot, and too dry, and Amanda was having sinus headaches, and somebody had given her a Soma, and somebody else was taking too many too-long baths and singing (or *something*) in this weird voice, and Amanda was having troubles with her agent, and the battery in her trusty strap-on forehead flashlight was on the blink, and there were other factors that I missed or forgot to pay attention to, but anyway the long and the short of it was that Amanda Davis needed my humidifier. Needed it *at once*, with characteristic urgency and the whole of her being. It was 9:30 at night, and the humidifier was in my studio, and apart from Joanna Morrissey, the Colony's photographer, I had never had anybody into my studio at MacDowell, ever, not even for one second. It would be, I thought, like letting somebody into your lung, or into your medulla oblongata. I had forced even poor Joanna to take most of the pictures out-side through the sheer force of my leeriness.

The humidifier sat disused in a corner of Calderwood, crafted in a homely, 1979 shade of putty brown, vaguely Soviet in design, with a water reservoir that must at one point have been as smooth and transparent as Amanda's prose but was now scratched and coated with hard-water deposits. The whole apparatus seemed, in fact, to be in want of sandblasting and had an indefinable air of skankiness, which was why I had never bothered to fill and plug it in, even though it was so dry in the studio (Calderwood being a "live-in," or combination studio-and-bedroom) that in the middle of the night, when I reached across the blanket for my water glass, my arm was trailed by a tiny display of static-electric fireworks.

I had tried to warn my friend Amanda—we were okay friends before our two-week overlap at MacDowell, and after it, for the unforeseeably brief time that remained to us, true-blue—about the unpromising appearance of the humidifier in my studio, which I now regretted having mentioned at all, but the woman lived and died by smiling at the warnings of caution gnomes like me, and after she recovered from her initial reluctance

THE NEWEST STUDIO AT MACDOWELL, CALDERWOOD, OPENED IN 2000. SCORED IN GRANITE BY THE FIREPLACE IS A QUOTATION FROM THE STUDIO'S NAMESAKE, STANFORD CALDERWOOD: "THERE IS ONE PLEASURE — AND ONE ONLY — THAT I ENJOY EVERY SINGLE DAY OF MY LIFE. THAT PLEASURE IS READING."

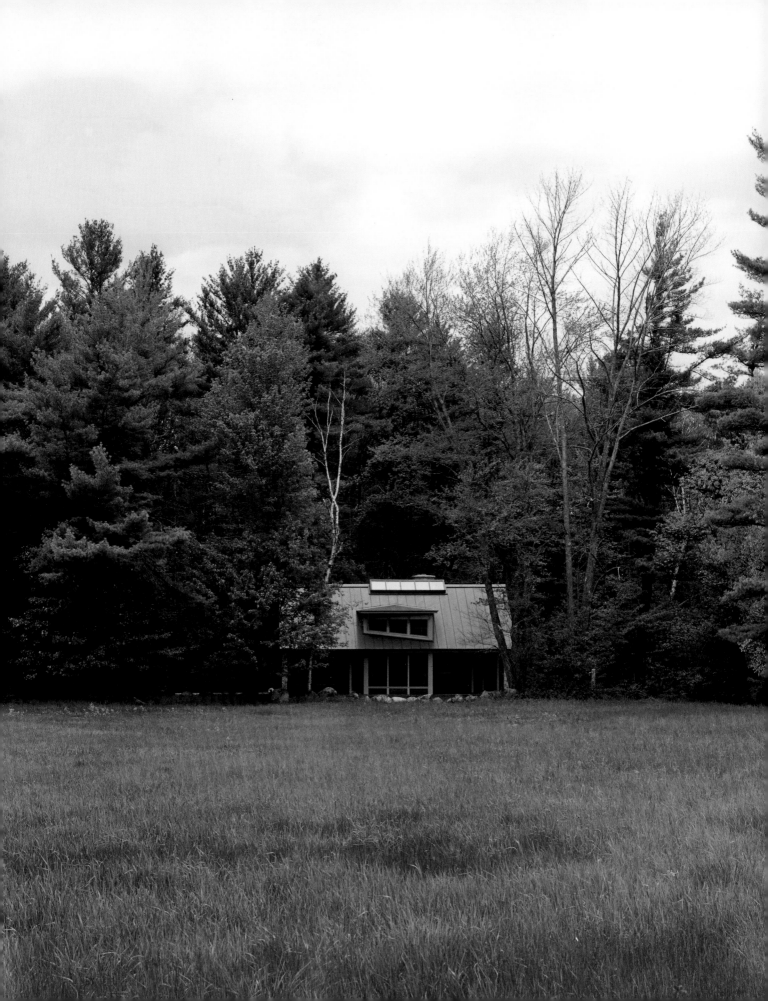

to breathe moist air (or anything else for that matter) emitted by that thing in the corner, she went to work on it with a Scotch Brite sponge and a bottle of cleaning product that she discovered under the sink.

The next forty-seven minutes were spent in cleaning the calcified humidifier, and while she scrubbed and rinsed and scrubbed, the sleeves of her sweater pushed back, blowing her hair out of her face, we talked about books that we loved, and the things that were and were not working in our current projects, and the worst bad jobs we'd had (she won), and whether or not dessert had been good (we both agreed that the name "Indian pudding" seemed to promise more than it delivered), and the Colonists who were here now and the various curious features and points of interest and crotchets they displayed, and Colonists who were not here now, but who had been here, with one or the other of us, in prior years—the ghost of residencies past.

At minute forty-eight, my eye happened to alight on the label of the bottle of cleaner, and found that its text included an extremely tiny warning that read (more or less) DO NOT EVER BREATHE MOIST AIR EMITTED BY AN ANCIENT HUMIDIFIER THAT HAS BEEN CLEANED WITH THIS PRODUCT or words to that effect. Sadly, wearily, a little bitterly, hands scrubbed raw, she returned the old machine, now sparkling-clean and ready to humidify the bedroom of a Colonist or of some Red Army field marshal with eczema, to its corner. We hugged awkwardly—I loved Amanda, but I still felt weird about having somebody in my studio—and she tromped off into the night, her forehead-light dancing and slicing the darkness, and periodically winking out as if in token of her disappointment.

Both of us forgot to mention the deadly but clean humidifier to my wife, who subsequently stayed in Calderwood, where she used it for two weeks without apparent ill effect.

Exactly one year later, I was back at MacDowell again, doing my laundry, and there on a shelf over the workbench sat the humidifier—Amanda's humidifier, as I now thought of it, though of course she had never used it. Somehow it had gravitated back to the basement of Colony Hall, conforming to the secret trajectories, following the lay lines and invisible forces that control the migratory behavior of alarm clocks, flashlights, bedspreads, spare table lamps, typist's chairs, thesauruses, from studio to studio at MacDowell. And so here it was. And here Amanda was not.

I sat at dinner every night, that next year, with the latest crop of my fellow Colonists, and we talked about the food, and about how long we had left to go in our stays, and who was leaving soon, and who was supposed to be showing up in the next week or two.

The people whose work had gone well that day were appropriately modest but secretly burning with the ardor of it, which those of us whose work had not gone well noted with the acute sensitivity of self-reproach. The previous year, I had always sat next to Amanda at dinner, and let her (as if I had any choice) talk my ear off. This year I had to do the talking myself. Amanda had been killed in the crash of her father's small plane, in North Carolina, on March 14 of the previous year, not long after our time together at MacDowell.

After you've enjoyed a few residencies at MacDowell, the experiences you had and the people you met and got to know become interleaved. They never blur, at least not for me, any more than my experiences of the four separate years of high school or college blur. Each of them comes fitted, in memory, with its own set of faces, books read, setbacks encountered and breakthroughs achieved, mishaps and dance parties, the inside-out movie and mind-altering tone-poem of a fellow Colonist that you puzzled over as you crunched home through the moonlight and the snow. Every time you go back, and reencounter the relatively unchanging routines and traditions of the place, the reliable assortment of odors and views the place affords, you can't help thinking about what's missing: the people you were there with before. For the length of your stay, they're as much a part of the landscape and ambience as the walls of your studio, the smell of clam chowder coming from an open thermos, the way your lunch basket creaks as you hurry up the road to get it back to the kitchen by 4 P.M. Their subsequent absence (unless your residencies happen to coincide again), when everything else is so much as it was before, feels poignant and somehow stark, especially if you go, as I generally have, in the dead of winter.

Work in any studio at MacDowell, and your efforts are observed by the names on the "tombstones." These are the wooden boards, rounded or pointed at the top, on which all the artists who work in any given studio sign their names, on departing, and give the dates of their tenure there. The tombstones get hung from nails on the wall, one after the other, year after year, and in the oldest studios you can see them by the dozen. Given the nickname, I guess everybody who works long enough in one of those older studios — or rather, staring at the walls, avoids work long enough — remarks after a while that many of the artists and writers and composers whose names appear on the tombstones are, or by now must be, dead. Some of the tombstones have been hanging there on the wall for so long that the names on them, like inscriptions on their weathered namesakes in old New Hampshire churchyards, have faded to illegibility. They are meant to be, I suppose, the record of an active human presence, of the continuity and collective nature of artistic endeavor, but I have always found them to be a powerful reminder of oblivion.

I think that it's in this sharpened consciousness of our transience — the way that snow and salt and leaves keep going about their business, and pancakes keep getting fried, and experimental films keep tying grand loops in the mind, and footprints in a sandy road keep filling up with rain — that MacDowell offers its greatest power and benefit to the artist. It's no wonder that Thornton Wilder worked on *Our Town* at MacDowell, bringing a graveyard onto the stage, and filling the world — or reminding us of how the world is filled — with the presence of the dead. Art is long, and life is short, and no matter how well you know that to be true, *feeling* it — having vanished faces and stories and names and styles of dress and conversation come springing back to you with sudden force every time you do the laundry, or turn on the lights in the library — strengthens and emboldens you and dares you to leave some kind of a mark, on your tombstone, that time may not efface. It's a vain effort, for most of us, but that didn't stop Amanda, and whenever I go back to MacDowell I'll be struck by all those chance reminders of her, and I'll think of her bold example every time I pass my hand across the blanket of my bed, and a bright spray of sparks breaks the darkness.

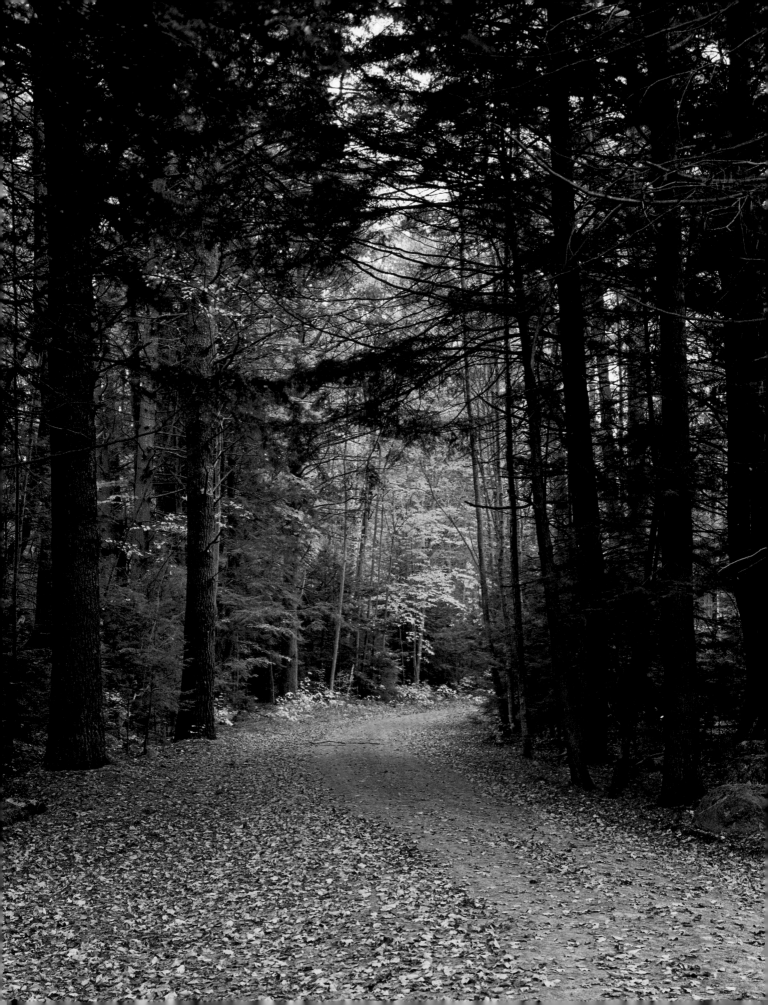

Passing It On
Jacqueline Woodson

August is almost over when I step out of my car in Peterborough. I am nervous about the two months ahead of me at what until this point I've only known as *one of the most prestigious writing colonies in the country*. If so, I am thinking now — months after my letter of acceptance arrived — why did they choose *me*? Ask myself this again as I am greeted by the hush of Colony Hall, the soft-spoken people who smile and show me around. Ask again that night at dinner as writers I've read, composers I've studied, artists whose work I've seen in art museums come out to greet me. Years later, I will come to know this feeling as "imposter syndrome," will come to know MacDowell as the first place where the feeling surfaced and the place, too, where it slowly began to subside. Here, in Peterborough, where save for at the Colony there are few people of color, I will begin to write about what it means to be young and black; as if by doing so I can bring other blacks into this loving and lonely space, a space where the absence of color makes me hyperaware of my own. A space where as an artist I am revered and respected. How lost am I here, how utterly and fantastically afraid.

·

It is the summer of 1973 and I am ten years old. For three years now, when asked — as I often am — what I want to be when I grow up, my answer has remained the same: a writer. In this working-class poor neighborhood, in the Bushwick section of Brooklyn, my answer is met with raised eyebrows and worried glances toward my mother, who prompts, "And…"

"And a teacher too."

But I am lying. I don't want to be a teacher. I don't even like most of my teachers. For three years, I have been coached to answer this way as a means of salving their anxiety over my unrealistic, very real desire to spend my life writing. A part of me believes that this will happen but at ten, I have never met a black writer, have never read a book by a person of color. My neighborhood doesn't exist beyond my experience of it. My childhood, I believe, is like no one else's. At ten, I don't know that I am invisible, don't have this language yet. What I do know is that I love the look of my name Jacqueline Amanda Woodson written across the page—even better when a title and the word "by" precede

it. What I know is that there are so many stories living inside my head and when I sit in my backyard writing them down, I feel whole and good and powerful.

•

Winter now. In a few months, I'll turn eleven. This morning, my teacher presses a book into my hand—*Zeely*, by Virginia Hamilton.

"She's a lot like you," my teacher says.

I am an odd girl—too tall, too thin. Most days, I'd rather be alone with pencil and paper. The stories come and keep on coming—black girls in pretty dresses who are beautiful and love to dance, grandmothers who fry chicken on warm Sunday afternoons, boys playing scully and spinning tops, teenagers doing dances in the streets—my world, on the page. When I speak, the words race out of me and tumble over themselves. *Slow down,* people stay. *Stick to one story. Get to the point.* But there are so many points. And never enough time to tell the whole story.

"Like me how?"

"Young," my teacher says. "Black. Female."

This moment is with me still.

•

We are pleased to inform you... You have a voice... Publication date to be determined...

•

Dear Jacqueline Woodson,
In your book...did anything like that ever happen to you?
I'm in the seventh grade and my mom...

Dear Jacqueline Woodson,
Can a person be a writer if their family doesn't have a lot of money to publish a book?

Dear Ms. Woodson,
Are you black?

Dear Jacqueline Woodson,
I hate, hate, hate, hate reading and my teacher said she's in shock 'cause I finished read-
ing....I wonder if you wrote that book about me 'cause my friends and me...

Dear Jacqueline Woodson,
Will you read some of my poems and come to my school? Do you know celebrities?

Dear Jacqueline Woodson,
I like Virginia Hamilton and James Baldwin, too. I write everyday, too. My mom says I
should be a lawyer.

Dear Jacqueline Woodson,
What's your favorite color? Food? Season? Book?

As if to ask, Who *are* you?

•

It is spring when the letter comes. Almost twenty years have passed since that summer
of 1973. During the day, I work with runaway and homeless children, teaching them the
importance of their voice. At night, I write.

We are pleased to inform you...

I call my grandmother first. "I've gotten a fellowship. They're giving me two months to
live in the woods and write!"

"Is that some kind of cult, Jackie? You know me and your mama worry about you."

I am the first writer in my family. *We are pleased to inform you...*

•

Four mornings a week, I go downstairs to my office and sit at my writing desk. In the years since I wrote my first book, I've met thousands of young people in the U.S. and in other countries. Too often still, they are surprised that I'm a woman of color. Even more surprising is that I didn't come from a long line of writers, that my family was not well-off.

But what is most surprising for too many young people is that they can find themselves on the page, that they can open a book and feel something I did not feel for so much of my childhood: legitimized.

This morning, I try not to think about the thirteen-year-old in Texas who is going into business because her parents "don't want me to be a writer." I try not to remember how her words moved easily across the page in a way that made me believe she was way beyond her years—as an artist, as a human being. I begin to tell a story about a boy living in Brooklyn and try not to let my mind wander to that school in Brooklyn where forty-eight African-American fifth graders were shocked that my white publicist wasn't "Ms. Jacqueline Woodson."

In the story, the boy's mom is coming out and the boy is afraid—afraid of what his friends will say, afraid of what it means in terms of his own sexuality, afraid that his family will always be "different." I try not to remember the stories I've read about young people being the targets of various bigotries. But the rain is coming down and beating against my windows, the sky is a heartbreaking gray and it's hard not to think about the impact of ignorance. I am a writer now because I have always wanted to be one, because I have stories to tell. I write for young people because my own childhood was so important to me, and because young people matter.

This morning, I am thinking about how a book can hold up a mirror for a young person or reveal a world. How, much more important than just experiencing the story, young people learn tolerance and compassion through literature.

This morning, I am thinking about the work ahead of me, the work ahead of all of us as artists, as humans—the futures we can help shape—often, by looking back.

•

But walking along the quiet roads in Peterborough, the past is just beginning to surface and the future—my future—is still as inconceivable as the notion of walking where James Baldwin and Audre Lorde once walked. I step lightly in this new place, let what little sun there is left to the day settle into my dark skin. This moment will inform what I write from this point on. All of it is quickly becoming a part of me.

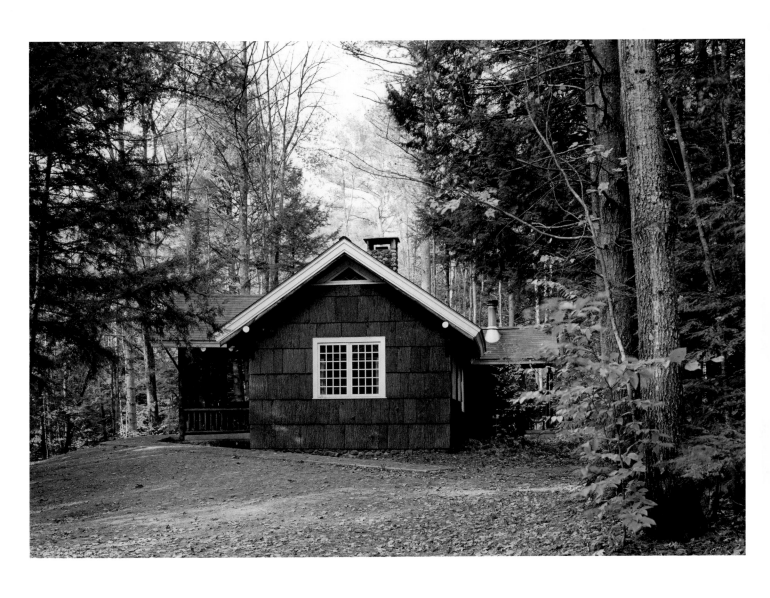

LIKE SCHELLING, WOOD STUDIO, OPENED IN 1913, IS SIDED WITH LARGE, OVERLAPPING PIECES OF WHITE-PINE BARK.

Postscript:
The Place I Have Been
Jean Valentine

Chekhov dreamed of starting such a place for artists in Russia.

You have silence and space here to think, to read, to do nothing, to sleep — all encouraged by the wordless way this place has of saying your work matters.

Windows open on other artists, other people, both of the past and of the present. Once I spent time in a studio where James Baldwin once spent time.

The hands of the staff, whether fundraising, or washing the sheets for our beds, they comfort us. Encourage us, as the sun encouraged Frank O'Hara that morning at Fire Island:

> Frankly I wanted to tell you
> I like your poetry. I see a lot
> on my rounds and you're okay.

Thank you (plural), MacDowell.

CHENEY STUDIO

Acknowledgments

A Place for the Arts: The MacDowell Colony, 1907–2007 is the work of many hands, hearts, and minds. The editors owe sincere thanks to all the MacDowell Colony Fellows who advised on the project and contributed to its content. Peter Cameron deserves special credit for working so sensitively with many of the authors. MacDowell's chairman, Robert MacNeil, and its former president, Thomas Putnam, provided unshakable moral support from the outset. Gratitude also goes to Mary Carswell, MacDowell's former executive director, who nurtured the idea from its inception, and to William N. Banks, a member of the board and former Fellow who serves as the Colony's institutional memory.

Many members of the Colony's staff, especially Cheryl Young, David Macy, Brendan Tapley, and Elizabeth Weinstein, provided invaluable assistance at many levels. The book's managing editor, Diana Murphy, supplied much more than managerial skill in seeing the book through to publication, and Miko McGinty upheld the Colony's high artistic traditions with her design, aided greatly by the photography of Victoria Sambunaris and the photo research of Rita Jules and Polly Cote.

This book could not have been realized without the financial support of MacDowell's many loyal donors over the years. The editors are especially grateful to Ilse Traulsen, whose faith in MacDowell and whose extraordinary generosity toward this project have put us deeply and lastingly in her debt.

About the Contributors

Joan Acocella has been a Colony Fellow seven times, most recently in 1998. She reviews dance and books as a staff writer for *The New Yorker*.

Peter Cameron has had seven Colony Fellowships. He is a novelist who has taught at Columbia, Oberlin, Sarah Lawrence, and Yale.

Michael Chabon, a Colony Fellow six times between 1996 and 2005, won the Pulitzer Prize for fiction in 2001 for his novel *The Amazing Adventures of Kavalier & Clay*.

Carol Diehl is a painter and critic who teaches at the School of Visual Arts in New York. She is a regular contributor to *Art in America* and was a Colony Fellow in 1995 and 1997.

Vartan Gregorian, the chairman of the board of The MacDowell Colony from 1990 to 1992, is a former president of the New York Public Library and of Brown University. He is currently the president of the Carnegie Corporation of New York.

Verlyn Klinkenborg, a Colony Fellow in 1997, holds a Ph.D. in English from Princeton and for ten years has been a member of the editorial board of the *New York Times*.

Robert MacNeil, the chairman of the board of directors of The MacDowell Colony since 1993, is the cofounder of *The MacNeil/Lehrer News Hour* on public television. His most recent book is *Do You Speak American?*

Paul Moravec is University Professor at Adelphi University. A five-time Colony Fellow, he won the 2004 Pulitzer Prize in music for his composition *Tempest Fantasy*.

Robin Rausch, who holds a master's degree in music history from Bowling Green State University in Ohio, is a music specialist at the Library of Congress.

Ruth Reichl, a Colony Fellow in 2000, 2002, and 2005, is an author and former restaurant critic for the *New York Times*. She is the editor-in-chief of *Gourmet* magazine.

Victoria Sambunaris is a photographer who earned her M.F.A. at Yale University. She teaches at the Yale School of Architecture.

Jean Valentine is a poet who has had nine Colony Fellowships. She won the Yale Younger Poets Award in 1965 and the National Book Award for Poetry in 2004.

Wendy Wasserstein, who died in 2006, wrote *The Heidi Chronicles*, which won the 1989 Pulitzer Prize for drama. She was a Colony Fellow in 2003 and 2004.

Carter Wiseman, president of The MacDowell Colony board of directors since 1999, is a former architecture critic for *New York* magazine. He is the author of biographies of I. M. Pei and Louis I. Kahn and teaches at the Yale School of Architecture.

Jacqueline Woodson, who writes primarily for children, has won the Caldecott Medal and the Coretta Scott King Award. She was a Colony Fellow in 1990, 1994, and 1998.

Kevin Young, a poet, has been a Colony Fellow five times, most recently in 1998. He has taught at the University of Georgia and Indiana University.

Index

Page numbers in *italics*
refer to photographs.

Acocella, Joan, 31
 essay by, 30–33
Adams Studio, *72, 74, 75*
African-American Colonists, 100–101, 220
Alexander, Jane, 184
Alexander, John White, 84, 127n.11
Alexander Studio, *28–29, 84–85, 112, 179*
Alpha Chi Omega fraternity, 124
Alpha Chi Omega Studio, *125*
American Academy in Rome, 58, 76
American Academy of Arts and Letters, 58
American art
 current standing of, 200–201
 of nineteenth century, 50, 52
American popular culture, and
 anti-Americanism, 189, 192
Americans for the Arts, 185
Amerika, 99, 128n.57
Ames, Winthrop, 70
Andrews, Mary Ellen, 111
anti-Americanism, 189, 192
Armory Show of 1913, 127n.11
artists' colonies, 12
 The MacDowell Colony the oldest, 104
 many new ones following the lead of
 MacDowell, 113, 188
 novels about, 33, 111

arts, the
 funding support for, 16, 109, 126,
 178–201
 public and private investment in,
 184–85
 returns from investment in, 184–85
 risk-taking in, 184, 188
 U.S. funding support, compared
 with other countries, 194
Avery, Milton, *17,* 100
Aylon, Hélène, 123

Baetz, Anna, 117
Baetz Studio, 111, *117*
Baker, George Pierce, 64, 70, 72–74, 124
Baldwin, James, *17,* 21, 100–101, 105, 117, 220
Ballard, Frederick, 74
Ballet New England, 118
Banks, William N., 115
Banks Studio, *96*
Bark Studio (later Schelling Studio), *67*
Barnard College, 64, 66
Barnard Studio, *68–69,* 124
Basquiat, Jean-Michel, 40
Bates, Esther Willard, 74
Bauer, Harold, 87
Bauer, Marion, 128n.39
Bazelon, Irwin, 98
Beach, Amy, 88, 128n.39
Beers, Charlotte, 194

Benet, Stephen, 82

Benet, William, 82, 86

Berkshire Music Center (Tanglewood), 94

Bernstein, Leonard, 102, 113, 128n.50

 Edward MacDowell medalist, 168,
 168

 Kaddish Symphony, 108

 Mass, 12

Blitzstein, Mark, 82, 86

Bloom, Amy, 204

Blumberg, Skip, 115

Blumenthal, Michael, 114

Bodenheim, Maxwell, 86

Bogan, Louise, 132n.83

Boghosian, Varujan, 16

Bond, Charles H., 156

Bond, Isabella Bacon, 156

Bond Hall, *18, 37, 156–57*

Bori, Lucrezia, 87

Boston Symphony Orchestra, 54

Boyle, Kay, 105

Boyle, T. Coraghessan, *East Is East,* 33

Brakhage, Stan, 115

Branscombe, Gena, 76, 128n.39

Brodeur, Clarence and Marie, 95, 98

Brown, J. Carter, Edward MacDowell
 Medal presentation speech, 169

Brown, John, 200

Bush, George W., 194

Business Committee for the Arts, 185

Butler, Nicholas Murray, 56

Cadman, Charles Wakefield, 89

Calcagno, Lawrence, 111

 MacDowell series, 111

Calder, Alexander, Edward MacDowell
 medalist, 162, *162*

Calderwood, Stanford, 118, 210

Calderwood Studio, 210, *211*

Cameron, Donna, 120

Cameron, Peter, 66

 essay by, 204–7

Campaign for MacDowell, 115–16

Campaign for the Studios, 116, 118

Campbell, Kim, 189

Canaday, John, Edward MacDowell
 Medal presentation speech, 163

Carnegie, Andrew, 59

Carnegie Hall, 87

Carswell, Mary, 116, 118

Cather, Willa, 82, 86

 Death Comes for the Archbishop, 82

Center for Arts and Culture, 189

Central Intelligence Agency (CIA), 180

Chabon, Michael, 124

 essay by, 210–14

Chamberlin, F. Tolles, 74–76

Chapman, George, 78

Chapman Studio, *78*

Cheney Studio, *222*

Cincinnati MacDowell Society, 124

Cleveland, Grover, 59

Clinton, Bill, 184

cold war, 99

Cole, Ulric, 128n.39

Colonists

 alumni, 16, *17,* 76

 connections among, after their
 residencies, 154–55

 the first, the Mears sisters, 64

men, 72, 82

number at The MacDowell Colony
 per year, 79, 100, 113

prizes and awards to, 124

recognized vs. unknown, concern
 about balance, 108

retitled Colony Fellows, 100

women, 64, 79–82

See also residencies

Colony Hall, *14–15, 19,* 74, 82, 94, 100, *149,*
 153, 156–57

view from, *77*

Colum, Mary, 101, 102

Colum, Padraic, 101, 102

Columbia University, 54, 56, 58, 64

communism, 99

consultants in poetry at the Library of
 Congress, 111, 132n.83

Copland, Aaron, 78, 82, 92, 93, 99, 102, *104*

as Edward MacDowell medalist, 102,
 104

as president of The MacDowell
 Colony, 102, 108

Cottingham, Robert, 120

Crimmins, Agnes L., 74

cultural diplomacy, 178, 180–81, 188–201

culture wars, 197

Cunningham, Merce, Edward MacDowell
 medalist, 171, *171*

Currier, T. P., 58

Currier Gallery of Art, 118

Danforth, Dr. Loomis L., 127n.15

Daniel, Lewis, 94

Danielpour, Richard, 115

Daniels, Mabel, 128n.39, 128n.50

Davis, Amanda, 210, 212–13

DeCamp, Rosemary, 102

DeFleur, Margaret H., and Marvin L.
 DeFleur, *Next Generation's*
 Image survey, 192

Delta Omicron music fraternity, 38, 124

Del Tredici, David, 111

In Memory of a Summer Day, 111

Diamond, David, 31, 89, 93, 128n.50

Diehl, Carol, essay by, 136–40

Dining Room, *37, 47*

Djuric, Mihailo, 118

Drue Heinz Studio for Sculpture (former
 icehouse), *34–35,* 118, *121, 134–35*

DuBose, Jennifer, 82

Duchamp, Marcel, 100

Eaton, Evelyn, 98

The Eaves, 79, *79, 80–81, 158–59,* 210

Edward MacDowell (Memorial)
 Association, 76, 79, 87, 99

gift of property to, 63

name change, 128n.35

Edward MacDowell Medal, 89, 104, 115,
 160–74

list of medalists and introducers,
 173–74

Ellis, Adrian, 181

Erdrich, Louise, 38

Eugene Coleman Savidge Library, *175,*
 182–83

Fargnoli, Patricia, 31

Fillmore, Louise, 99, 101

Fillmore, Parker, *76, 99*

filmmakers, at The MacDowell Colony, 109, 111, 115

Fimple, Vernon, 105

Finn, Helena Kane, 192

fire pond, *145*

Firth Studio, *22-23, 186-87*

Fish, Janet, 38

Fitzgerald, Robert, 132n.83

Florida, Richard, 200

Foss, Lukas, 94, 105

 The Prairie, 94

Frank, Robert, 123-24

Frankfurt, Germany, 50

Franzen, Jonathan, 66, 120

Friedlander, Lee, 115

 Edward MacDowell medalist, *167, 167*

Fulbright Scholarships, 180

Gaitskill, Mary, 66

Gardner, Isabella Stewart, 70

Gardner, Leonard, 108

Garland, Hamlin, 58, 88

Gelb, Leslie, 192

Gershwin, George, 86

ghosts of The MacDowell Colony, 89, 93, 210-14

Gilbert, Henry F., 76

Gnade, William, 31

Goll, Yvan and Claire, 94

Gray, Spalding, 115, 117

Great Depression, 88

Gregorian, Vartan, 12, 16

 essay by, 16-21

Grumbach, Doris, 111

 Chamber Music, 111

Hagedorn, Herman, 72

Hagen, Daron, 154

Hallmark Hall of Fame, Marion MacDowell's appearance in, 102

Hardwick, Elizabeth, Edward MacDowell Medal presentation speech, 166

Harris, Roy, 128n.50

Harvard University, 73

Hecht, Anthony, 132n.83

Heinz Studio, *134-35*

Heleniak, David, 115

Hellman, Lillian, Edward MacDowell medalist, 165, *165*

Here Is New York: A Democracy of Photographs, exhibition, 123

Hersey, John, Edward MacDowell Medal presentation speech, 165

Heyward, Dorothy, 82, 86

Heyward, DuBose, 66, 82, 86, 124

Heyward Studio, *97*

Hier, Ethel Glenn, 128n.39

Hijuelos, Oscar, 115

Hill, Edward Burlingame, 76

Hillcrest, *48-49,* 56, 82, 100

 MacDowells' purchase of, 118

 Music Room, 59, *60-61*

House Committee on Un-American Activities, 99

Howe, Mary, 86, 128n.39

Hughes, Karen, 194

Huntington Hartford Foundation, 113

hurricane of September 23, 1938, 92, 93

interdisciplinary artists, 115

Ivey, Bill, 184

Jacobsen, Josephine, 111, 132n.83
Jefferson, Thomas, 200
Johnson, Fenton, 155
Johnson, Lyndon, 181
Joyce, James, 101

Kawata, Tamiko, 178
Kelley, Jessie Stillman, 87
Kendall, George, 101
Kennedy, John F., 181
Kinnell, Galway, 38, 115
Klinkenborg, Verlyn, essay by, 24–27
Kohut, Andrew, 194
Kolb, Barbara, 115, 118
Kopit, Arthur, 66
Koussevitzky, Olga, 95
Koussevitzky, Serge, 87, 94–95
Kubik, Gail, 94
Kuhns, Dorothy, 82
Kunitz, Stanley, 132n.83

Lamb, Wendy, 154
Lang, Benjamin, 52
Laramee, Eve, 155
Leonard, John, Edward MacDowell Medal
 presentation speech, 164
Life magazine, 99
Liszt, Franz, 50
The Lodge, 95, *96, 97, 130–31*
London Times, 94
Lopatnikoff, Nikolai, 128n.50
Lorde, Audre, 66, 220
Low, Seth, 54, 56
Lower House, 64
Luening, Otto, 100

lunch basket tradition, 10, *42, 44, 45,* 82,
 98, 213
Lynes, Russell, 109

MacDowell, Edward, *53, 55*
 death of, 64, 127n.15
 final illness, 58, 111
 injured in traffic accident, 58
 Keltic Sonata, 87
 musical study and career in Europe,
 50, 52
 music of, 52, 87, 98, 128n.35
 at Peterborough, N.H., retreat, 10,
 129n.59
 piano virtuosity of, 52, 54
 students of, 58, 64
 teaching at Columbia University, 56,
 58
MacDowell, Edward and Marian, graves
 of, *106–7*
MacDowell, Marian (Mrs. Edward), *54,
 57, 83, 103*
 confidants of, 73, 111
 continuing involvement with the
 Colony in her old age, 101–2
 death of, 102, 108
 illnesses, 86, 95
 lecture recital tours to raise money,
 70, 72, *83,* 88
 letter of support to Copland, 99
 meets and marries Edward
 MacDowell, 50
 ninety-fifth-birthday celebration,
 101–2, 129n.65

performance of Edward
MacDowell's music at Carnegie
Hall (1929), 87
Pictorial Review award to, 82
purchase of Hillcrest, 54–56, 118
resignation from active management
of the Colony, 95, 98
student of Edward MacDowell in
Europe, 50
support for Edward's work, 54–56
support of artists, 124–26
Victorian social mores of, 82
MacDowell Amphitheatre, *71, 198–99*
MacDowell Club of Allied Arts of
Oklahoma City, 124
MacDowell Club of Boston, 54
MacDowell Club of New York, 59, 74,
93–94, 127n.11
MacDowell Clubs (generally), 70–72, 124
MacDowell Colony
1910–19 decade, 64–79
1920–29 decade, 79–87
1930–39 decade, 87–93
1940–49 decade, 93–99
1950–59 decade, 99–102
1960–69 decade, 102–9
1970–79 decade, 109–13
1980–89 decade, 113–16
1990–99 decade, 116–20
2000–present, 123–26
closed in 1939 because of 1938
hurricane, 92, 93
in the cold war, 99
contribution of, to image of
America, 178

cost to residents of room and
board, 63, 88
creative energy at, 113–15
distinguished alumni of, 16, *17*
endowment fund project, 86–87
European refugee artists at, 94
executive board, 109, 126
farm operations at, 74
first studios, *62, 64,* 118
foundation support for, 109
founding of, 63–64
fundraising, 88–89, 108, 115–16
hundredth-anniversary celebration,
10, 12
influence on other artists' colonies,
104, 113, 188
land deed to, 63
management after Mrs.
MacDowell's retirement, 101
mortgage paid off, 87
Mrs. MacDowell's promotion of,
70–72
a National Historic Landmark, 104
National Medal of Arts awarded to,
120
on the National Register of Historic
Places, 104
"not for everybody," too rural for
some, 105
open to the public on Medal Day,
104
public image of, 82
rules (and bending of), 73, 82, 98, 101
silver anniversary celebration (1932),
87

and town of Peterborough, N.H., 64–70, 120

 year-round program started in 1955, 100

 See also Colonists; residencies

MacDowell Crusade, 87

MacDowell Downtown, 120

MacDowell Fellowship in dramatic composition, at Harvard, 74

MacDowell in the Schools, 118

MacDowell Studio, *13*

MacDowell Week (1927), 87

MacNeil, Robert, 12, 126

 as chairman, 16, 116

 essay by, 178–201

Macy, David, 120, 126

mailboxes at The MacDowell Colony, 36

Mailer, Norman, Edward MacDowell medalist, 164, *164*

Mapplethorpe, Robert, 181

Marian MacDowell Day (1952), 101–2

Maupin, Armistead, 184

Maxwell, William, 89

 They Came Like Swallows, 89

McCarthy, Mary, Edward MacDowell medalist, 166, *166*

McFadden, Elizabeth, 74

McKim, Charles, 58

Mears, Helen Farnsworth, 64, *65*, 124

Mears, Mary, 64, *65*

Medal Day, 104

Mendelssohn Glee Club, 59

Men's Lodge, 74, 76, 82, 95

Midori, 185

Millay Colony, 113

Miller, Arthur, 194–97

Mixter Studio, *193*

Moe, Eric, 120

Monday Music Studio, *92, 202–3*

Monk, Meredith, 115

 Edward MacDowell Medal presentation speech, 171

Moravec, Paul, 124

 essay by, 152–55

Morgan, J. P., 59, 63

Morison, Mary, 56

Morrissey, Joanna, 210

Muldoon, Paul, 154

Murray, Pauli, 100–101

music, European education in, in Edward MacDowell's time, 50

Musical Courier, 52

music clubs, 124

music festivals at The MacDowell Colony (1910s), 76, 79

Music Room, 59, *60–61*

Music Teachers' National Association, 88

Muslim world, 189, 192

National Endowment for the Arts (NEA), 116, 181, 184

National Endowment for the Humanities (NEH), 109, 181

National Federation of Music Clubs, 79, 87, 124

National Institute of Arts and Letters, 58

National League of American Pen Women, 88

Nef, Evelyn Stefansson, 118, 119

Nef Studio, 118, *119*

Nehalem Colony, 113

Nevelson, Louise, Edward MacDowell
 medalist, 163, *163*

Nevins, Marian. *See* MacDowell, Marian

New Hampshire Federation of Women's
 Clubs, 87

New Hampshire Historical Society, 118

New Hampshire MacDowell Celebration,
 118

New Hampshire Studio, *141, 150–51*

New Hampshire Symphony, 118

New Jersey State Federation of Women's
 Clubs, 124

New York Carol Club of Sorosis, 122, 124

9/11
 Colonists' responses to, 123
 world reaction to, 192

Nixon, Richard M., 111

nonprofit arts organizations
 economic importance of, 185
 increase in numbers of, 181

Norlin Foundation, 109

Nussbaum, Martha, 197

Nye, Joseph, 188

Oda, Makoto, 99–100

Oleszko, Pat, 155

Olsen, Tillie, 66

Omicron Studio, 36, *38*

open studio tradition, 36

Osborn, Elodie, 109

Ossabaw Island Project, 113

pageantry movement, 70

Pageant Theatre, *71*

Pan's Cottage, *77, 79*

Parks, Suzan-Lori, 204

Patchett, Ann, 204

peace circle for 9/11, 123

Pei, I. M., Edward MacDowell medalist,
 169, *169*

Perry, Julia, 129n.61

Peterboro Basket Company, 42

Peterborough, N.H.
 Colonists' trips to, 146
 Conval High School, 120
 Elementary School, 120
 pageant of 1910, 64, 70, *71*
 relations of The MacDowell Colony
 with, 64, 70, 120
 Wilder's *Our Town* presumably
 based on, 89

Peterborough, N.H., MacDowell property
 abandoned farm purchased by Mrs.
 MacDowell, 54–56, 118
 deed of gift to the Edward
 MacDowell Memorial
 Association, 63
 Edward MacDowell's wish to turn it
 into an artists' retreat, 58
 See also Hillcrest

Peterborough Historical Society, 120

Peterborough Players, 156

Phi Beta fraternity, 124, 204

Phi Beta Studio, *205*

photographers, at The MacDowell
 Colony, 111, 115

Pictorial Review, 82

Porgy and Bess, 86

post office at The MacDowell Colony, *37*

public broadcasting, 181, 184
Putnam, Thomas, 10, 118

racism in America, 197
Raff, Joachim, 50
Ralston, Marion Frances, 128n.39
Ranck, Edwin Carty, 74
Rand Corporation, 184
Rausch, Robin, 12
 essay by, 50–132
Raymond, Monica, 115
Read, Gardner, 128n.50
Reich, Steve, Edward MacDowell medalist, 172, *172*
Reichl, Ruth, essay by, 43–46
residencies
 evaluation of applications, 79, 116, 118
 limit on number of repeat visits, 101, 116, 129n.64
 number of applicants, 113
 record for most repeat visits, 105
 See also Colonists
Reynard, Grant, 86, 94
Ringgold, Faith, 114
Robertson, Leslie, 120
Robinson, Edwin Arlington, 72–73, *72, 73,* 93
 Tristram, 82
Rockefeller Foundation, 109
Rogers, Bertha, 120
romances and weddings at The MacDowell Colony, 82
Roosevelt, Eleanor, 88
Roosevelt, Theodore, 58
Rorem, Ned, 124

Edward MacDowell Medal presentation speech, 168
Roth, Philip, Edward MacDowell medalist, 170, *170*
Rustic Canyon, Pacific Palisades, Calif., artists' colony, 113

Santa Cruz, Domingo, 100
Saturday Review, 109
Schapiro, Meyer, Edward MacDowell Medal presentation speech, 162
Schelling, Ernest, 66, 87
Schelling Studio, *65, 67*
Schneider, Cynthia, 194
schools, local, Colonists helping out in, 118, 120
Schuman, William, 109
Schumann, Clara, 50
Sears, Helen, 128n.39
September 11, 2001, terrorist attacks. *See* 9/11
Serra, Richard, Edward MacDowell Medal presentation speech, 172
Serrano, Andres, 181
Sheng, Bright, 78, 115
Sherin, Ed, 184
Sigma Alpha Iota fraternity, 124
Sinclair, Upton, 56
Smith, Chard Powers, 86
Society for American Women Composers, 88
Sondheim, Stephen, 86
Sorosis Studio, *122*
Sousa, John Philip, 87
Souther, Louise, 128n.39

Sparhawk-Jones, Elizabeth, 101
Sprague-Smith studio, *31, 32*
Star Studio, *125*
Stein, Gertrude, 89
Stein, Sol, 101
Stetson, Katharine Beecher, 76
Stevens, May, 114
Stock, Frederick, 87
Stokowski, Leopold, 87
studios
 the first, at The MacDowell Colony,
 62, 64, 118
 naming of, 74
 new, 118
 nighttime use of, rule against, 82
 renovation campaign, 116
 visiting without an invitation, rule
 against, *73,* 98
 wired for electricity, 100
Styron, William, 154
 Edward MacDowell Medal presenta-
 tion speech, 170
Szarkowski, John, Edward MacDowell
 Medal presentation speech, 167

Tabachnick, Anne, 114
Talma, Louise, *17,* 105, 108, 129n.64
Taylor, Deems, 76
Tenney farm, purchase of, 74, 153
Tewksbury, Blake, *45*
Toch, Ernst, 102
"tombstones" (wooden boards signed by
 former Colonists), 115, 124, *141,*
 213, *217*
Tonieri, Emil and Mary, 94

Topiary, 123
Trask, Spencer and Katrina, 113
Trimble, Lester, 108
Tuchman, Barbara, 114
Turner, J. M. W., 139
Tuszynska, Agata, 155
Tutwiler, Margaret, 194

United States
 image of, abroad, 178, 200–201
 support for the arts, compared with
 other countries, 194
United States Information Agency
 (USIA), 178, 180, 188
Untermeyer, Louis, 132n.83
U.S. Conference of Mayors, 185
Ussachevsky, Vladimir, 100

Valentine, Jean, text by, 223
Van Veen, Stuyvesant, 94
Veltin Studio, *73, 90–91,* 146
Virginia Center for the Creative Arts, 113
visiting artists, 100
Von Eschen, Penny M., 197

Walker, Alice, 12, 38, 108, *110*
Ware, W. R., 56
Warhol, Andy, 139
Wasserstein, Wendy
 essay by, 144–48
 Third, 147–48
Watergate period, 111
Watson Studio, 100, *176–77*
Waugh, Alec, 102
 Islands in the Sun, 102

Weeks, Edward, Edward MacDowell
 Medal presentation speech, 161
Weister, Mrs. Alice, 113
White, Richard Grant, 50
Whitehead, Colson, 78
Whittemore, Reed, 132n.83
Wiesbaden, Germany, 52
Wilder, Thornton, 82, 90, 93, 105, 108, 115
 The Bridge of San Luis Rey, 82
 Edward MacDowell medalist, 104,
 161, *161*
 fundraising efforts for the Colony,
 88–89, 92
 Our Town, 12, 89, 124, 214
Williamson, Suzanne, 123
Winsor, F., Jr., 193
Wiseman, Carter, 126
Woodberry, George Edward, 56
Woods, Mark, 123–24
Woodson, Jacqueline, essay by, 216–20
Wood Studio, *92, 221*
World Trade Center, 123, 155
World War II, 93–95
Wylie, Elinor, 82, 86, 93

Yaddo, Saratoga Springs, N.Y., 113
Young, Cheryl, 118, 126
Young, Kevin, 38
 essay by, 36–41
Yu, Jessica, 204